T DUTCH &THEIR BIKES

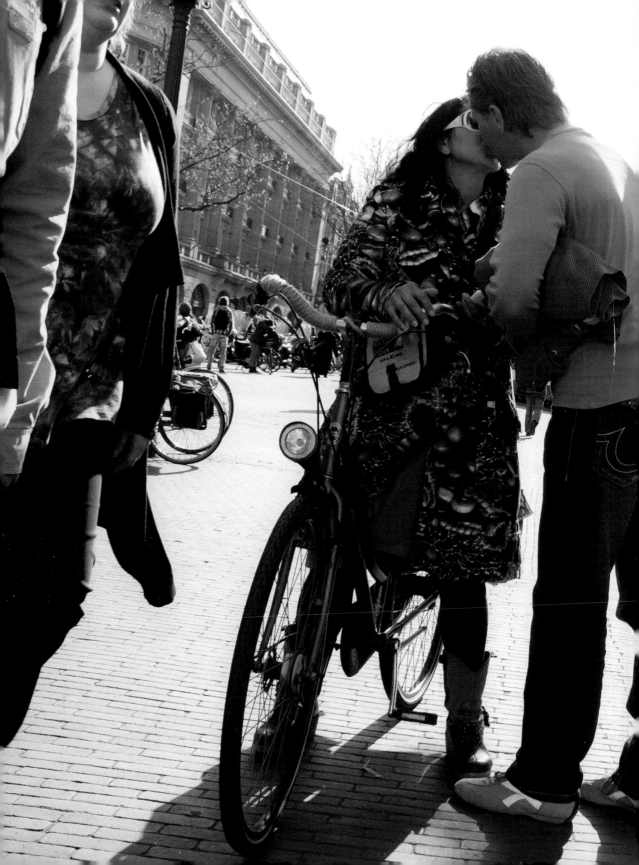

THE DUTCH & THEIR BIKES

SCENES FROM A NATION OF CYCLISTS

SHIRLEY AGUDO

XPAT SCRIPTUM PUBLISHERS

"In my opinion, the Dutch are rather blind to their own cycling culture. Thanks to Shirley Agudo, that will change."

Kaspar Hanenbergh, cycling historian and co-author of *Ons Stalen Ros* (*Our Iron Horse*), about Dutch cycling history until 1920

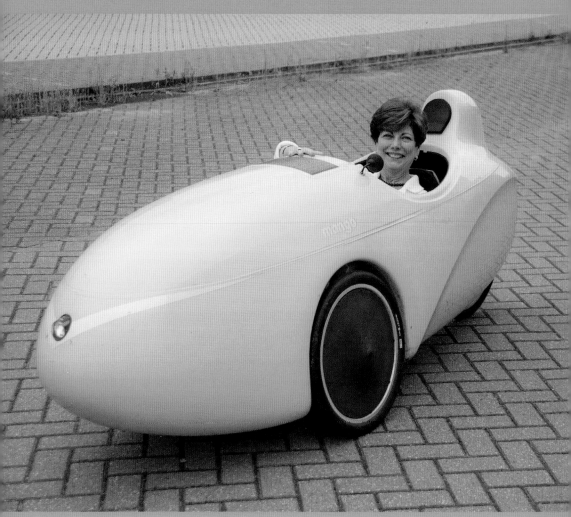

THE DUTCH & THEIR BIKES
SCENES FROM A NATION OF CYCLISTS

WELCOME TO THE WORLD OF EVERYDAY CYCLISTS!

The Netherlands – commonly referred to as Holland – is the most cycling-friendly country on earth. Cycling is a way of life for the Dutch. Everyone cycles, day in and day out and, typically, several times a day.

Cycling is a primary means of transportation in this nation where there are more bikes than people – 16.8 million people and 18 million bikes. And, although it's a very small country (41,526 sq km or 16,033 sq mi), there are about 35,000 km (almost 22,000 mi) of cycling paths, and that number is growing daily.

Many countries around the world are making strides to emulate the Dutch bicycle culture – some with initial success, and others with great struggle. Their goal is to learn from the Dutch how to make cycling an integral – and safe – part of everyday life.

As an American photojournalist who lives in the Netherlands, I am constantly in awe of the Dutch bicycle culture. My hope is that the images I have amassed will resonate with people far and wide – to everyone around the world who is interested in the Dutch cycling phenomenon and wants to make cycling a more viable option in their own culture – as well as to those who can simply enjoy the view.

WHAT'S THEIR SECRET?

Why do the Dutch cycle so much, and how did they come to have the most advanced cycling infrastructure on the planet? In as few words as possible, I will answer these questions. My photographs – and the perspectives of others that I have quoted – will do the rest.

I hope you enjoy this visual journey through the land of cyclists.

Shirley J. S. Agudo
Author/photographer

City of Amsterdam

"*The Dutch & their Bikes* is a compelling collection of images about our nation of cyclists. Amsterdam's reputation as 'the world's best cycling city' is certainly true, and Shirley Agudo brings it all to life."

Eberhard E. van der Laan
Mayor of Amsterdam.

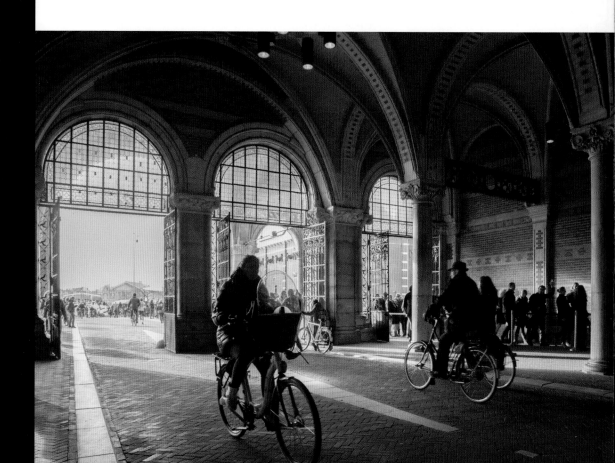

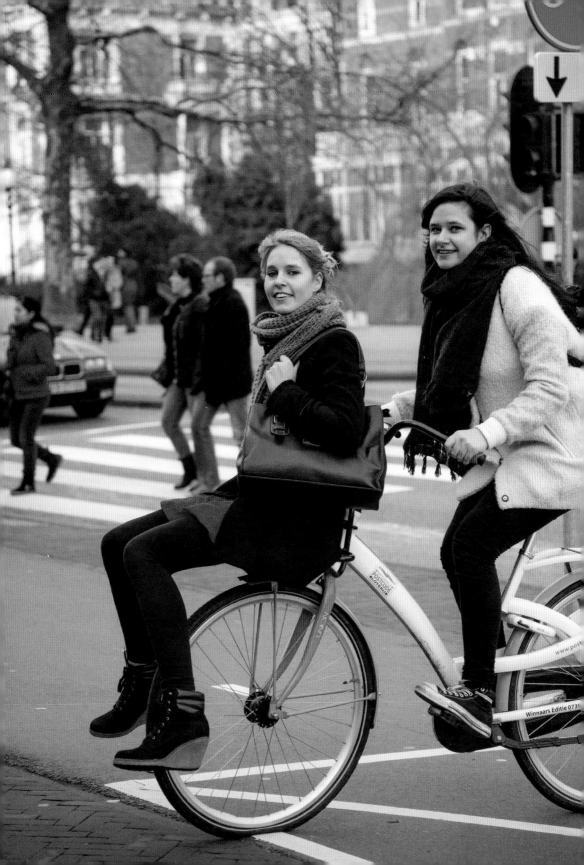

A WAY OF LIFE
A NATION OF EVERYDAY CYCLISTS

CYCLING IN THE NETHERLANDS: THE FACTS

- The Netherlands is the most advanced, cycling-friendly country on earth.
- The Netherlands is the only nation in the world with more bicycles than people. (Population: 16.8 million; number of bikes: ca. 18 million)
- Amsterdam, the capital, with a population of ca. 800,000, has an estimated 880,000 bikes. (Usage has gone up 44% since 1990.)
- Cycling is ingrained in the Dutch culture. Dutch children learn to cycle almost before they learn to walk. Children are taught how to cycle when they are about three years old, and are prepped for mandatory cycling exams to be taken when they are age ten.
- There are roughly 35,000 km (22,000 miles) of cycling paths – 29,000 km (18,020 mi) of which are segregated.
- 27% of all trips in the Netherlands are made by bike. (18% in Denmark, 10% in Germany, and 1% in the USA) For trips less than 7.5 km (4.7 mi), 34% is the estimate.
- In Amsterdam, some 60% of people cycle to work on a daily basis. Of all trips made in Amsterdam, over 50% are made by bike, for commuting to school and work, shopping, going out, etc. This means that, collectively, Amsterdam residents cycle approximately 2 million kilometers (almost 1,243,000 miles) – daily!
- Less than 10% of all cycling in the Netherlands is specifically for recreational or fitness purposes. The Dutch are *practical* cyclists, meaning that they use cycling primarily as a means of transportation – for shopping, commuting to school or work, visiting friends and family, and going out for entertainment.
- The average cycling distance per trip is 3 km (1.9 miles). On average, the Dutch cycle 900 km (559 mi) per person per year.
- According to Dutch research, in an average-sized town, cycling will get you to your destination 5% quicker than driving; in big cities (over 100,000 inhabitants): 10% faster.
- The average speed of cycling is 15 to 18 km per hour (9 to 11 mph).*
- The Netherlands is the largest producer of bicycles in Europe.

- 1.3 million bikes are purchased every year in the Netherlands, with a total value of €1 billion (ca. $1.4 billion). (Electric bikes now account for over 10% of sales.)
- The average price of a new bike is €954 (ca. $1,293). Most Dutch people prefer to buy a very solid, high-quality bike that will serve them well for long-term, everyday cycling. The selection of bikes to choose from is staggering.
- There are more than 2,000 bike shops in the Netherlands – a country that is only 41,526 sq km (16,033 sq mi), about the size of the US state of Maryland.
- The annual budget for cycling infrastructure in the Netherlands is approximately €400 million (ca. $542 million). Amsterdam alone spent €20 million ($27 million) a year between 2007 and 2010 to improve cycling infrastructure.
- Thanks to a dedicated infrastructure – with separated bike paths along urban arterials and traffic-calmed residential streets – cycling in the Netherlands is most likely the safest place to cycle in the world (i.e. with the lowest risk per km cycled).
- Helmets are not required in the Netherlands. According to the Dutch Cyclists' Union (Fietsersbond), helmets give cyclists a 'false sense of security' and, further, making helmets compulsory would lead to fewer people using their bikes. (Research shows that 60% of people would stop cycling if they had to wear a helmet.) The overall benefits of cycling seem to carry more weight in the Netherlands than the suggested advantage of wearing a helmet. Plus, many other cycling safety measures are employed throughout the Netherlands to make cycling a safer proposition.
- Cycling under the influence of alcohol is an offence in the Netherlands, with the same blood alcohol limit as for motorists: a level of 0.5.
- Using a cell phone while cycling in the Netherlands is strongly discouraged but not against the law.
- Bike parking is a science – as well as an art – in the Netherlands. At train stations alone, throughout the country, there are a total of 320,000 official bike parking spaces, and this number is growing all the time. The Dutch are renowned in general for their innovative designs, including those for bike parking facilities.

* The record for speed cycling is held by Dutchman Fred Rompelberg: 269 km per hour (167 mph). (Record set in 1995 at Bonneville Salt Flats, Utah; unbeaten to date). Born in 1945, Rompelberg is regarded as the world's oldest professional cyclist.)
Leontien van Moorsel is regarded as the 'country's most successful cyclist'. Over a career interrupted by illness, she won four Olympic Golds and 10 World Championship jerseys. On top of that, she set the world hour record for women, in 2003, at 46.07 km (28.6 mi).

- Amsterdam is very strict about proper bike parking because public space is very scarce, both at train stations and in the inner city, due to such narrow streets. There are about 250,000 bike racks in the city, and they are meant for parking – not for bike storage. In order to create places for bikes that are used frequently, the municipality carts bikes away on a regular basis.

 If bikes are parked in racks in public spaces for longer than 2 – 4 weeks, or if they have become wrecks, these bikes will be carted away to the Fietsdepot (Bike Depot). These abandoned, or 'orphan bikes', account for ca. 15% of bike parking spaces. Retrieving a bike from the Fietsdepot currently costs €10 (ca. $14). Approximately three-quarters of these bikes are never claimed. Of the almost 74,000 bikes brought to the Amsterdam Fietsdepot in 2013, only around 21,000 were claimed by the owner; about 70% were unclaimed. (Bikes are only held for three months.)

- There are approximately 750,000 bikes stolen each year in the Netherlands. However, only one in three bike thefts is reported.

- Bikes essentially rule the road in the Netherlands. Since almost all motorists also cycle, they are generally more conscientious about cyclists in traffic. Moreover, if a driver hits a cyclist, he or she is, in most cases, automatically assumed 'at fault' – the logic being that the driver is commanding a much more powerful and therefore dangerous vehicle and, consequently, should be on constant lookout for the welfare of cyclists.

- The Dutch are very hardy people, and they cycle routinely through rain, sleet and snow, as well as gale-force winds.

WHY THE DUTCH CYCLE SO MUCH

Simply stated, the Dutch cycle on a routine basis because it is:

- Efficient: Quicker to short destinations and for in-city trips
- Economical: Cycling is much cheaper than driving, in terms of both fuel and parking. In addition, those who cycle to work in the Netherlands can claim 19 euro cents (.26 US) per km as a deduction on their taxes. Some employers also provide 'company bikes' to their employees, free of charge.
- Convenient: A country-wide cycling infrastructure exists that is well-maintained and continually expanded.
- Safe: There are bicycle-specific traffic lights, dedicated cycling lanes, well-marked cycling routes and related cycling-traffic signs on virtually all roads and streets ... combined with a general awareness and respect from motorists.
- Healthy

- **Enjoyable**
- **Environmentally-friendly**
- **Overall, it just makes sense. It's practical. It's 'cyclelogical'.**

It's very important to note here that cycling has successfully become such a prominent part of everyday life in the Netherlands because the Dutch government, both national and local, supports cycling in a major way. This cannot be emphasized enough.

THE CUTTING EDGE
Cycling innovations are constantly in the news in the Netherlands. Here are a few that are currently turning heads:

- **Cycling super highways for long-distance commuters, suburban and touring cyclists, such as the one from Haarlem (NL) to Amsterdam.**
- **Bicycle bridges (and tunnels), such as the Burgemeester Jan Waaijerbrug, in Zoetermeer (which generates its own energy for lighting, via solar panels on top of the light fixtures), the suspended Hovenring in Eindhoven, the Snelbinder in Nijmegen (a cycle bridge attached to a railroad bridge), and the spectacular Nesciobrug (Nescio Bridge) in Amsterdam – the longest bicycle and pedestrian bridge in the Netherlands (780 meters / 2,559 feet).**
- **Lighted or 'glow-in-the-dark' bicycle paths**
- **Heated bicycle paths, for winter conditions**
- **Park 'n Bike, targeted for medium-sized cities where there is less public transport**
- **World's largest bike parking garage, currently being built in Utrecht, for ca. 12,500 bicycles; target date of 2016 for the first part and 2018 for completion. See: www.youtube.com/watch?v=ynIRAhoqoBc**
- **Bike GPS systems**
- **Airbags on car windshields to protect cyclists in accidents**
- **Electric bikes: Bikes with battery packs were mostly of interest to the elderly but are now making huge headway with the younger crowd who have come to realize that they are a quicker way to get from point A to point B. They are also popular for commuting longer distances to work … without getting sweaty.**

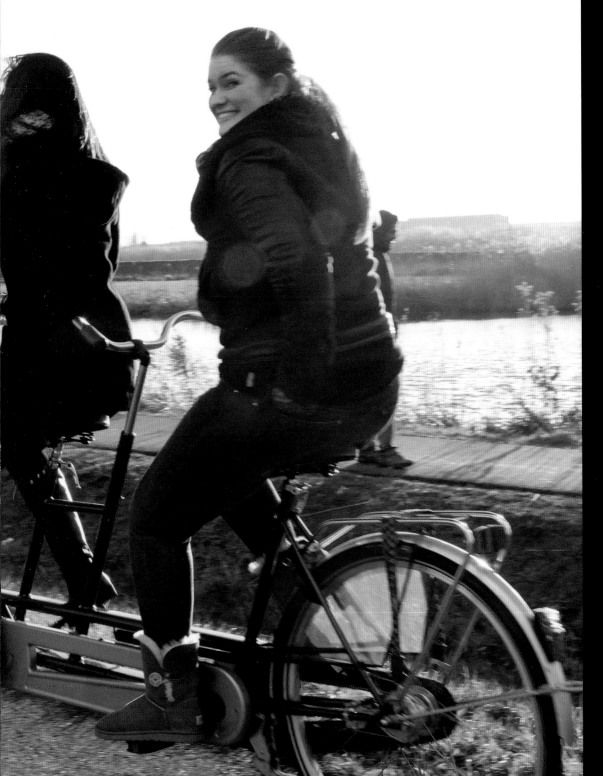

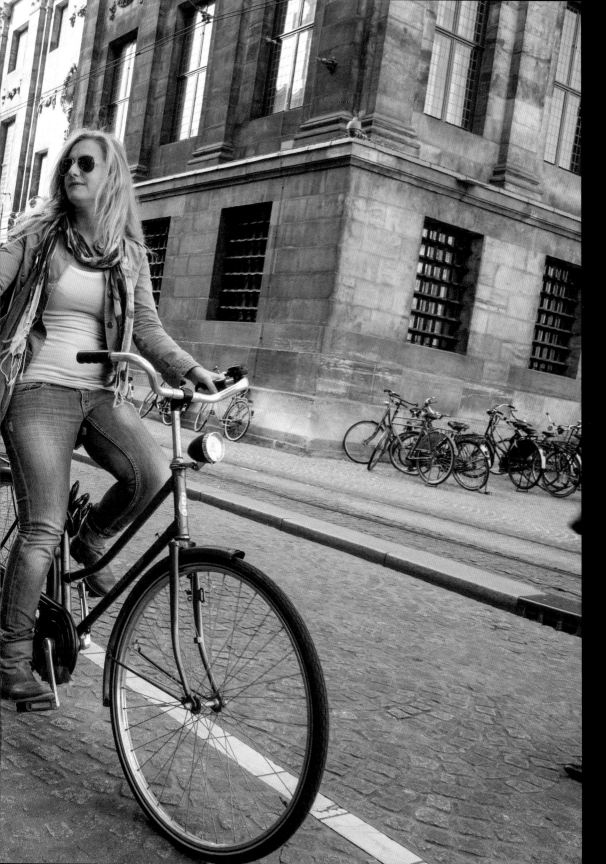

PERSPECTIVE
WHY THE NETHERLANDS BECAME A COUNTRY OF CYCLISTS

by Guido van Woerkom, President and CEO, ANWB, The Royal Dutch Touring Club*

In mid-August (2013) the British Prime Minister David Cameron presented a new national scheme to promote cycling in urban areas and promised to spend 77 million pounds sterling on cycle infrastructure in the UK. In this presentation he pointed to the Netherlands as a role model to follow.

The Netherlands is definitely a country of cyclists. There are more bicycles than inhabitants in the country. And for distances of up to 7.5 km (4.7 mi), the bicycle is the most frequently used mode of transportation. But in what way did the Netherlands develop into a 'biker's country'? Was this built into our genes? Or can it be traced to geographical factors such as the absence of hills or slopes of any importance? I would argue that the answer could be found in our history. The Netherlands became a nation of cyclists due to the actions of specific groups, with a most prominent role being that of the ANWB.

INTRODUCTION OF THE BICYCLE IN THE NETHERLANDS (1870–1895)

The bicycle was not invented in the Netherlands. The first bicycles used in our country were imported. They arrived in the Netherlands in the second half of the 19th century, first from France and later from the UK. In this period, Dutch blacksmiths started to copy these imported bicycles and a national bicycle industry gradually emerged.

Bicycles were first mainly used by young men between the ages of 12 and 25. These youths used their cycles for touring and for racing. The speed of these new machines was very attractive to these young men, but dangerous as well. Contrary to what one might expect, this lack of safety was also an attraction. By riding such an unstable machine, one could prove one's courage.

These young men organized themselves in local bicycle clubs – the first established in Amsterdam around 1870. In 1883 these local bicycle

*The Royal Dutch Touring Club ANWB, founded 1883

associations decided to form a national cycle association in the form of the ANWB. The British Cycle Association, founded in 1878, was a role model for the Dutch in the years to come.

The ANWB developed as an association that promoted the use of bicycles in the Netherlands. It organized tours and bicycle races and it even stimulated the construction and the exploitation of a race course in the city of Nijmegen. Following in the footsteps of its British example, from 1884 on, the ANWB annually published handbooks containing the addresses of hotels and restaurants worth visiting by cycling tourists, and it also published cycling maps.

Another facility introduced by the ANWB in the Netherlands was the bicycle repair box, which the organization placed at approved hotels and restaurants from 1896 on. These boxes contained not only repair sets, but medical first aid material as well, including material to splint broken bones. In about 1900 the ANWB started to introduce insurance for cyclists to soften the financial pain caused by cycling accidents.

THE BREAKTHROUGH OF THE BICYCLE (1895–1920)

The ANWB was keen on measures to improve the safety of bicycles. The association was very enthusiastic about the so-called Safety Bicycle, which was introduced in 1886. These bicycles, with wheels of the same size, a chain to drive the machine, and other new accessories, were an important step in improving the safety of cyclists and an effective means of increasing the popularity of cycling. After the breakthrough of the Safety Bicycle, increasingly more women and older men also started to ride bicycles. Other types of bicycles fell into disuse within a few years. The effectiveness of the Safety Bike was further improved by the introduction of pneumatic tires and the back-pedal brake as well as by a step-by-step development of bicycle lights. In the 1890s the number of cyclists in the Netherlands started to increase steeply, and membership in the ANWB started to grow steadily as well.

The ANWB also influenced the use made of these machines. From the early 1890s on, the association campaigned for the work-related use of bicycles. In its periodical *De Kampioen* (The Champion) there were articles on the usefulness of bicycles for telegram deliverymen, doctors and army messenger couriers.

In 1900 the ANWB transformed itself from an association of cyclists into a tourist organization aiming to serve tourists traveling by whatever means they wanted to use. The decision to transform was inspired by the introduction of the first motorcars on Dutch roads

in 1896. Beginning in 1902 the ANWB supervised quality controls of the petrol sold in the Netherlands and soon started to organize the distribution of petrol themselves. Other facilities for motorists followed suit. The ANWB ceased to be an association of cyclists only. But the ANWB also continued its activities aimed at cyclists. The association advised the Dutch cycle industry on ways to improve the safety and the user-friendliness of the existing models of bikes. The ANWB also stepped up its efforts to make the very strict municipal cycling regulations more lenient. It advocated more relaxed speed limits on inner city streets and drafted parts of a new national traffic code in 1906 to encompass all local traffic legislation.

The ANWB also focused on cycle paths. From the late 1890s on, the association advocated the construction of special cycle paths since the surface of many main routes was not fit for cycling. It experimented with new, more cycle-friendly types of road surfaces and even bought its own steamroller to facilitate the construction of macadam cycle paths. From 1908 on, it engaged in a growing network of local and regional cycle path associations in the Netherlands with the aim of constructing a national network of recreational cycle paths. The association even had special road signs designed for these cycle paths in the form of so-called 'paddenstoelen' (mushrooms). These days, more than 5,000 of these mushrooms continue to decorate all of the important recreational areas in the Netherlands. These road signs are one of the most celebrated symbols of the ANWB. When in the 1920s the number of bicycles rose further to more than two million, hundreds of thousands of cyclists flocked to the countryside or the seaside on spring and summer weekends.

MASSIVE BICYCLE USE (1920–1940)

More striking, and even more important, was the rise of bicycle use in the urban environment. In the 1920s, streets in Dutch cities were filled with tens of thousands of cyclists. Rush-hour traffic counts revealed that about 80% of all urban traffic at this time consisted of cyclists.

Workers, clerks and office girls plied the streets together with businessmen or bankers. The ANWB was very instrumental in this phenomenon. The association advocated the use of the so-called 'Dutch bike', a black bicycle with a sturdy frame and suitable safety accessories enabling its riders to bike in a straight, upright way in contrast to the more sportive way of riding a bicycle 30 years earlier. This type of bicycle, advocated in the ANWB periodical *De Kampioen*, was a type suitable for all classes and walks of life. It

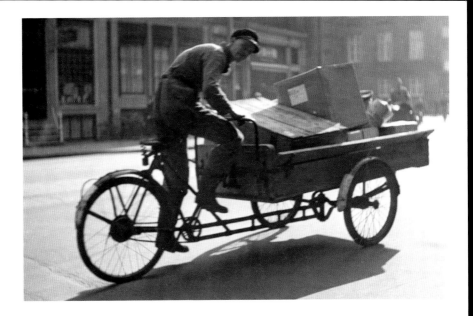

became one of the features of Dutch society. Not only did Dutch ministers bike to and from their work at the ministries, but the Dutch queen and her daughter also adopted the bicycle in this period. When the German prince Bernhard had to be presented to the Dutch population as a suitable husband for princess and future queen Juliana, a bicycle ride was chosen. In 1939, one out of every two Dutchmen possessed a bicycle.

When in the 1920s plans were drafted to modernize national, provincial and municipal road networks to accommodate the increasing numbers of motor vehicles, cyclists were not forgotten. Cycle paths were constructed in new urban districts and next to new provincial roads and national highways. When the first motorways were constructed in the Netherlands from 1934 on, accompanying cycle paths were an integral part of these schemes. Perhaps even more importantly, planners entitled the cyclists to a continued right of way and conceived of streets as spaces where different modes of traffic, including bicycles, would mix. Traffic regulations reflected this notion. At junctions, traffic from the right had the right of way, regardless of whether the traffic participant drove a car or rode a bike. In 1941 the German occupiers changed this rule into a priority for motorized traffic to facilitate their motorized columns.

UNDER PRESSURE (1940–1970)

In the course of the 1950s, the existing traffic situation in the Netherlands changed completely due to the start of mass motorization. From a mere 47,000 passenger cars in 1946, the number of motorcars in the Netherlands increased steeply in the 1950s, under the influence

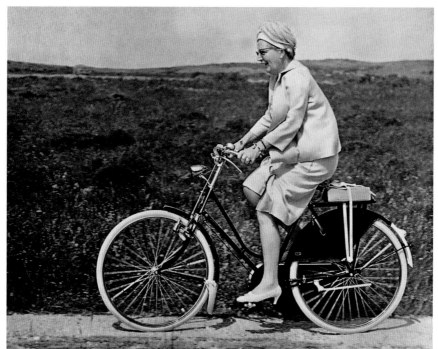

Prinses Juliana
– former queen
of the Netherlands
(1948–1980)

of economic growth and rising wages, to a level of 500,000 passenger cars in 1960. In 1970, 2.5 million cars were registered in the Netherlands. The national government reacted to this growth with an accelerated construction of motorways, and municipal authorities initiated the construction of ring roads and new parking facilities.

For bicycle users, less street space was available and road safety declined. For the first period in Dutch history, the number of people using bicycles decreased. The car replaced the bicycle as the most frequently used mode of transportation.

But the rising tide of automobile traffic in cities with the related congestion and air pollution immediately attracted its counter forces. In 1965 the Amsterdam movement Provo put forward a scheme to introduce white bicycles for free general use on the streets in order to combat the increasing air pollution and congestion. They stated: "The asphalt terror of the Amsterdam petit bourgeoisie must be halted." The initiative attracted much publicity and even resulted in similar initiatives in British cities such as Oxford and York. In Amsterdam, meanwhile, white bicycles distributed by Provo were soon stolen or otherwise disappeared. But the scheme struck a chord and its memory stayed in the collective conscience, both in the Netherlands and abroad.

THE BICYCLE RENAISSANCE (1970–1990)

The 1970s can be seen as a period of the renaissance of bicycle use in the Netherlands. Publications in the ANWB periodical *Verkeerstechniek*

(Traffic Engineering) revealed an emerging awareness among traffic engineers of the need to pay more attention to the bicycle. Traffic counts convinced them that bicycle use had decreased less than expected. Traffic engineers working for local authorities stressed the urgency to address the needs of cyclists in addition to the attention already given to the needs of motorists.

The staying power of the bicycle in Dutch cities also was a cause for alarm among traffic engineers. With the growing dominance of motorized traffic on urban streets, the average vehicle speed increased as well. The result was an increase of casualties among cyclists.

The engineers' favorite solution was the construction of separate bicycle lanes. This was a difficult task in already built-up urban environments, given the scarcity of space. Under these circumstances, traffic engineers decided to also accept streets with a mixed traffic flow of cars and bicycles and they adapted their designs to enable this mixed use. Under the name of woonerf, these streets were constructed not only in newly built urban quarters, but also laid out in older quarters. They were designed to slow motorists down in order to facilitate cyclists and pedestrians and the recreational use of the street. Non-motorized traffic had priority on the new streets, and a maximum speed limit of 20 km (12.4 mi) per hour was imposed.

The construction of cycle lanes and woonerven was boosted by the growing environmental awareness stimulated by the report of the Club of Rome (1972) and the first oil crisis of 1973. The autumn of 1973 saw the implementation of petrol distribution and the introduction of 'car-free' Sundays, enabling cyclists to cycle on empty motorways. In these circumstances, human-powered cycles seemed a better alternative to the motorcar with its dependency on petrol.

In 1974, white bicycles were introduced for free use by visitors to the National Park the Hoge Veluwe. This policy was directly inspired by the 1965 Provo initiative. In 1975 the ANWB stepped in and donated dozens and later hundreds of white bicycles. Nowadays, 1,700 white bicycles offer free transportation to the visitors of the Hoge Veluwe and they have become almost as much of a tourist attraction as the park itself and its art museum. In the same period the ANWB started the Nationale Fietsdagen (National Bike Days), a hugely popular recreational bicycle event held every spring.

In 1977 the budget of the Dutch Ministry of Transport earmarked 30 million guilders for the constructing of bicycle lanes. More than half of this was intended to build two through-cycle routes in the cites of The Hague and Tilburg. The cycle route built in the southern city of Tilburg proved controversial. The ceremonial opening of the cycle route in this city by Minister of Traffic Tj. Westerterp in 1977 was flanked by

protests from shop owners en route, who claimed that the cycle route would reduce accessibility for motorists and thus harm their businesses.

Local groups such as *Amsterdam Fietst* (Amsterdam Cycles) and the *Eerste Nederlandse Wielrijders Bond* (ENWB, First Dutch Cycling Association) founded in 1975 were very active on this battlefield. Debates on more bicycle-friendly traffic rules, more favorable traffic solutions for cyclists at junctions and the construction of separate bicycle lanes took place at the different national, regional and local levels. The ANWB was very active in this debate. In fact, the Royal Dutch Touring Club started the debate in 1969/70 before the other actors mentioned came into existence. It developed many regional recreational bicycle routes and did extensive research on ways to improve road safety for cyclists. In 1976, groundbreaking research on visual perceptibility was conducted by the ANWB, which resulted in 1987 in national rules on compulsory reflectors on bicycle tires, on the rear carrier and on the pedals. These regulations were an important step in road safety in the Netherlands.

City by city started to allow cycling against the traffic flow in one-way streets, thus enabling cyclists to choose the shortest routes. In the 1980s and 1990s, impressive stretches of new cycle paths were laid out.

Parallel to these events, the number of people cycling in urban areas started to increase again. Bicycle sales boomed in these decades. More than one million bicycles are sold annually in the Netherlands. Stimulated by these growing bicycles sales, the bicycle industry introduced new types of racing bikes, the mountain bike as a new off-road bicycle, folding bikes and different types of 'nostalgic' bicycles.

CONTINUING SUCCESS AND NEW INNOVATIONS (1990 – PRESENT)

The period after 1990 saw a continuation of the bicycle renaissance. In the 1990s, the bicycle became a priority at the Dutch Ministry of Traffic and Infrastructure. One of the pillars of this priority was a generous system of subsidies for the construction of municipal bicycle paths. Since then, almost every urban municipality in the Netherlands has formulated its own bicycle policy plan. Most of the cycle paths in the Netherlands today were constructed in this period. In 1980 the Netherlands consisted of less than 10,000 km (6,214 mi) of cycle paths; these day the Netherlands has 35,000 km (21,748 mi) of cycle paths.

Regulations were made more cycle-friendly. The lowering of the maximum speed limit from 50 km (31 mi) per hour to 30 km (19 mi)

per hour in inner-city areas is an important example of this trend, as is the re-establishment in 2001 of the old right-of-way for traffic – whether or not motorized – entering from the right at junctions.

Another pillar was a subsidy system through employers for the purchase of new bicycles. New types of bicycles were developed for the Dutch market, ranging from a revival of transport bicycles to bikes designed for bicycle couriers. The introduction of the electrical bicycle in the late 1990s resulted in a boost of bicycle use among the more elderly. There are presently 18 million bicycles in Dutch society and more bicycles than Dutchmen in the country. One million of these bikes are electrical bicycles.

The side effects of the bicycle's growing popularity are an increasing congestion on Dutch cycle paths, a growing parking problem in urban centers and at railway stations, and an increasing number of bicycle accidents. The ANWB is actively tackling these problems, including its involvement in a new, more stable bicycle type: 'the life cycle'. It has redeveloped its old system of bicycle repair kits into a streamlined system of 1,500 bicycle aid boxes placed at restaurants and cafes, and it even recently introduced a roadside assistance service for cyclists conducted by the *Wegenwacht* (ANWB Roadside Assistance). 110,000 clients have already subscribed to this new service.

The image of the bicycle in Dutch society is very strong. Cycling is still popular among all walks of life, as can be seen on Dutch streets. And – a continuum in history – cycling is still a symbol of Dutchness, as recent pictures of King Willem Alexander and Queen Máxima and leading politicians show. As I have explained, the ANWB has played a very active role in the popularity of the bicycle and in development of the bicycle infrastructure itself.

From a presentation for the FIA-conference on September 10, 2013; with special thanks to Hans Buiter, Club Historian of the Royal Dutch Touring Club ANWB

- The Royal Dutch Touring Club ANWB offers a wide range of services related to roadside assistance and medical and repatriation assistance abroad, legal assistance, travel, information products, insurances, selling travel-related products and many other products and services in the areas of recreation, tourism and mobility. Furthermore, the ANWB is active in lobbying in the fields of driving, mobility, travel and recreation.
- The ANWB is currently involved in innovations such as the so-called 'glow-in-the-dark' cycle paths – a collaboration with a Dutch artist to make cycle paths safer, with special paint.
- To learn more about the ANWB, visit www.anwb.nl
- Mobile ANWB Fietsen (Cycling) App: www.anwb.nl/mobiel/fietsen

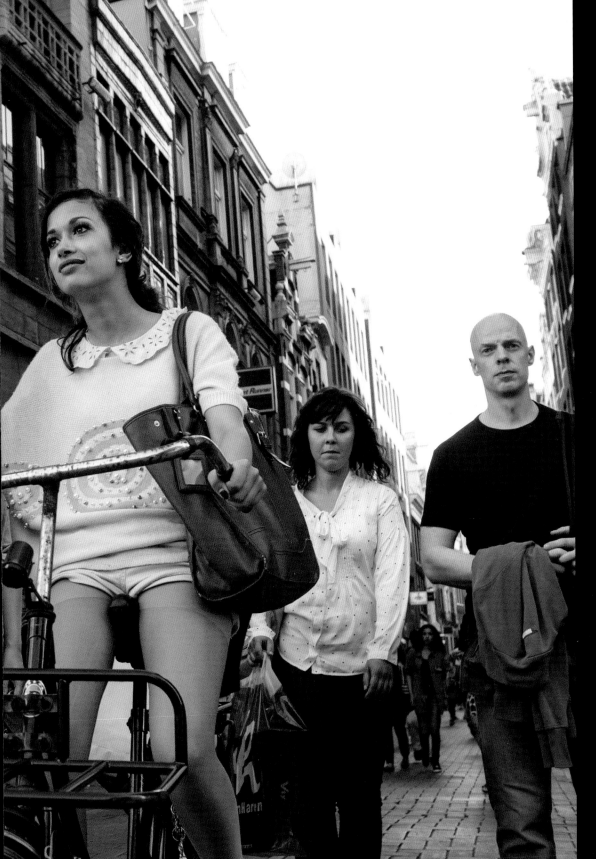

PERSPECTIVE
CYCLING IN THE NETHERLANDS
A SHORT HISTORY OF A LONGTIME HABIT

by Kaspar Hanenbergh, cycling historian and co-author of *Ons Stalen Ros* (*Our Iron Horse*)

Both of my parents are in their early eighties and they cycle to church every Sunday. My mother uses an e-bike, my father a normal, single-speed bicycle, with a drop-frame.

This is not an exception; it is very common in the Netherlands for people to cycle well into their later years. Statistics confirm this: only the distance covered annually diminishes above the age of 75 – not the use itself. Men over 75 years old cover 580 km (360 mi), instead of the average Dutch annual mileage of 989 km (615 mi). Women over 75 ride 205 km (127 mi) – not just the cyclists among them, but across the whole population. In a cycling life, the average Dutchman will have covered over 75,000 km (46,603 mi) pedaling – excluding the kilometers covered as a child, in the seat in front or behind mother or father. Cycling thus has virtually nothing to do with age or gender.

Cycling in the Netherlands also has nothing to do with sports. True, many people have a racing or a mountain bike and use it on slopes we call 'hills', and hills we call 'mountains', but always using it along with other more practical bicycles, to go to work, school, shopping or on visits.

Cycling also has nothing to do with wealth. Statistics even suggest a greater percentage of high-income citizens owning a bicycle compared to lower-income citizens. Cycling also, in my opinion, has not so much to do with either health or environmental considerations of the cyclist. True, it is a bonus to do some kind of 'workout-while-you-ride'. And true, in this densely-populated country, less pollution is always welcome. But at the same time, breathing in that polluted air as a cyclist cannot really be that healthy.

…No, the overwhelming reason for the Dutch to ride their bicycle is that it is practical. It's the fastest way to cover distances up to 10 km (6.2 mi) – with no worries about cost, timetables or parking facilities. This freedom of cycling is also an aspect of its practicality.

It has been this way for almost exactly a century, because from the year 1910 onwards the Netherlands has been the country with the highest number of bicycles per 1,000 inhabitants. Most countries, such as the US and the UK, had a bicycle boom around the year 1897,

after which the hype was over (US) or the growth rate rapidly fell (UK). The Dutch, however, never stopped. One in 10 had a bicycle in 1910; one in four in 1924. Data for the UK and US are scarce but, for 1928, ownership in the UK was estimated at one in seven. In the US it was one in 70.

These were the years the Dutch had to pay annual taxes for using a bicycle, but even that did not stop them. Moreover, they developed their own kind of riding: not bent forward to cut the wind, but with a straight back ... not only more 'dignified' for women, but also more practical, with a clear view of the other traffic – traffic that mainly consisted of other cyclists. Cyclists were king of the road, not only in numbers but also in distance covered. To illustrate this startling difference in the composition of road traffic: In 1928 there were 46 bicycles for each car in the Netherlands, versus four bicycles for each car in the UK. And in the US it was the other way around ... 12 cars for each bicycle!

Even when outnumbering cars 46 to one, local pressure groups in the Netherlands (e.g. the 'Rijwielpadverenigingen') argued that separate cycling paths were safer – not just for the cyclists, but also for the slower traffic such as horsedrawn carts. From the beginning, there have been two types of cycling paths: one straight along a main road ('Rijksstraatweg'), the other for recreational purposes twisting through the countryside. From 1920 onwards the ANWB (The Royal Dutch Touring Club) used special roadsigns for cyclists – the famous ANWB-*paddestoelen* (mushroom-shaped markers). Only recently they encountered competition: special Apps and waypoints for cyclists.

It is estimated that the car only surpassed the total mileage of the bicycle in the Netherlands around 1960. By that time the bicycle had sufficiently become part of the Dutch culture to withstand the age of the motor car and survive it. People always kept their faithful bicycle in the shed and learned to use it alongside a car.

Since the 1980s, the bicycle has been making a strong comeback – now with the help of the Fietsersbond (Dutch Cyclists' Union), pushing safety and accessability – at first as a protest movement, later as a valued partner of local government. Even the ANWB, strong promoter of cyclists interests between 1883 and 1940 but after the war far more car-oriented, realized that the bicycle was still the answer to questions raised when the worldwide traffic jam happened. In fact, they recently introduced a 'Wegenwacht' or break-down-service for cyclists. In a certain way, that is a full circle in history. The ANWB had also introduced large repair boxes for cyclists at inns way back in 1898.

PERSPECTIVE
DUTCH CYCLING CULTURE

by Jos Sluijsmans, Fietsdiensten.nl

Bicycle culture in the Netherlands is really becoming mature. Before, cycling was mainly functional. This counts for the bicycles for everyday use as well as for racing bikes and mountainbikes. Nowadays, Dutch cycling is much more influenced by designers, creative entrepreneurs and artists. The bicycle has become a lifestyle product and is not only functional anymore.

A challenge I see is in the rise of cargo bikes. The exponential rise of cargo bike usage on the streets of Europe, combined with the appetite of users to celebrate the use of the humble bicycle for carrying anything from their kids and shopping to commercial freight, will make this niche market more interesting for various commercial parties.

The extended use of bicycles and cargo bikes, e-bikes (electric bikes) and velomobiles makes new infrastructure necessary as well. The amount of super cycle highways, cycling bridges and cycling tunnels is really expanding. For the Dutch, the know-how and expertise of mobility management and cycling infrastructure is, apart from the bikes themselves, going to be a very interesting export product. Cycling will be, in fact, the 10th topsector in the Dutch economy.

According to Global Industry Analysts, Inc., one of the world's largest market research publishers, the global market for bicycles is forecasted to exceed US $78 billion by the year 2015. Today, 50% of the world population of nearly 7 billion people live in cities. By 2050, 70% of the then-expected global population of 9 billion people will live in the cities. When we want to keep on moving, the bicycle is the most energy-, speed-, and cost-efficient method of mobility.

The Dutch spend about €30 per person per year on cycling infrastructure. When other countries would spend the same for their inhabitants that live in the cities, that would come to an investment of 90 to 120 billion euros a year, and 180 billion in 2050.

I believe Dutch business is still not fully aware of the opportunities this opens. To increase this awareness is the biggest challenge for Dutch cycling culture and cycling advocacy for the coming years.

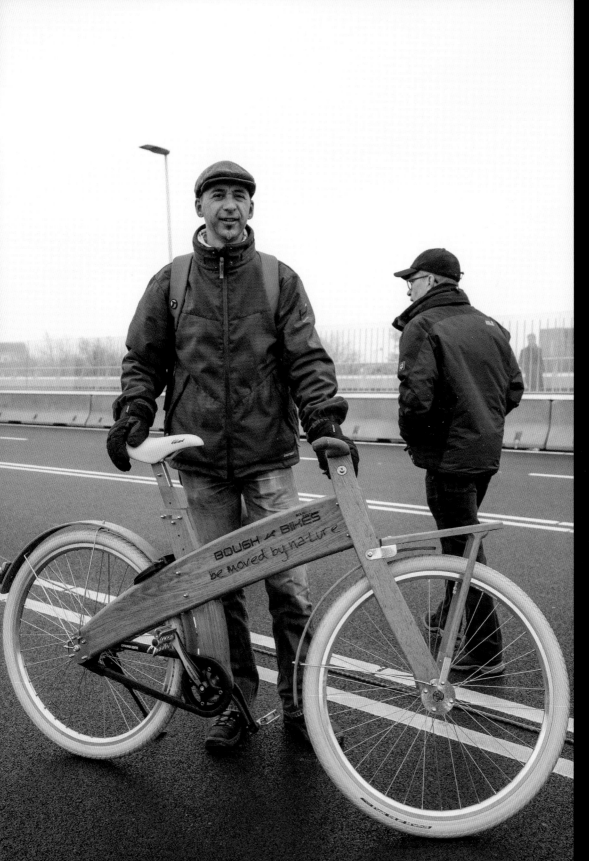

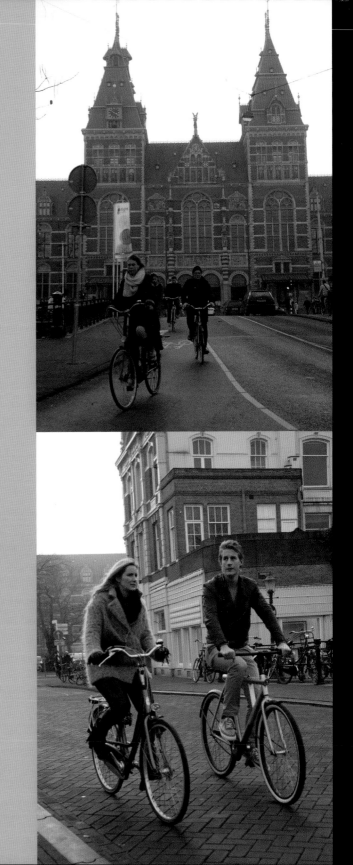

"The Netherlands doesn't just have one or two 'cycling cities'. It's the whole country."

David Hembrow, AViewfromtheCyclePath.com

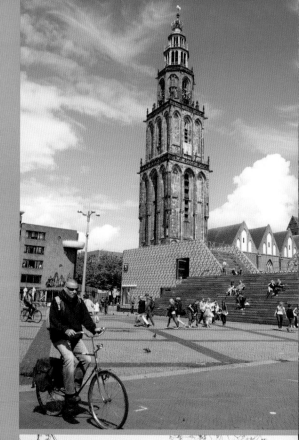

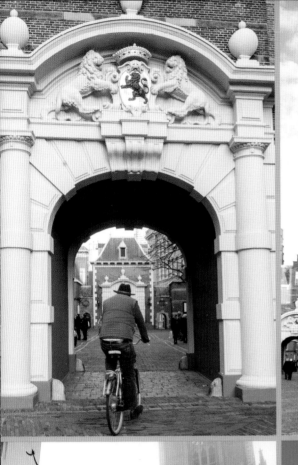
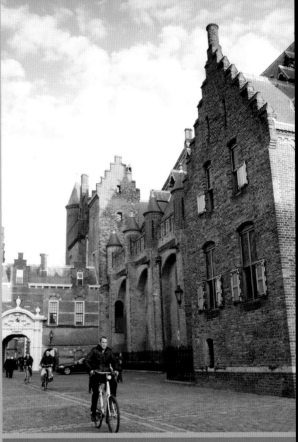

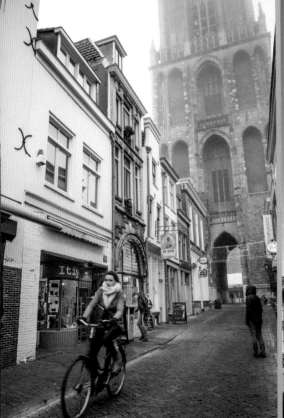
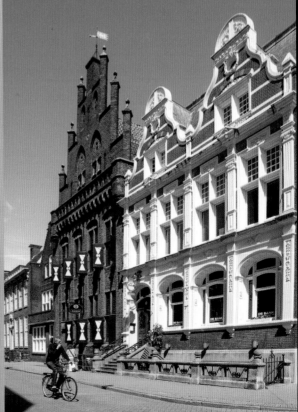

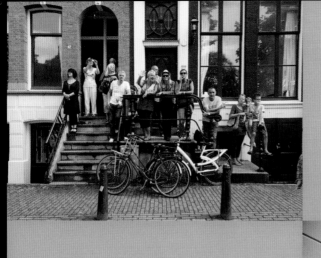

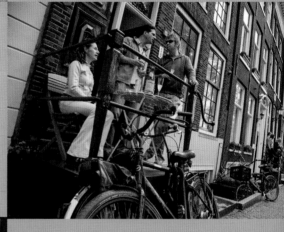

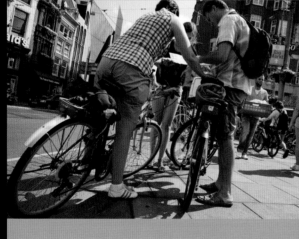

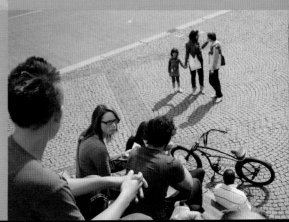

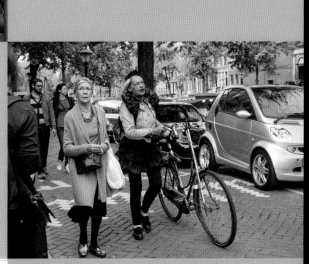

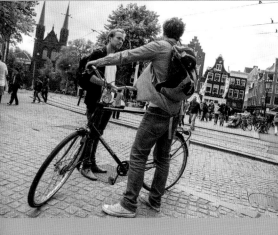

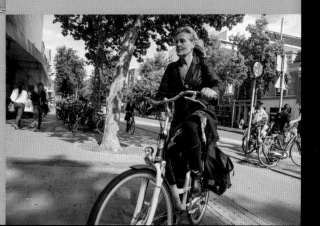

"People cycle (in the Netherlands)
because it's pleasant, not because
they're beating them with a stick
to stop them from driving.
... Groningen has the highest cycling
modal share of any place in the
world now. And it's a wonderful
place to come and cycle. You find
that people use their bikes for
everything in this city.
... But it's not just Groningen.
What people misunderstand about
the Netherlands is that the whole
country has actually transformed
itself for cycling. So while there's a
lot of cycling here, you'll find that
there's a lot of cycling in all the
other cities too ... and also in the
country in between the cities."

David Hembrow, AViewfromtheCyclePath.com,
for Streetfilms, 'Even More from The Netherlands:
Journey from Assen to Groningen!'

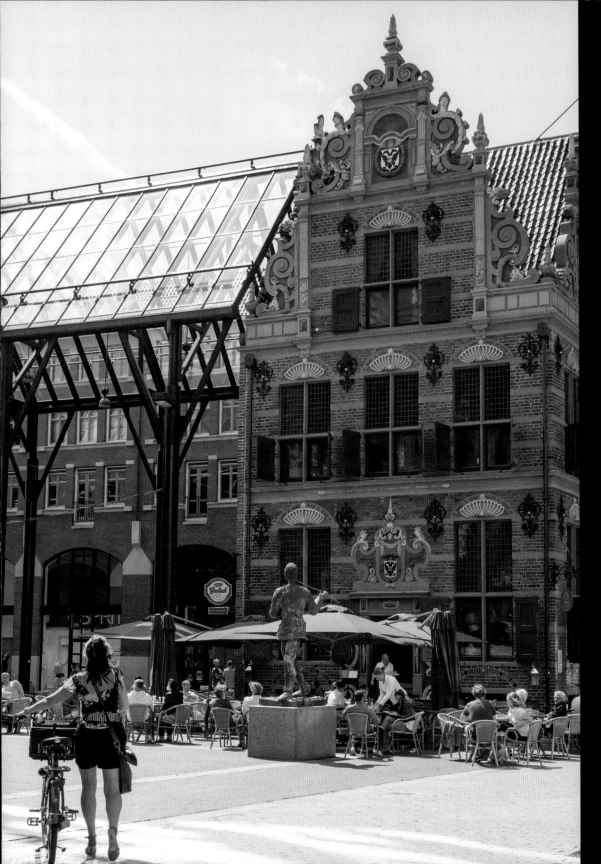

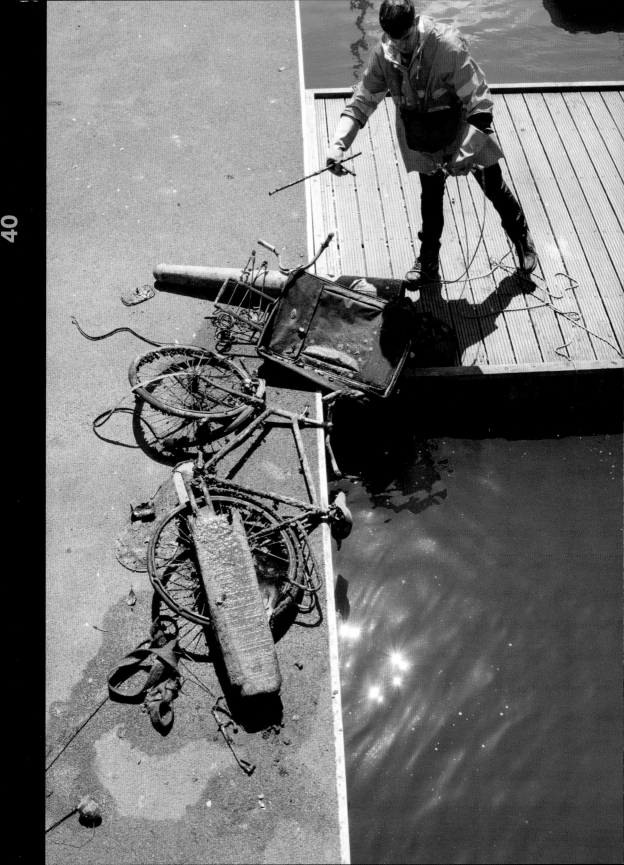

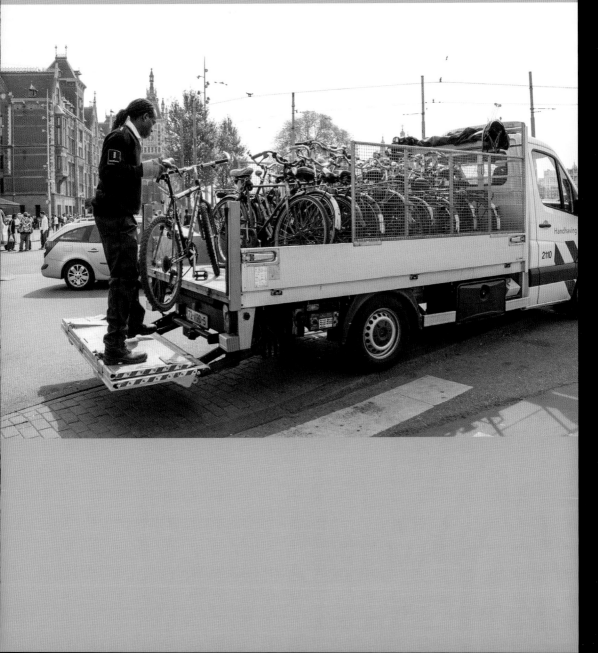

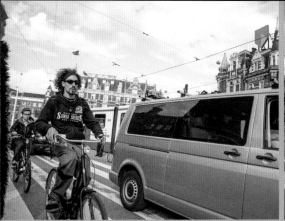
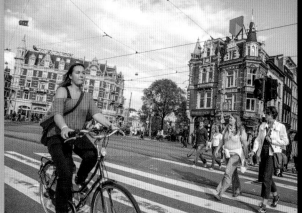

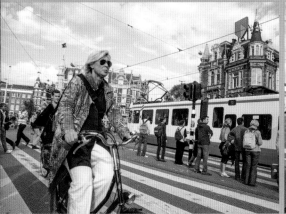
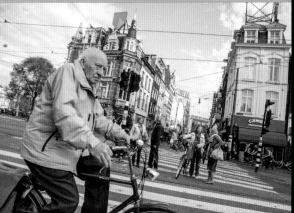

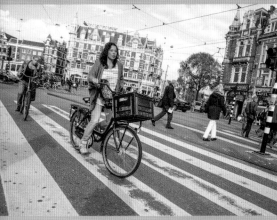

"Road safety is not a goal for cycling; it is a pre-condition. …The challenge is to make cycling convenient, practical and safe."

Tom Godefrooij, Sustainable Urban Transport
Specialist, and Senior Policy Advisor,
Dutch Cycling Embassy, The Netherlands

"Whenever anyone asked why I had immigrated to Holland, I didn't hesitate to reply: 'So I can be stuck in a bicycle traffic jam at midnight'."

Pete Jordan, author of *In the City of Bikes:
The Story of the Amsterdam Cyclist* (HarperCollins)
www.cityofbikes.com

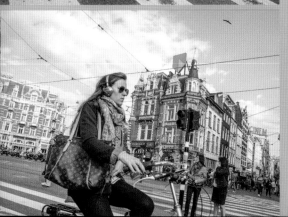

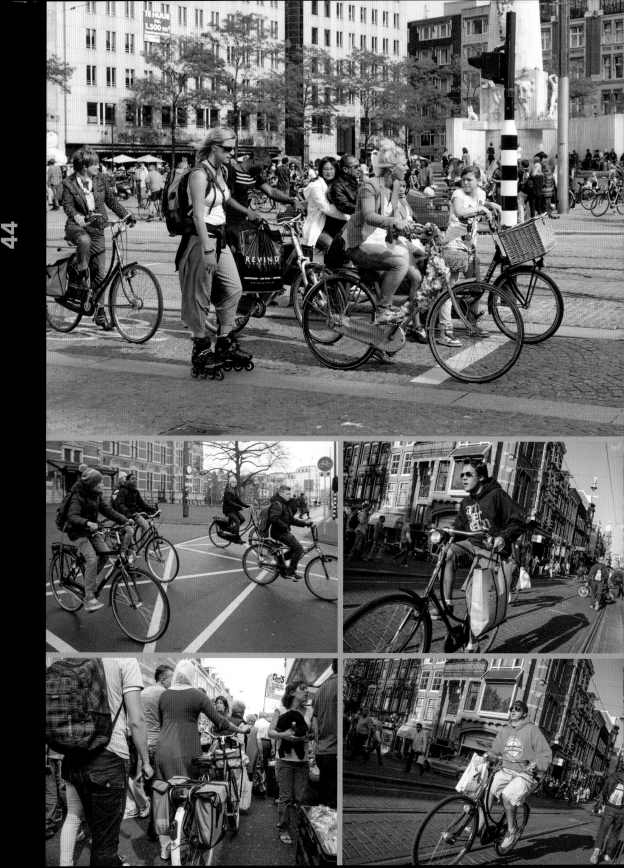

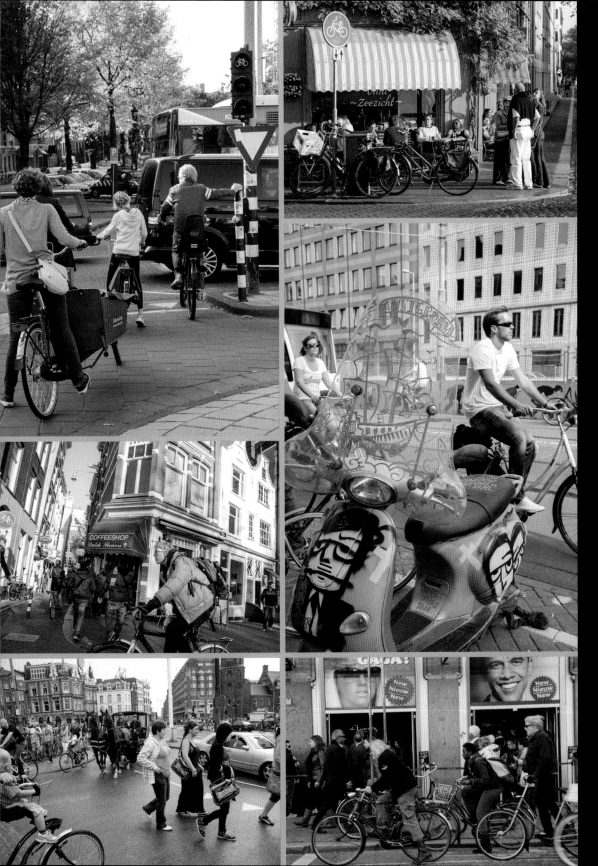

WHAT'S BEING DONE TO MAKE CYCLING SAFER

The Netherlands is a country of cyclists and proudly so! Practically every Dutchman has at least one bicycle, and we use it regularly, for good reason: cycling is healthy, sustainable and fun. In addition, to paraphrase an old Heineken ad: "It gets you to places other modes of transport can't reach."

...I often use my bike to go surfing, for instance.

Yet cyclists are vulnerable in traffic. Annually, around 11,000 cyclists get seriously hurt in the Netherlands while, in 2012 alone, 200 people were killed while cycling on Dutch roads. We mix with other traffic without much protection (the Dutch don't like helmets – not 'cool') and with a relatively large difference in speed. Most crashes involving cyclists occur in urban areas, often when a cyclist and a car intersect. In addition, many cyclists get hurt in 'solo accidents' or in bicycle-bicycle accidents.

It's a good thing that much can and is being done to improve bicycle safety. Infrastructural measures that separate bicycle traffic from motorized traffic as much as possible, improvements to bicycles, as well as educational measures are all aimed at lowering cyclists' crash rates. Other measures that can improve cyclist safety are bicycle helmets (cool models are already showing up), closed side underruns for trucks, and – made in Holland! – smart, external airbags on cars.

So, to quote Luka Bloom – the Irish singer/songwriter who loved cycling so much he even moved to Holland at one point in his life: "Pedal on, pedal on, pedal on!"

Peter van der Knaap, PhD, Managing Director, SWOV
(Institute for Road Safety Research, The Netherlands)

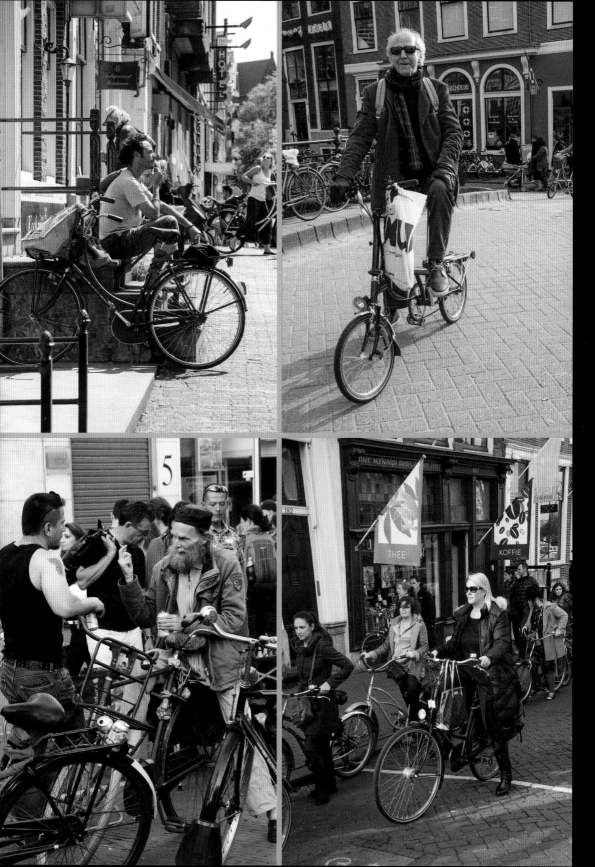

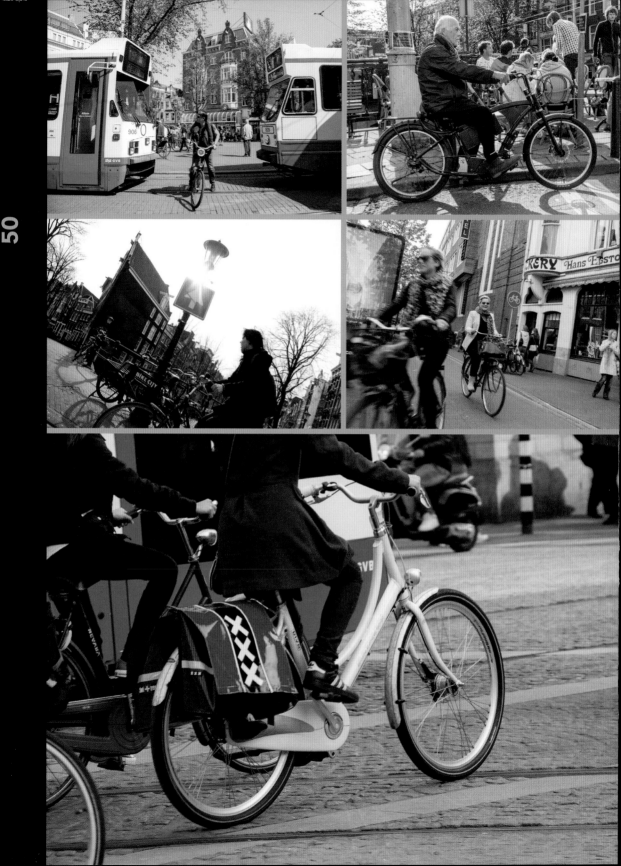

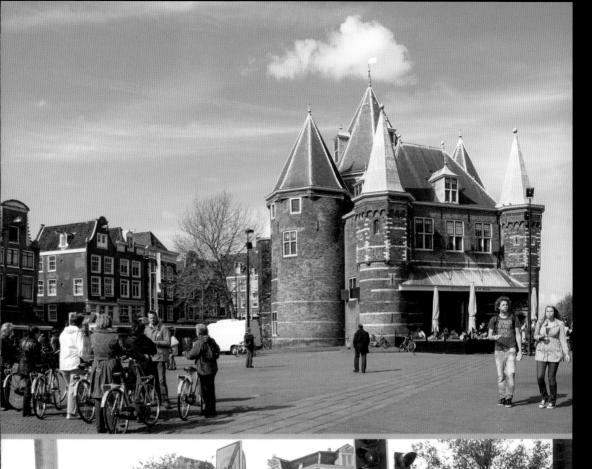

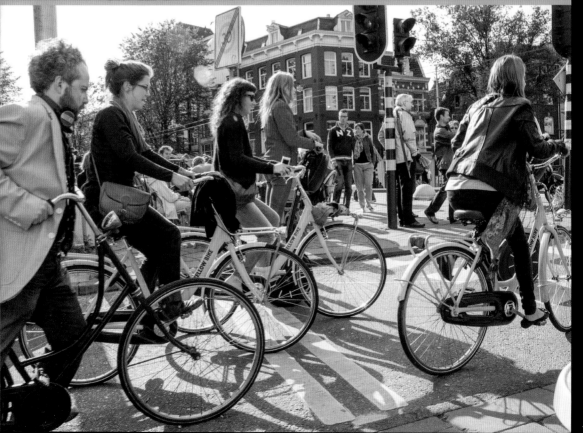

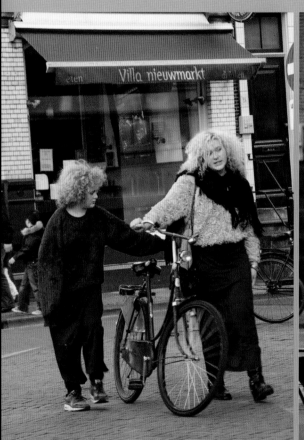
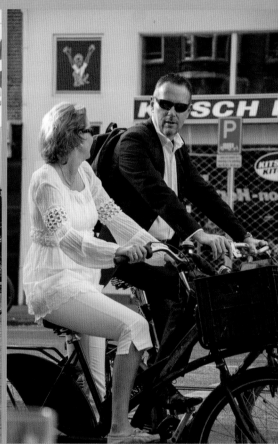

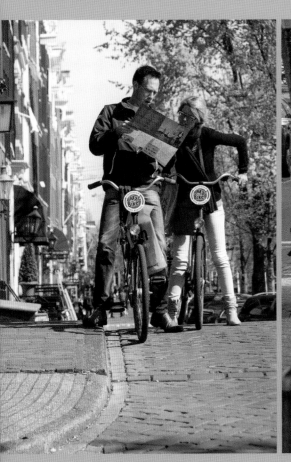
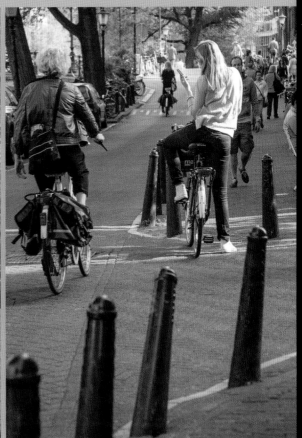

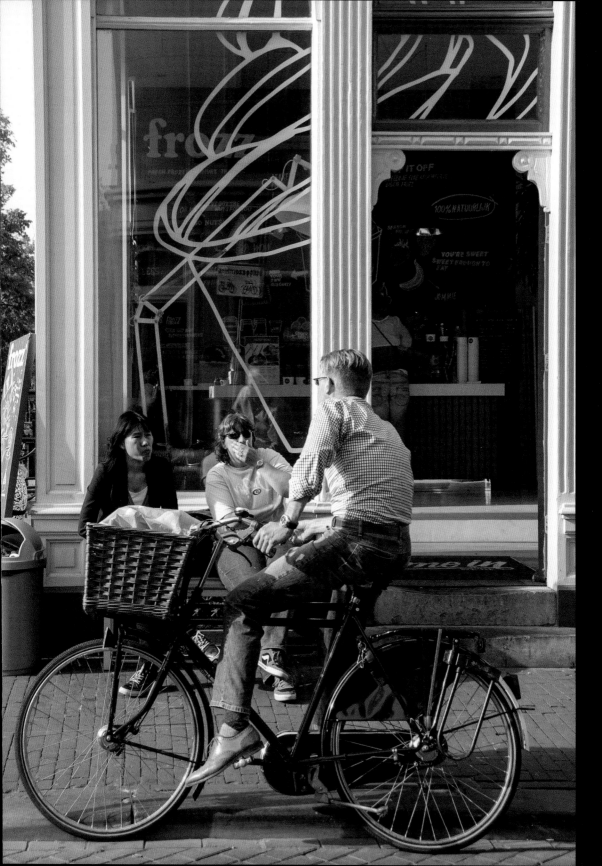

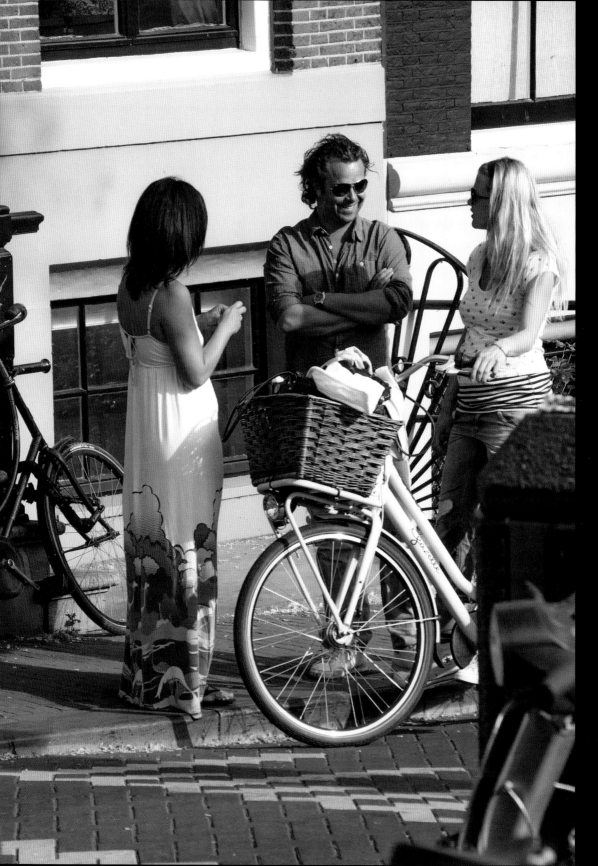

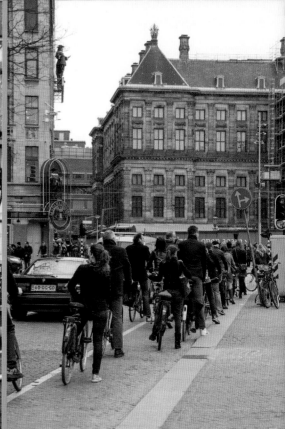
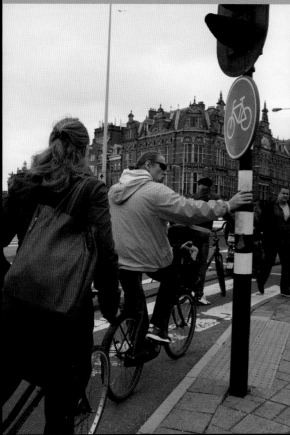
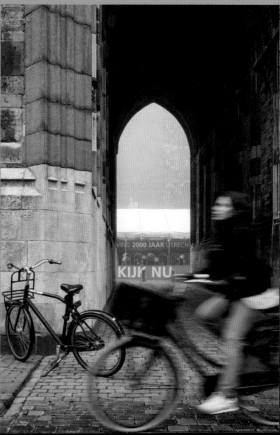

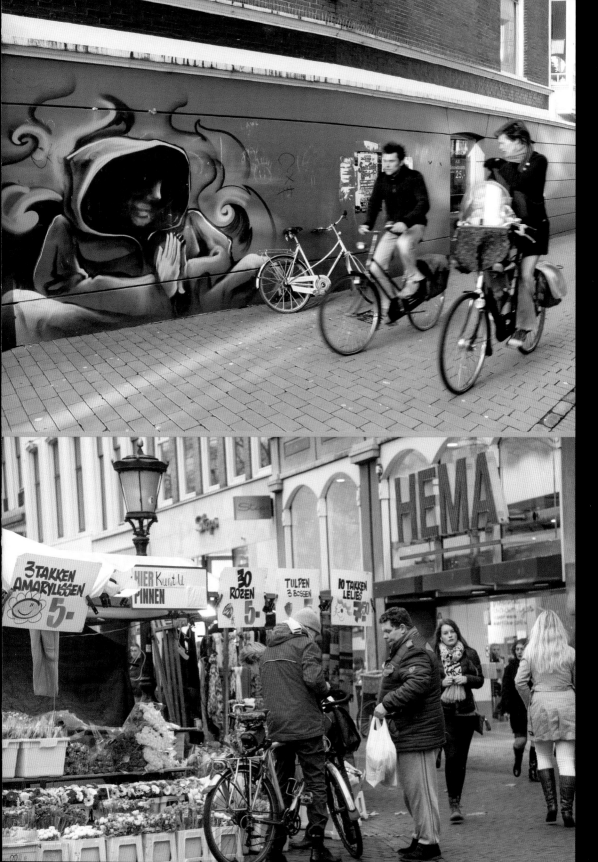

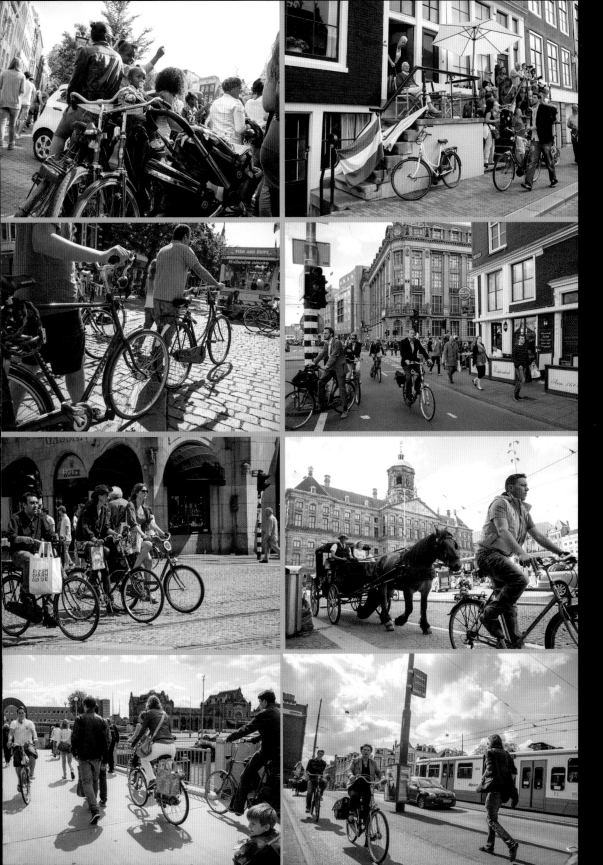

62

"Few nations are as bike crazy as the Netherlands. The Dutch have long known that bike travel is efficient, friendly and good for one's health. We at the United Nations, and our neighbors here in New York City, are catching on and catching up. ...We thank you, the Government and the people of the Netherlands, for yet another display of support for the United Nations and for our efforts to build a sustainable future for all."

United Nations Secretary-General Ban Ki-moon
(at ceremony marking Bike Rack Donation
by the Netherlands, July 31, 2013)

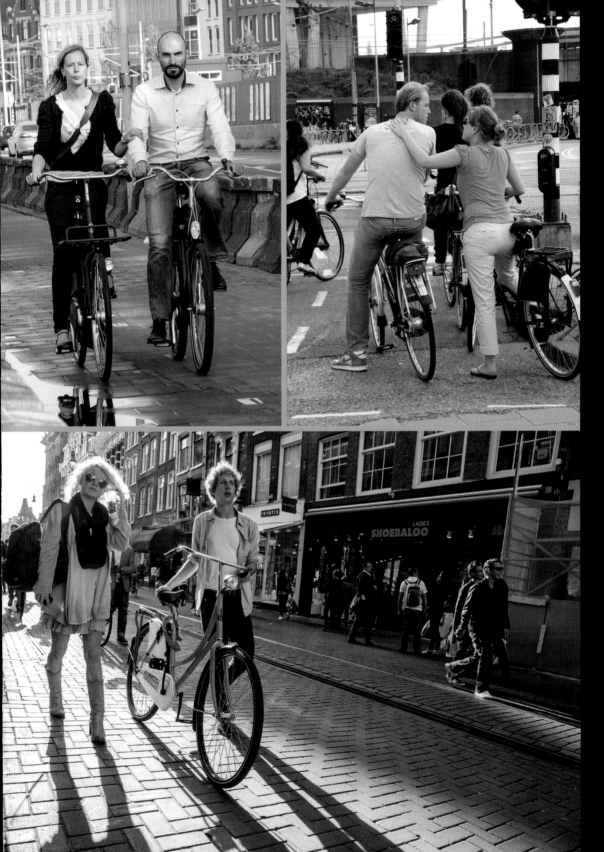

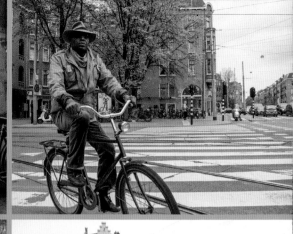

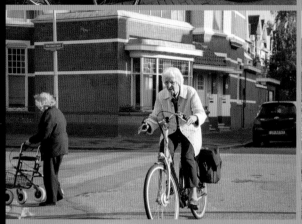

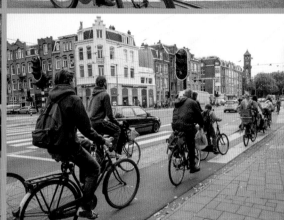

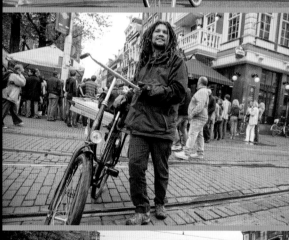

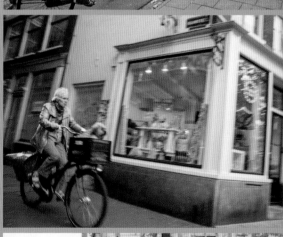

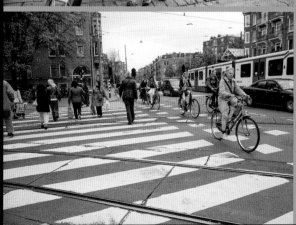

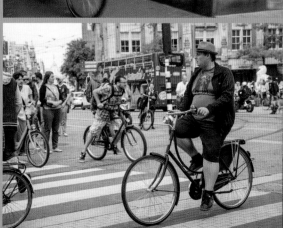

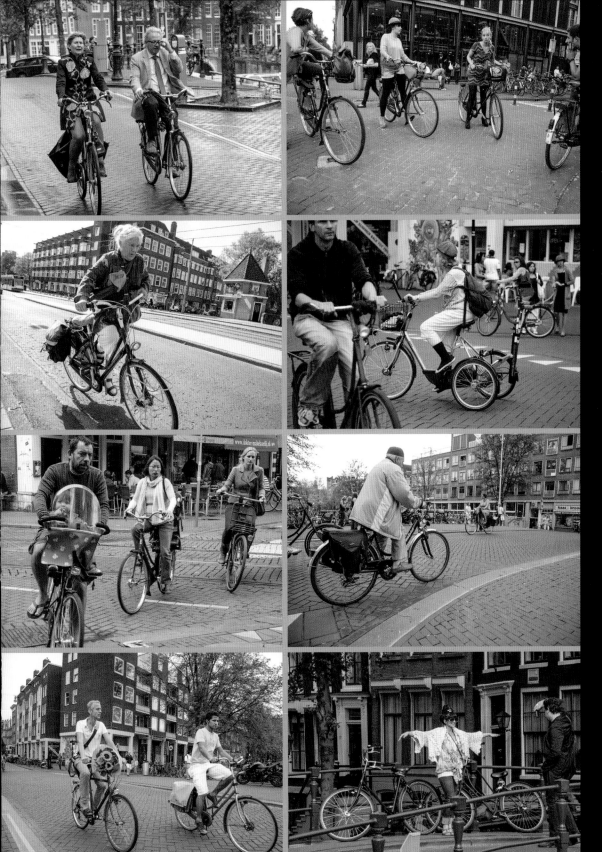

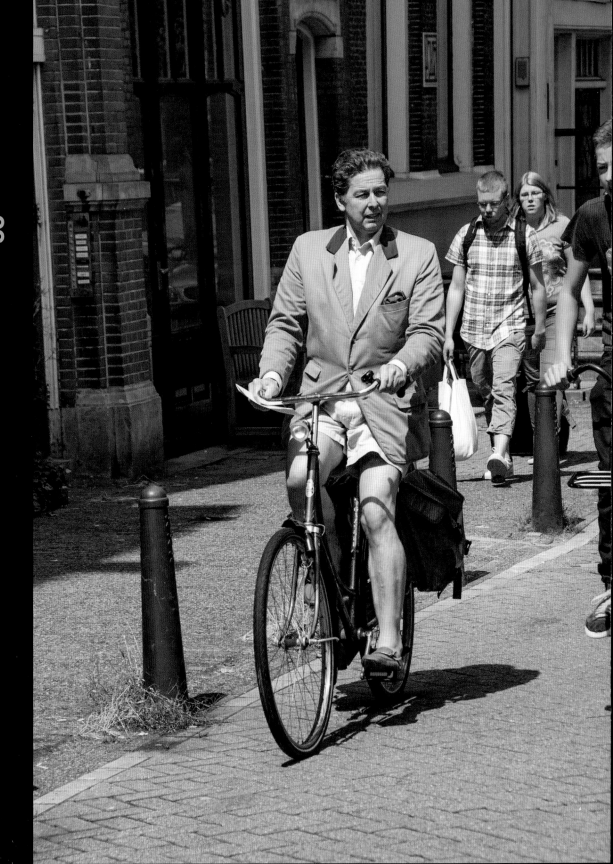

"The only way for cycling to achieve such popularity is for it to be so pleasant, safe and convenient that everybody from kids to elderly people ride bikes daily. Therein lies the great challenge of exporting cycling Dutch style: The city planning and infrastructure in most Dutch cities is amazingly bicycle-oriented, and this took decades to build in cities that were always pretty good for cycling. It's not at all just about bike lanes. It's about discouraging auto use, keeping auto traffic on specific routes, traffic calming, bike parking facilities, education and many other factors. Exporting that amazing Dutch experience of riding your simple bike through the city center along quiet streets or flowing with the rush hour bicycle traffic is a chicken/egg dilemma. It's been widely demonstrated here and in Copenhagen where 'bike-ification' began much later, that the masses simply won't ride bikes for transportation until it's the most convenient, pleasant, fastest, cheapest way to get around. Until then, urban cycling is the domain of young warriors and grizzled pioneers. But achieving the political and bureaucratic power and funding to create that cycling infrastructure requires broad support ... from regular folks, retirees, small business owners, parents, captains of industry, etc. It's just going to be a slow process rebuilding the world's cities to better suit the needs of real people, especially the more recently 'developed' cities that were built from the ground up with personal automobiles as the primary means of transport. Unfortunately it has to begin with intrepid bike warriors fighting the tide and danger."

Henry Cutler, American founder of WorkCycles,
a Dutch bike manufacturer, as quoted in an interview
by Alex Armitage for his blog, 'Red Kite Prayer'
(March 25, 2010)

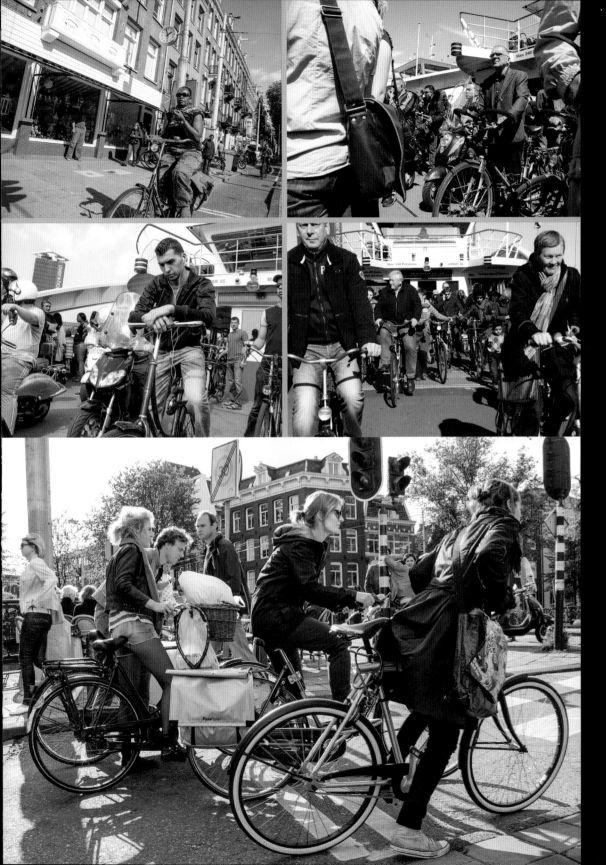

When asked why motorists seem
to give much more consideration to
cyclists in the Netherlands than car
drivers do in most other countries,
Ria Hilhorst said, "There are so
many cyclists in the Netherlands,
and motorists here are used to
cyclists. ...Moreover, they are
cyclists themselves."

Ria Hilhorst, Cycling Policy Advisor, City of Amsterdam,
Department of Infrastructure, Traffic and Transport

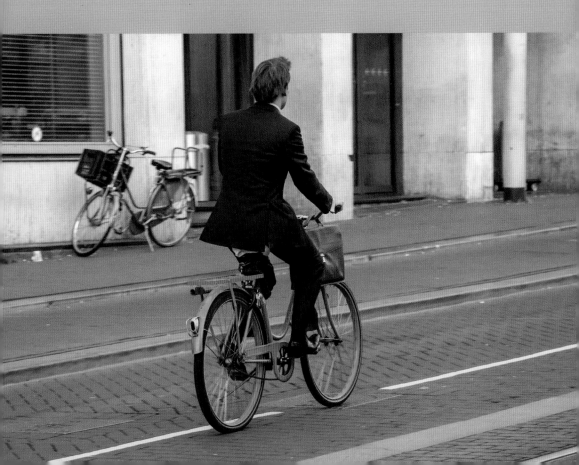

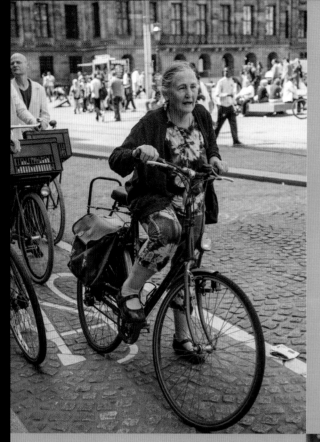

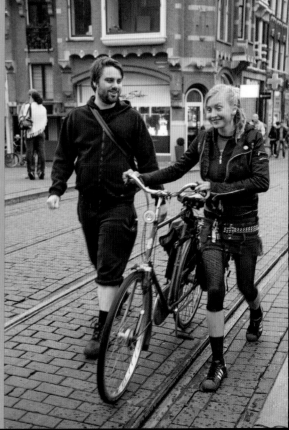

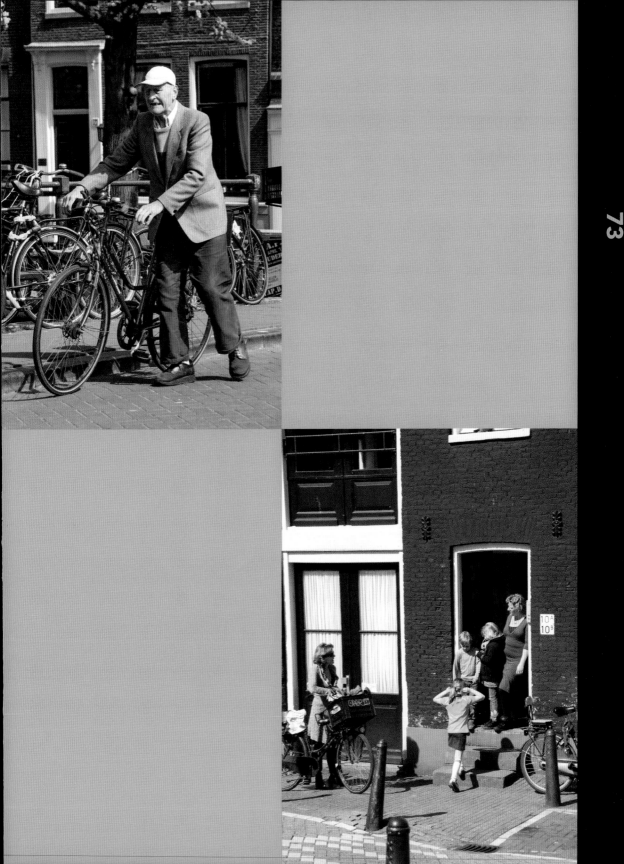

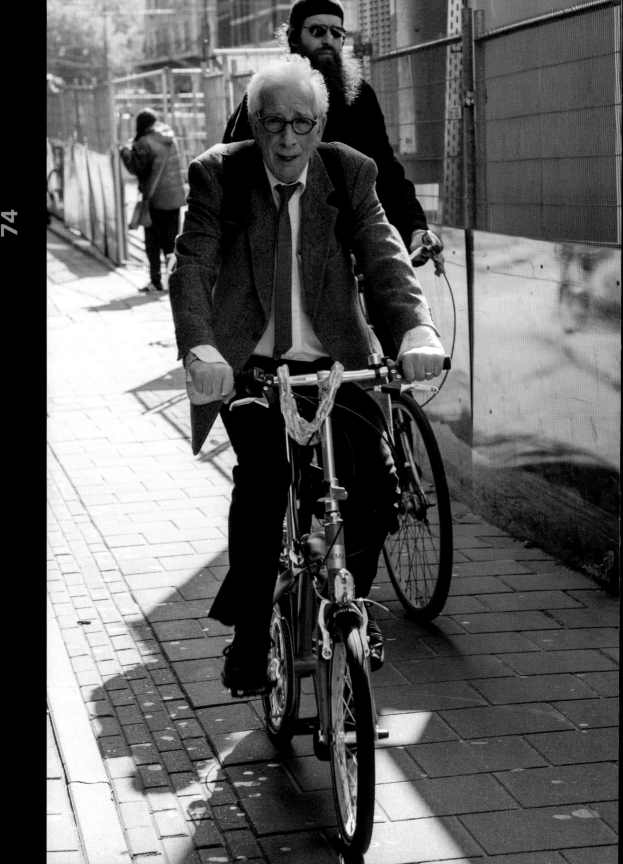

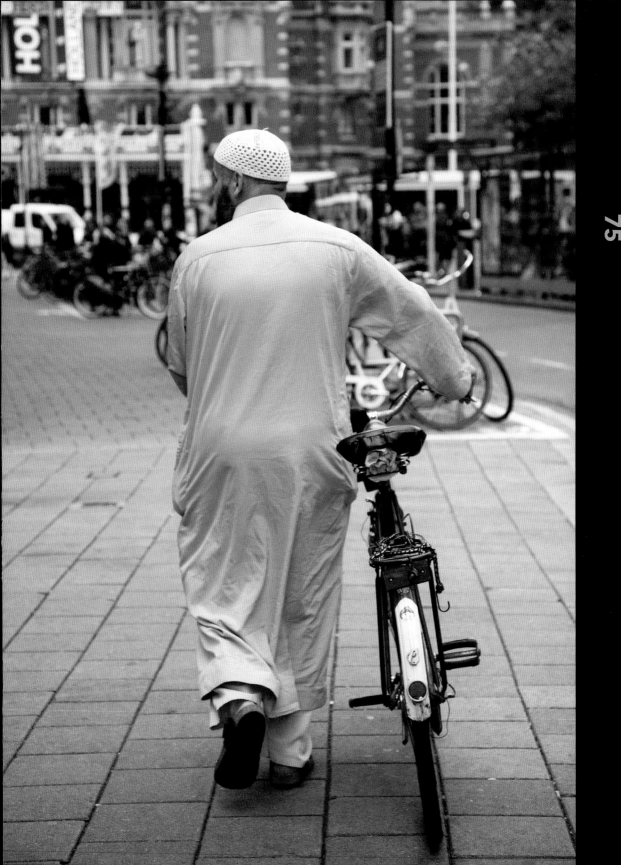

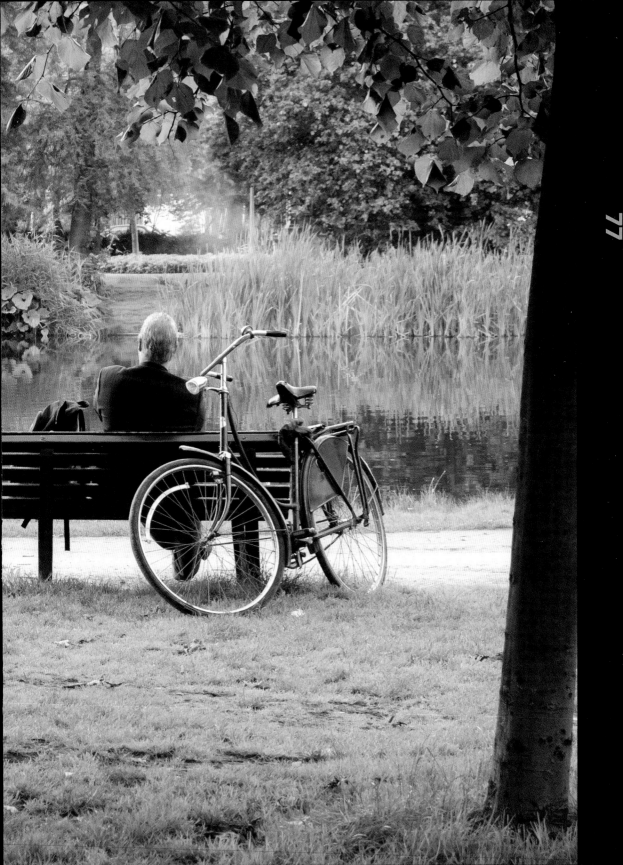

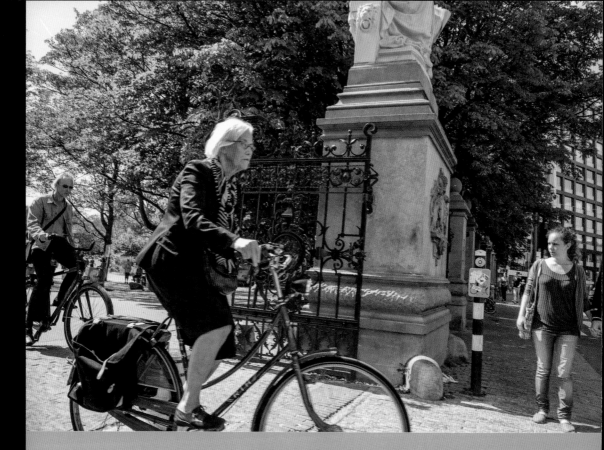

"Amsterdam is a beautiful city with a relaxed pace, a highly diverse population and a million other things I like. But mostly I like it because it's the undisputed cycling capital of the world. Amsterdam, like other Dutch cities, was only able to maintain its charm, history, quiet neighborhoods in the center, and incredible density and compactness because most people ride bicycles instead of driving automobiles."

Henry Cutler, American founder of WorkCycles,
a Dutch bike manufacturer, in an interview
by Alex Armitage for his blog, 'Red Kite Prayer'
(March 25, 2010)

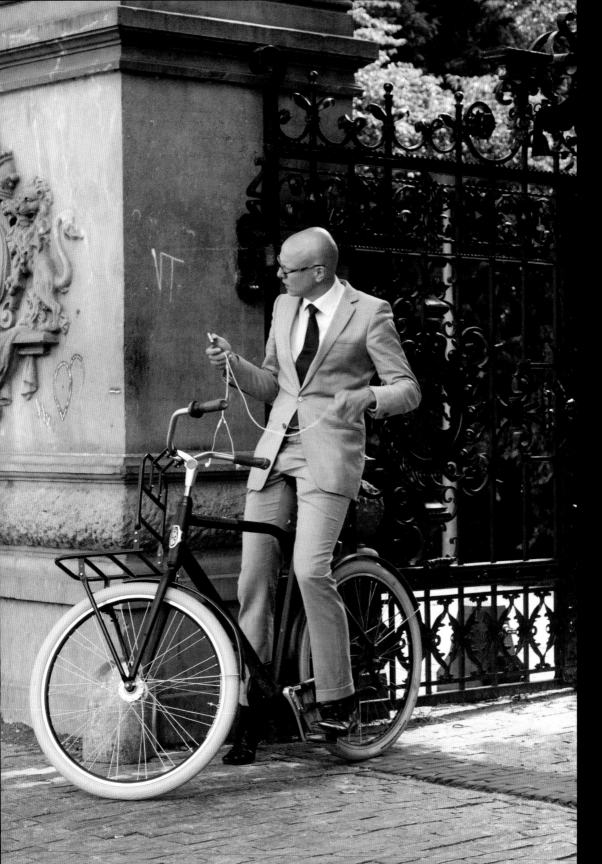

"The Dutch see cycling as transport for everyone and not as a sport for a few. Any time of the day or night, you can see people of every age group – from kids to the elderly, of both genders and all social backgrounds – cycling for everyday activities in their everyday attire. Infrastructure in the Netherlands is designed to be perfect for an 8-year old but also for a fast and fit young man or woman. The reliable type of bicycles the Dutch use don't require any special outfit or preparation ... so nobody thinks twice about using the bike to get from A to B. Cycling keeps people healthy and it requires less space, makes less noise and doesn't pollute like motor traffic does. Investing in cycling is for the benefit of all, not just for the people cycling. When cities create a good environment for cycling, it makes these cities much more livable for everyone."

Mark Wagenbuur, BicycleDutch.wordpress.com

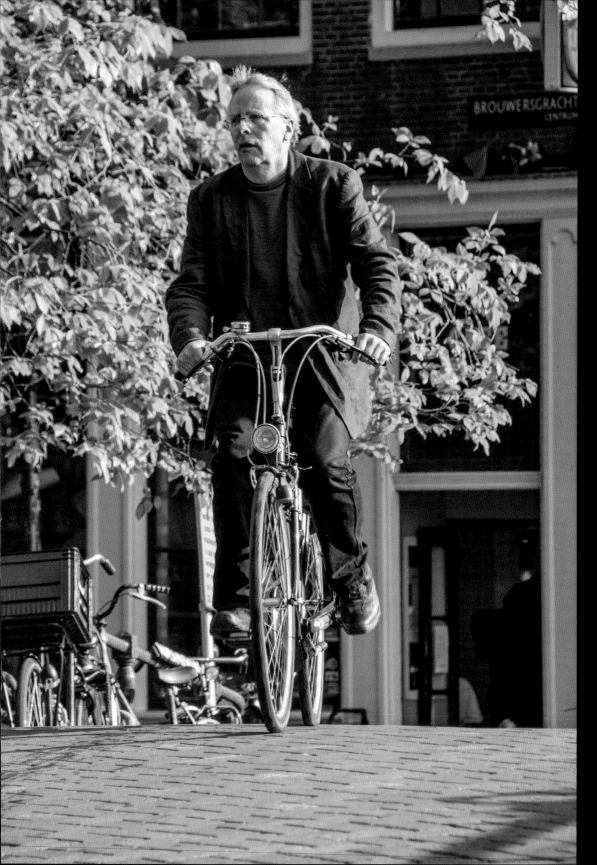

"... Cycling is a great equalizer. Other types of traveler can, if they spend enough, set themselves apart from their fellows. Train lovers can take the Orient Express; drivers splash out on slick sports cars; a private jet allows air travelers to avoid the hell of the airport terminal. But cyclists are all on a level; all have to meet each other's eyes. Even the priciest bike cannot make cycling glamorous. However much a cyclist spends, he will still look faintly ridiculous – crouched over the handlebars, pedaling furiously, weaving round obstacles, determined to get somewhere, rather as man travels through life."

Emma Duncan, Deputy Editor, *The Economist*,

for *Intelligent Life* magazine (January/February 2014),

'Intelligence, Big Question:

What's the Best Way to Travel?'

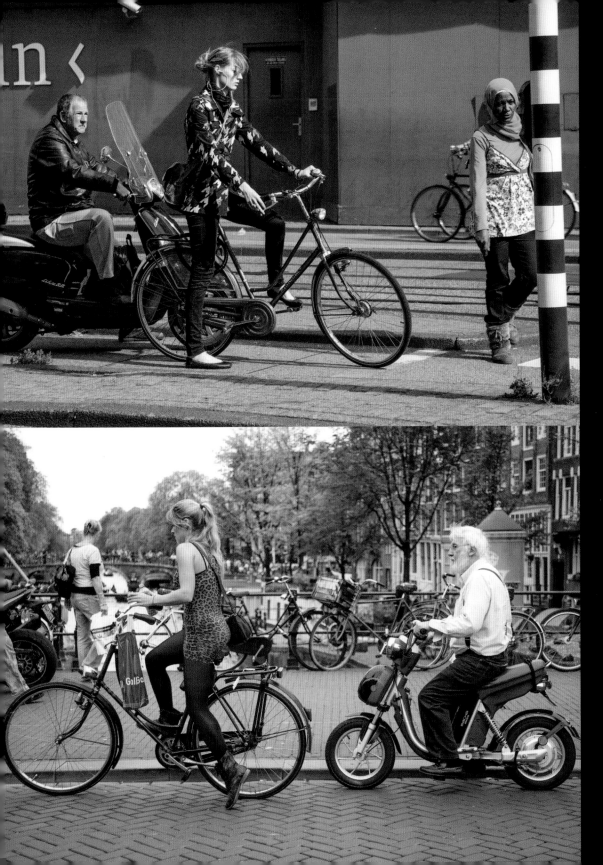

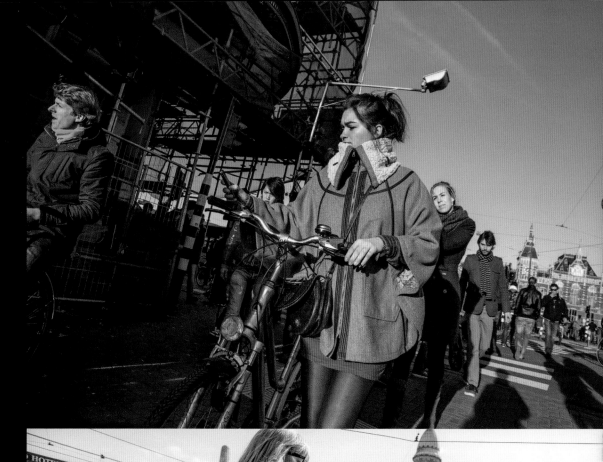

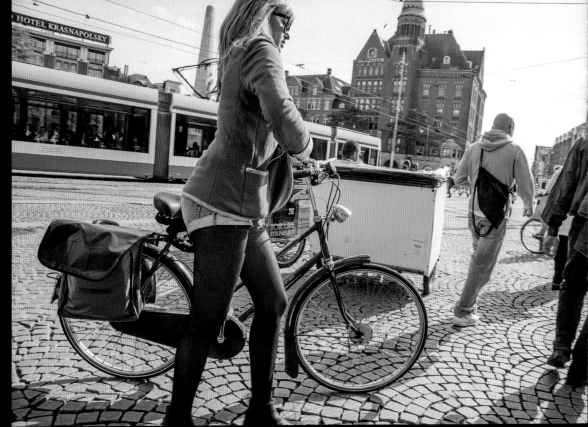

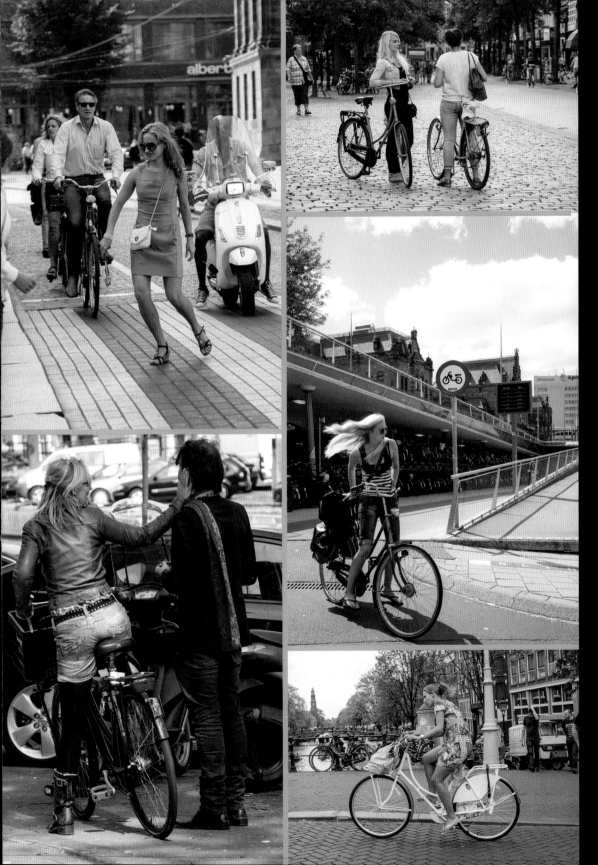

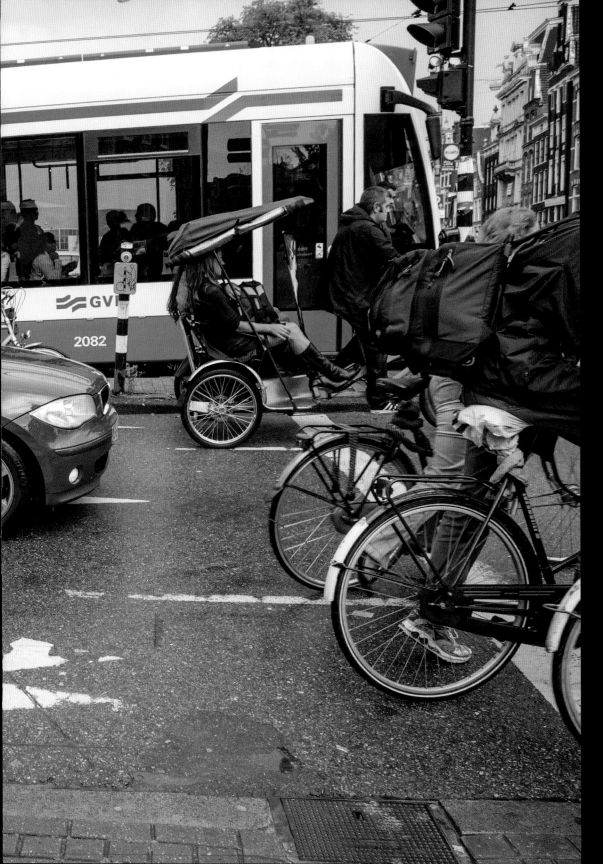

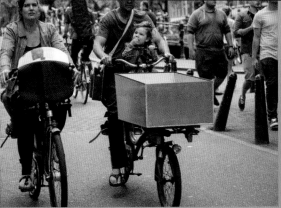

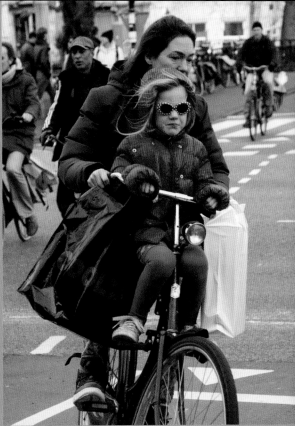

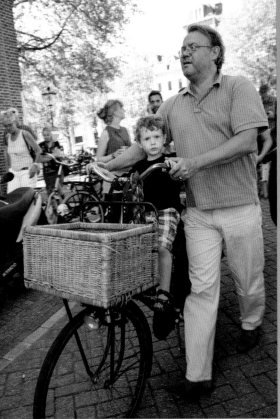

"To us Dutch people, riding our
bicycle is a given – it is in our genes.
As soon as they can walk, children
are put on a bicycle. We take it
for granted that the country is
littered with traffic lights put there
especially for cyclists. Living in a
country with the highest density
of cyclists in the world, we refuse
to put on a helmet when cycling.
And let's not forget our extensive
network of bicycle paths: 32,000
kilometers! In short, if you think
of the Netherlands: you think
of cycling!"

Angelique Vermeulen, Marketing Consultant,
NBTC Holland Marketing

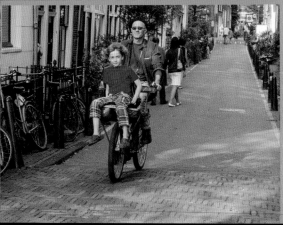

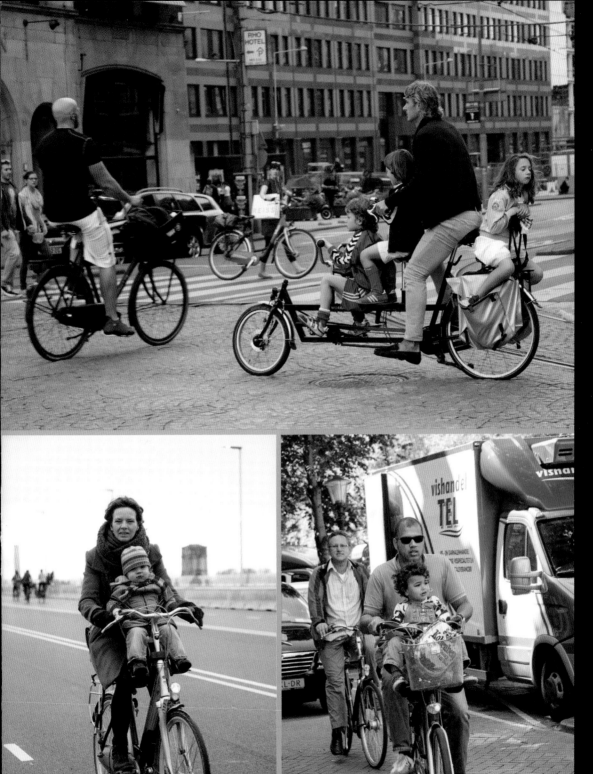

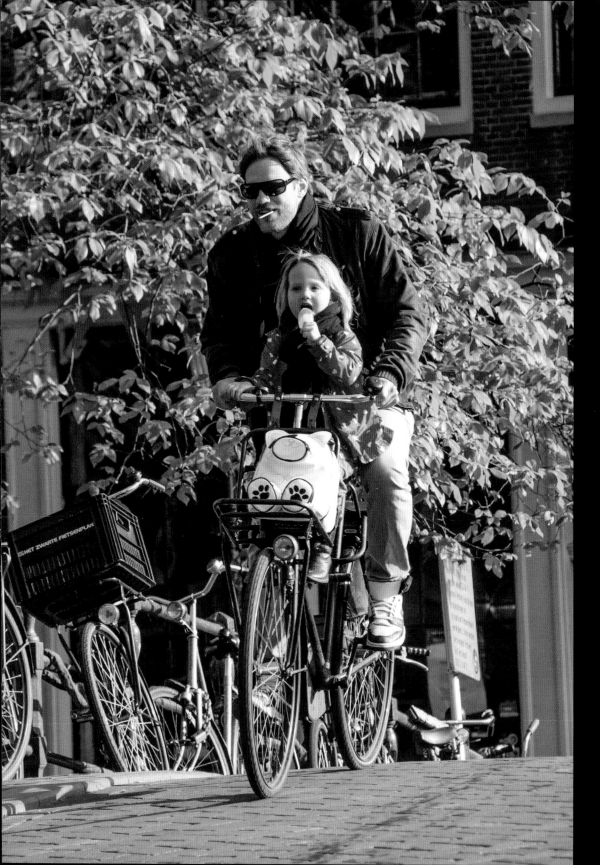

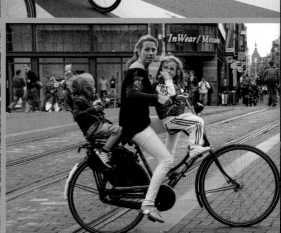
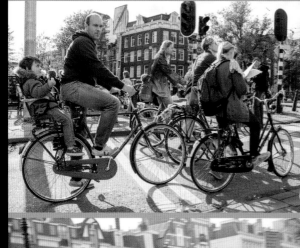
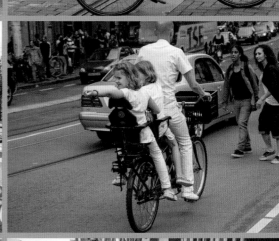
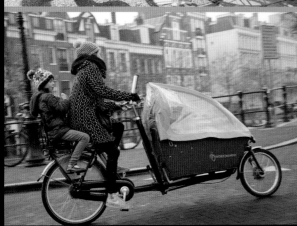
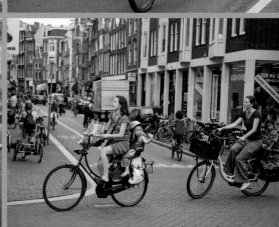

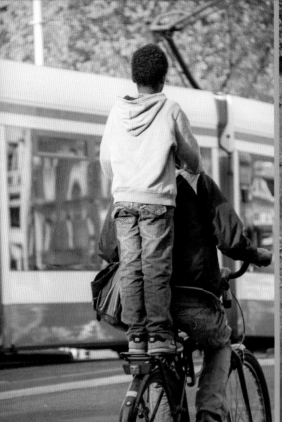
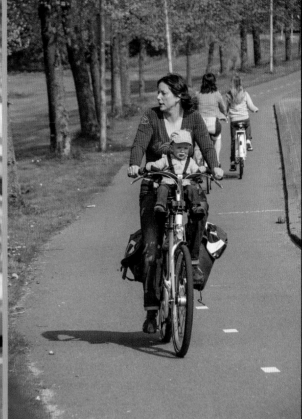

"'Bikeability' is something the Netherlands excels in. Urban planning incorporates cycling paths in the transportation network. There are separate traffic lights for cyclists and special signs to regulate cycling traffic. Children learn the traffic rules for cycling in special training courses in grade school. All Dutch children around the age of 10 are required to take a theory test for cycling as well as a practical examination which is overseen by the police. Their bikes are checked and certified."

HollandTrade.com

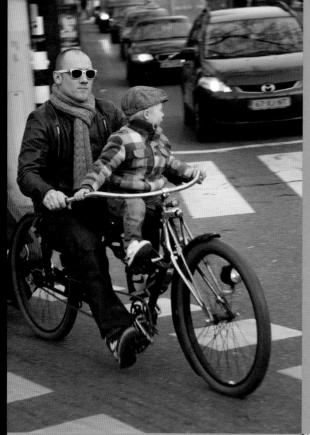

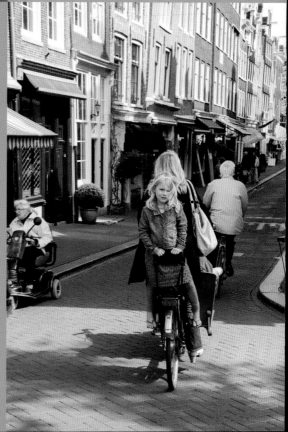

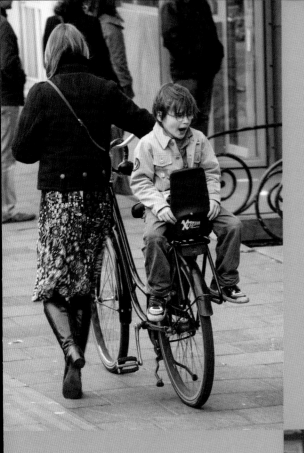

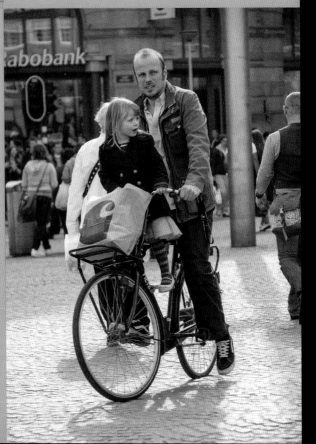

"Recent studies continue to shed
light on how everyday cycling is
not only good for our cardiovascular
health but also a way to save billions
in health care costs. While everyday
cycling is starting to be recognized
as a low-impact form of exercise,
there remains resistance to
accepting riding a bike as a form
of preventive health care across
North America.
... Clearly, biking is advantageous
for one's physical health. It's widely
known that cycling is a low-impact
form of exercise that's good for
the cardiovascular system, a way to
control weight gain, and benefits our
immune system. In addition, daily
bicycling can have positive effects
on our mental well-being."

Karin Olafson, for *Momentum Magazine* (January 6, 2014),

'Is Bicycling a Form of Preventive Health Care?'

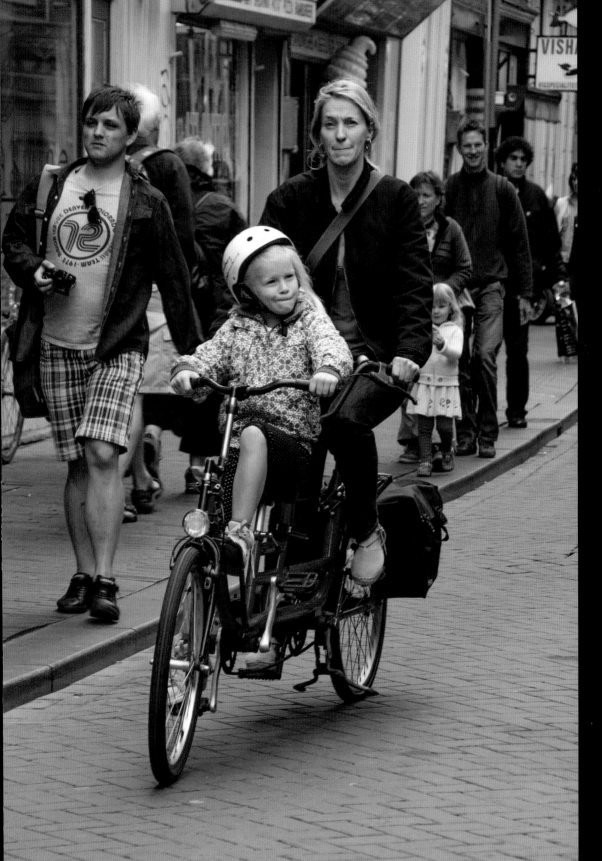

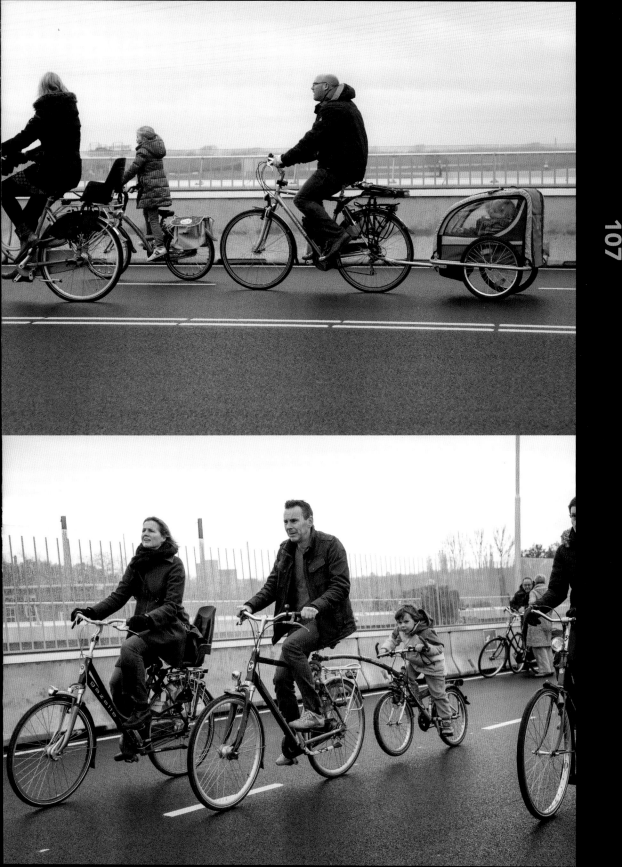

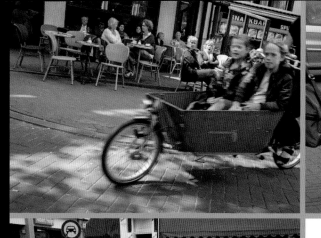
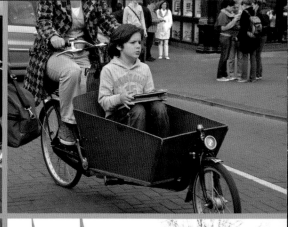

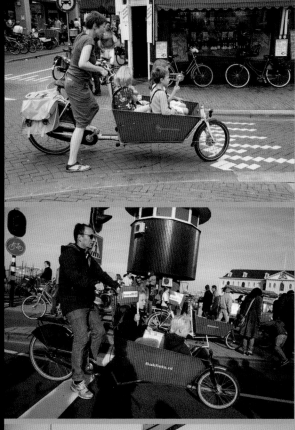
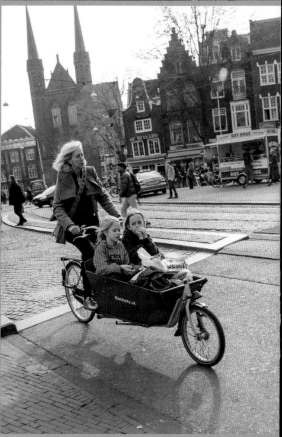
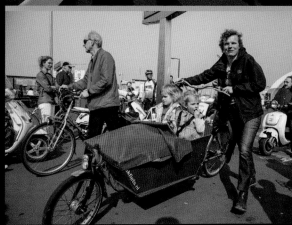
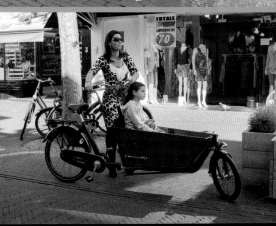

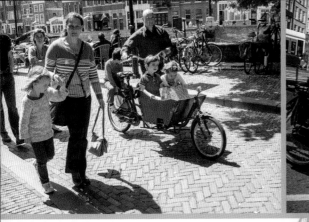
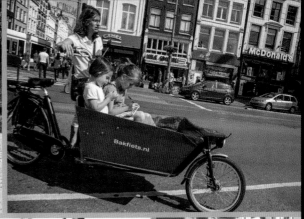

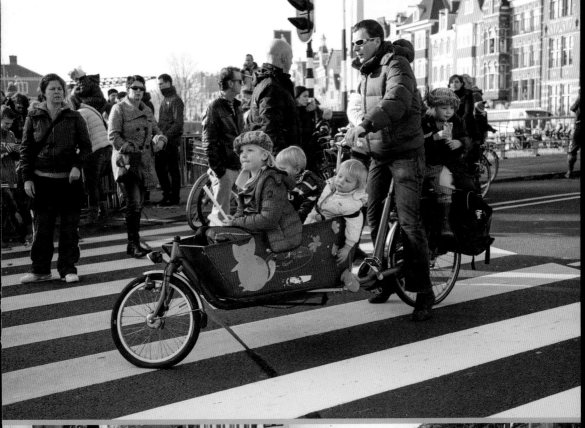

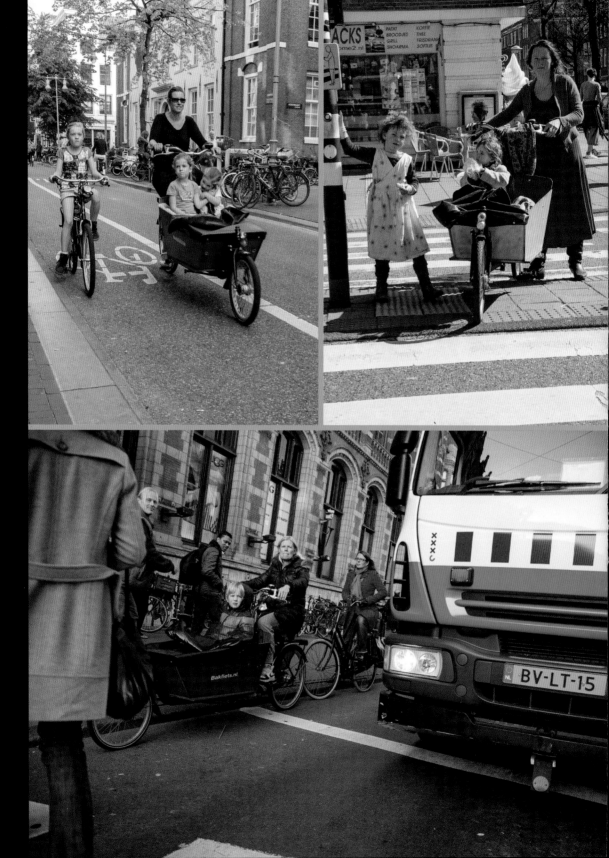

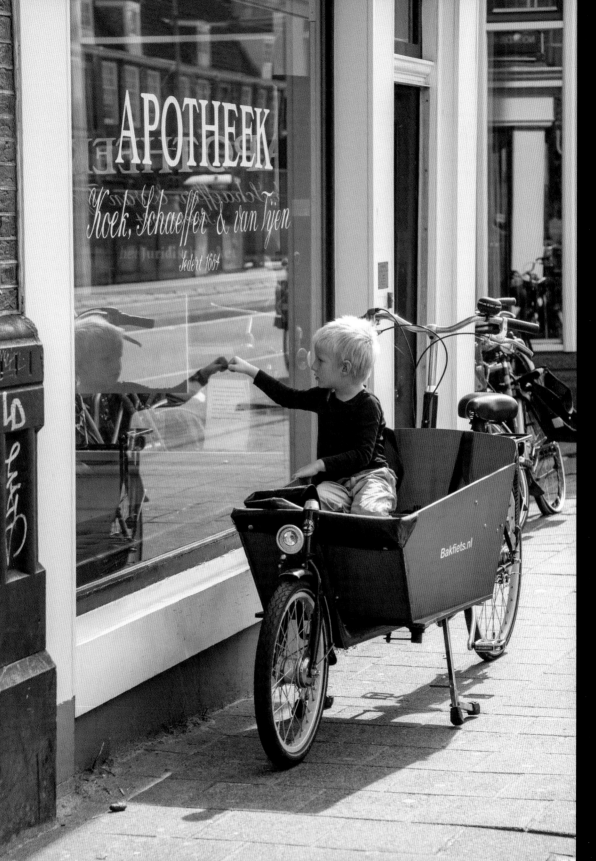

"I'm on a mission to put cycling on the agendas of architects, urban designers and fellow academics, who see the potential for bicycles to change cities and buildings. … My favorite bikes are a titanium racing bike I use for racing, a Velorbis retro commuter for riding to cafes and work, a single speed ultra-light Brompton that I take with me when I travel on planes, a 29er hardtail mountain bike that I get lost on in remote places, an old track bike that scares me, a 1984 Colnago Super with all original Campagnolo components that is plugged into a virtual realm that I train in … and a Dutch-made Bakfiets, that could easily replace half of the bikes I just mentioned."

Steven Fleming, PhD, Senior Lecturer, School of Architecture & Design, University of Tasmania, Australia; author of *Cycle Space: Architecture & Urban Design in the Age of the Bicycle*, www.cycle-space.com

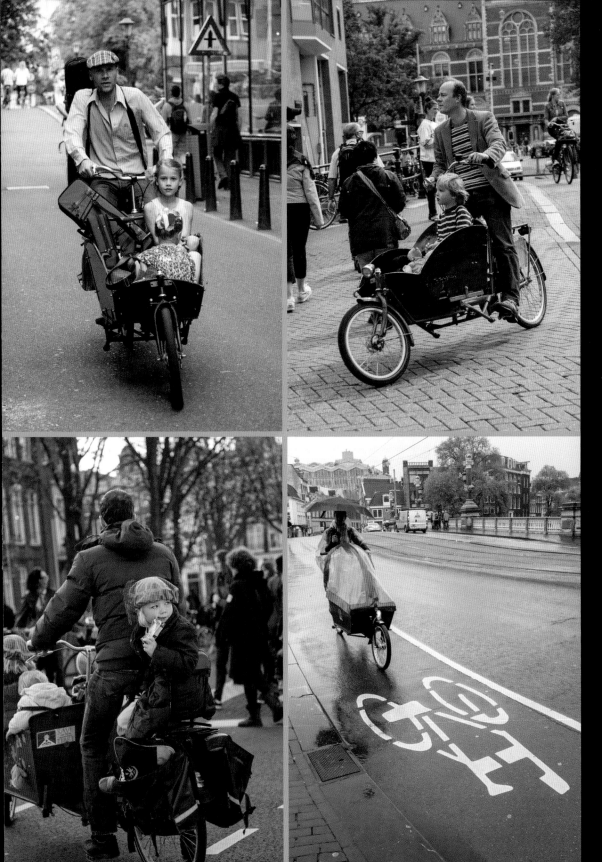

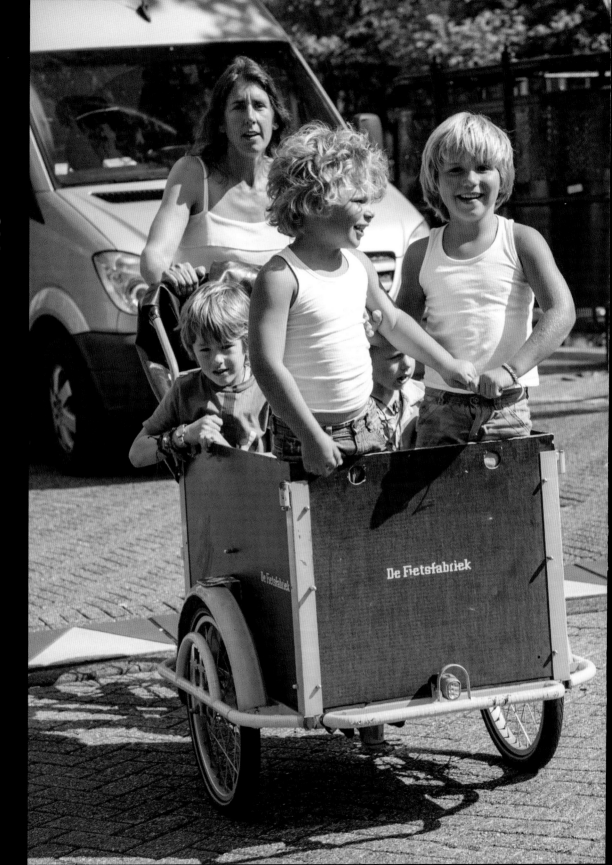

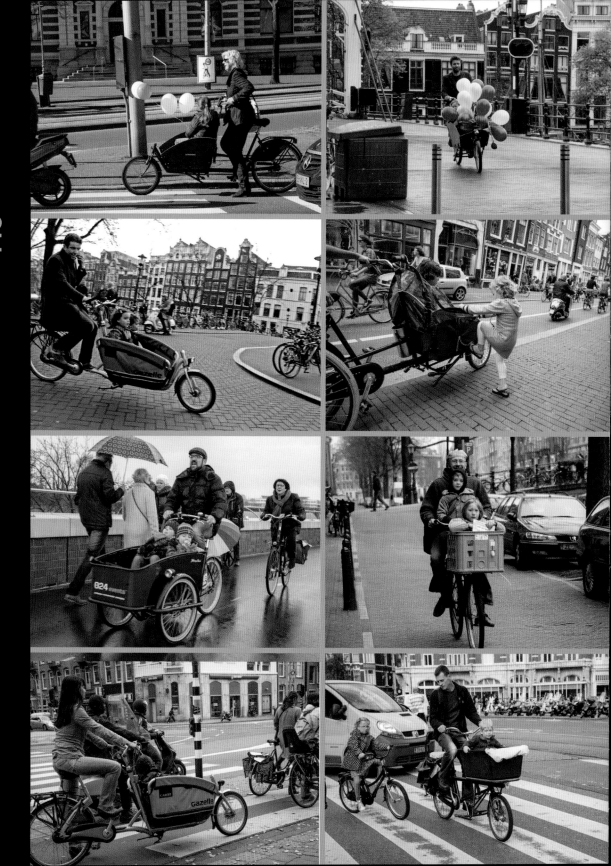

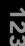

"The Dutch have created the safest and most complete bicycling network in the world, but we need to look beyond infrastructure and into their collective souls to better understand why riding a bicycle is so normal in the Netherlands."

Charles Rubenacker, Bicycle-Culture.com

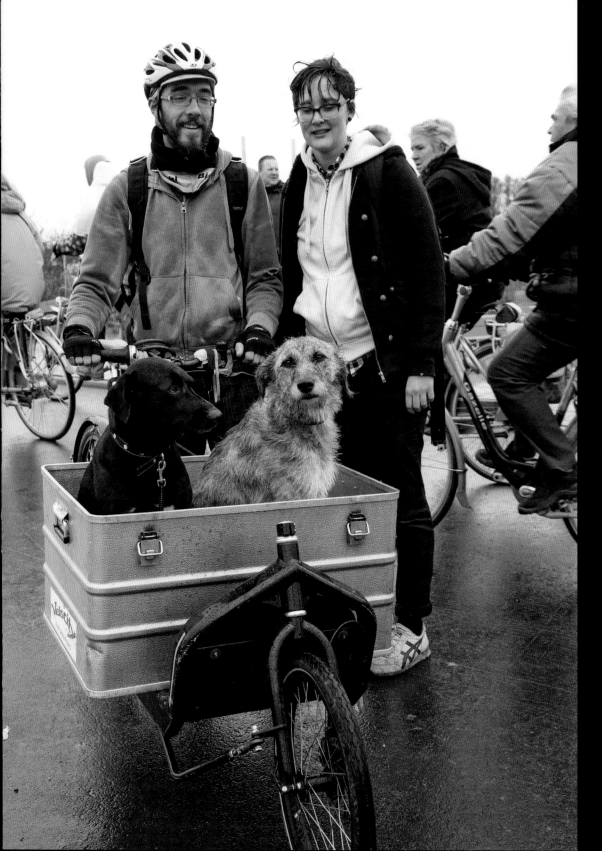

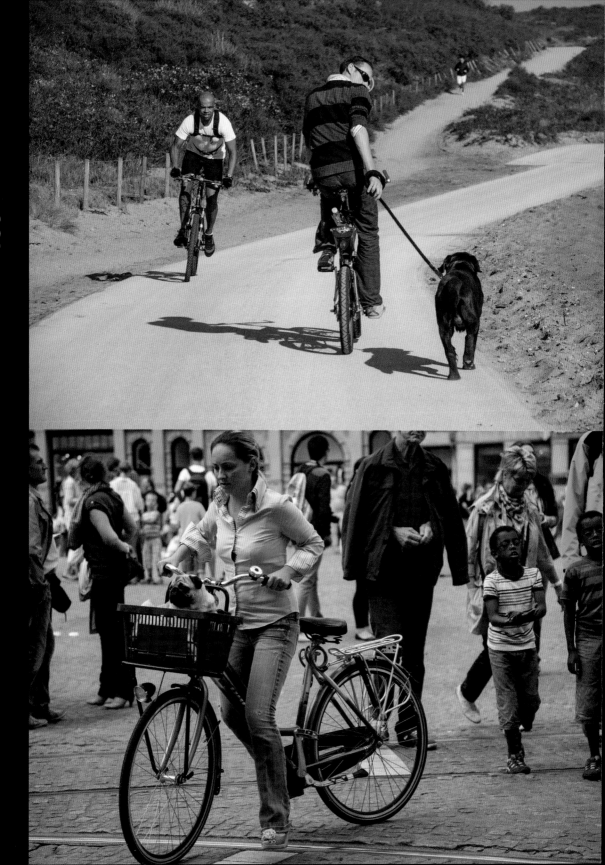

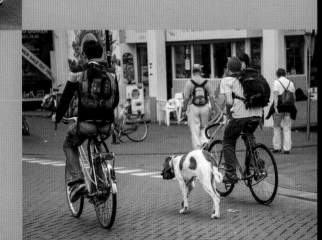

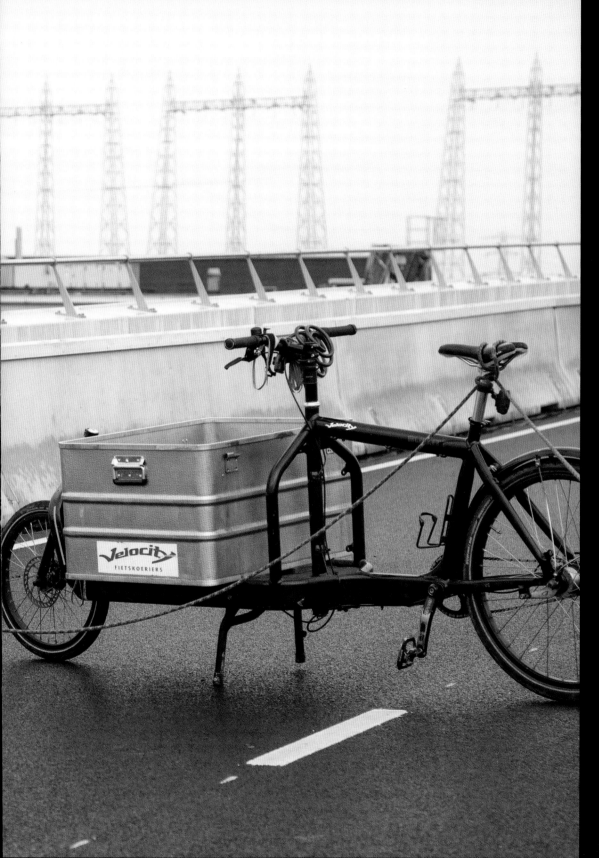

"A bicycle isn't considered to be a strange toy ... it's not a sporting object ... it's a simple method of transportation. You don't think about cycling any more than you think about your feet when you're walking."

Professor Greg J. Ashworth, Dept. of Planning,
University of Groningen, The Netherlands,
for Streetfilms, 'Groningen: The World's Cycling City'

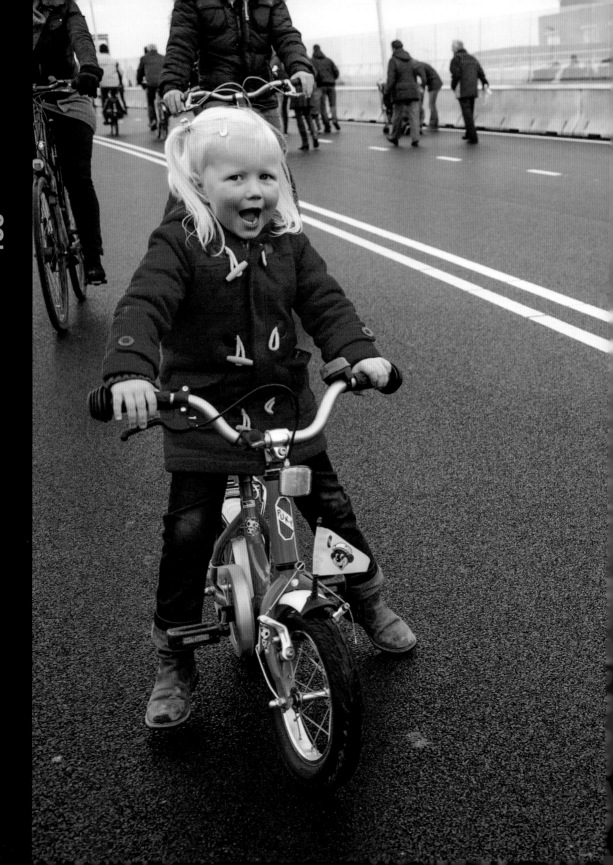

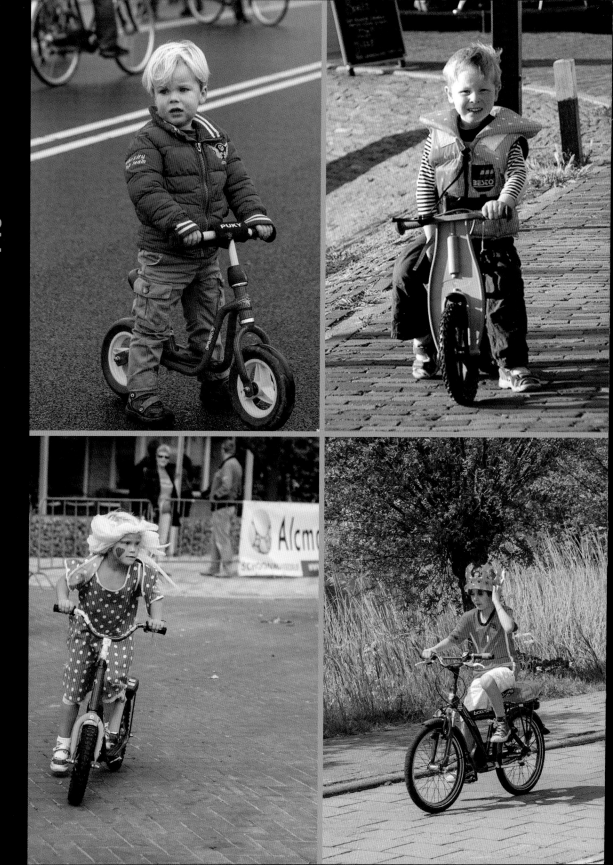

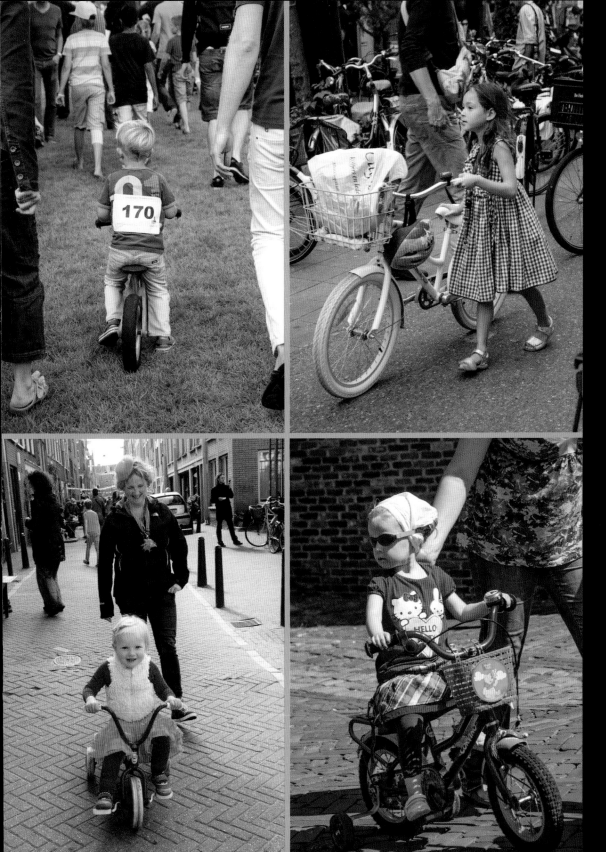

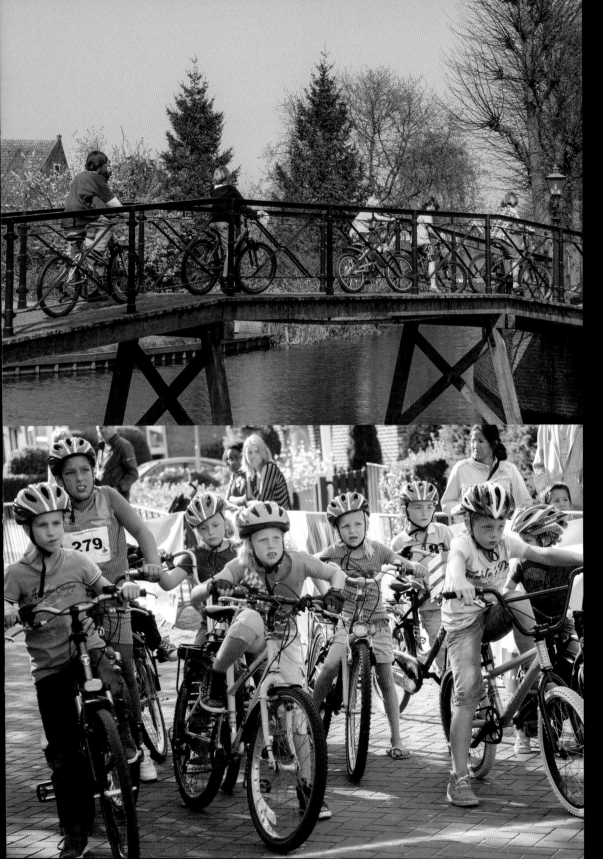

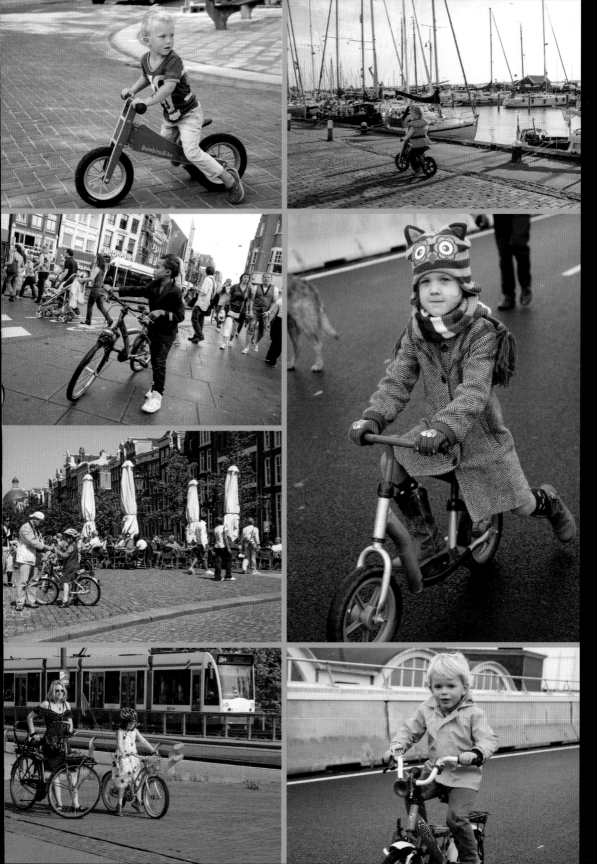

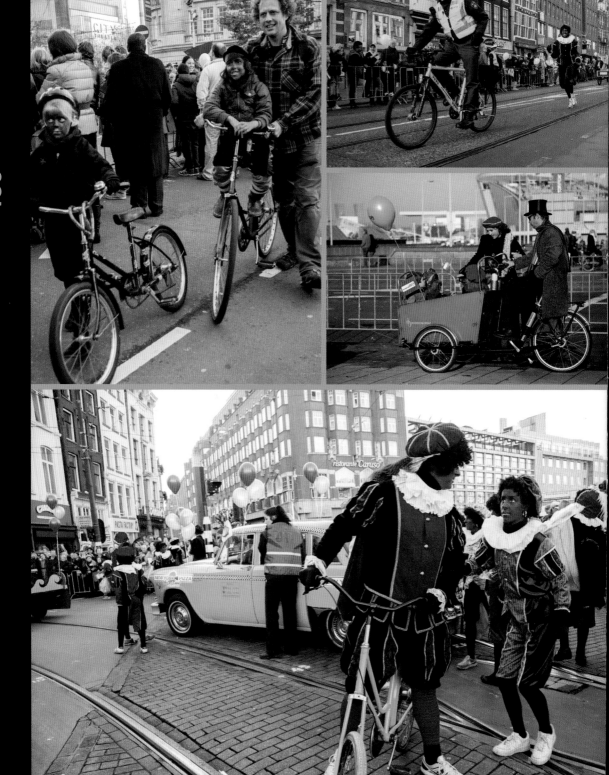

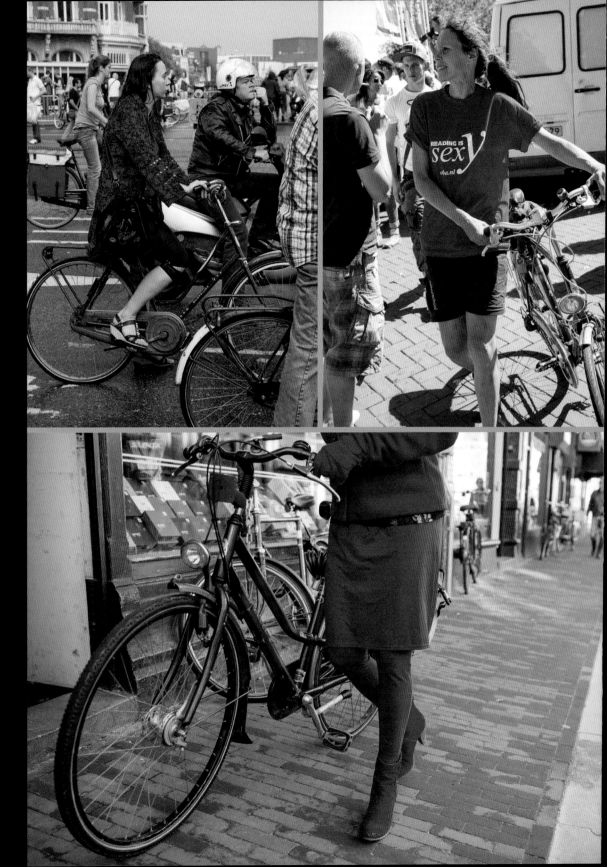

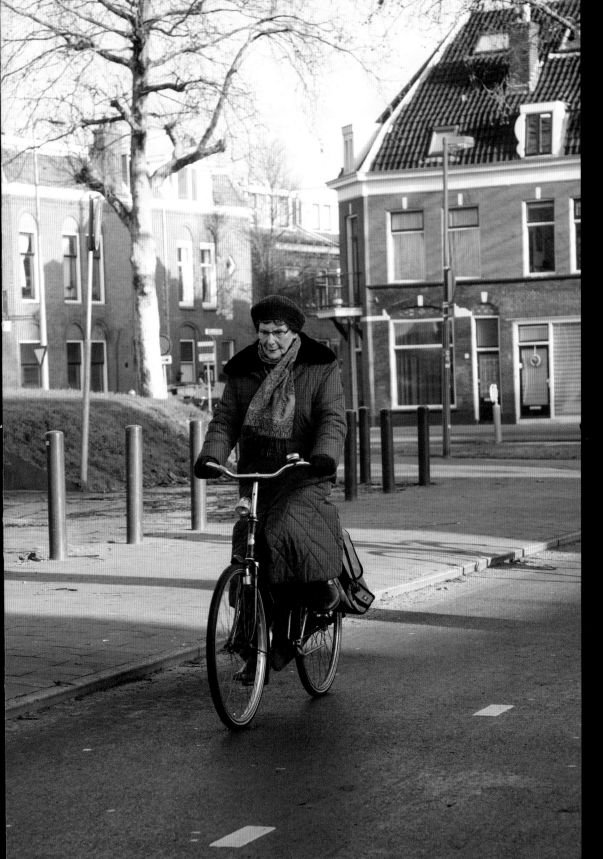

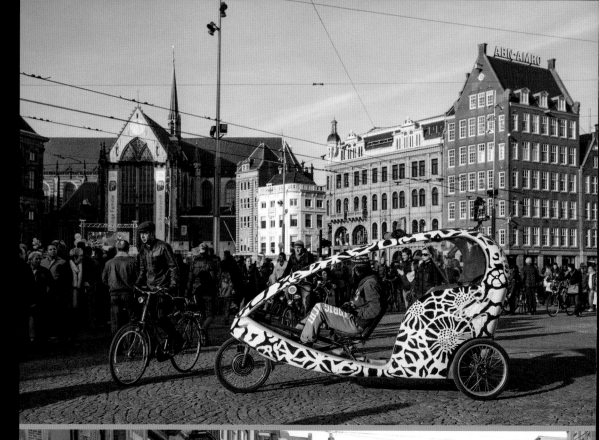

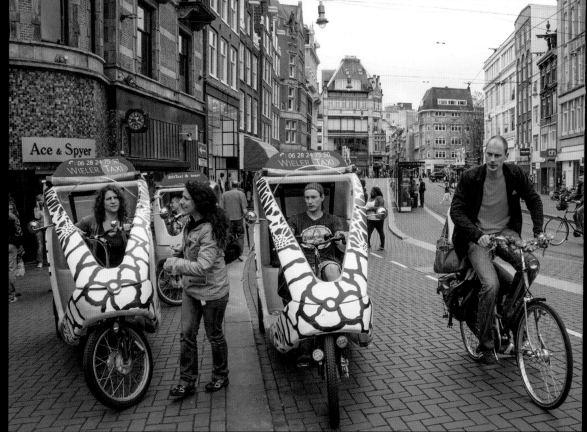

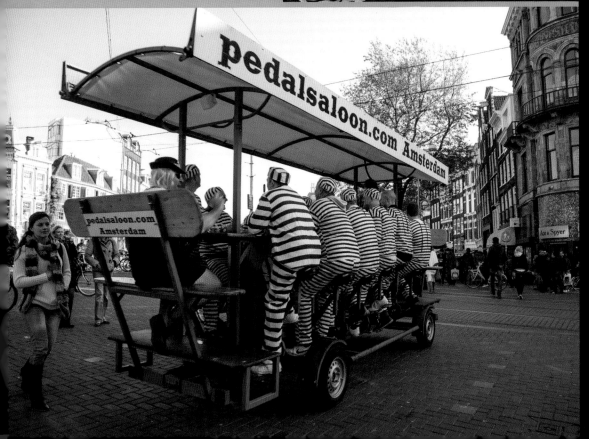

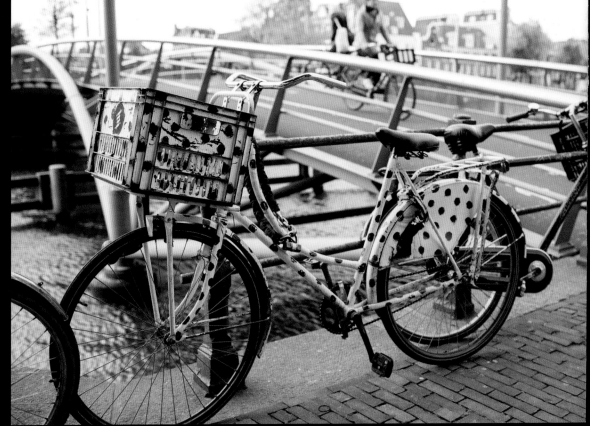

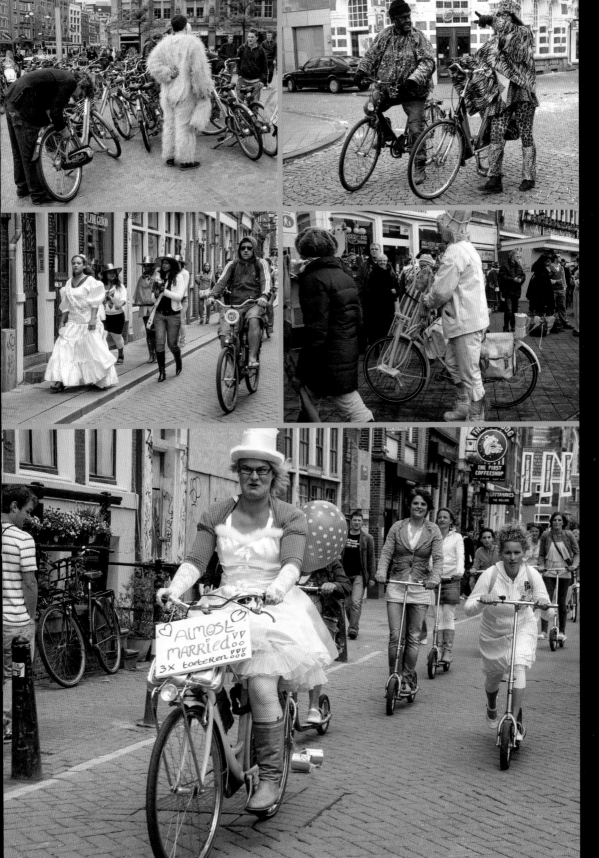

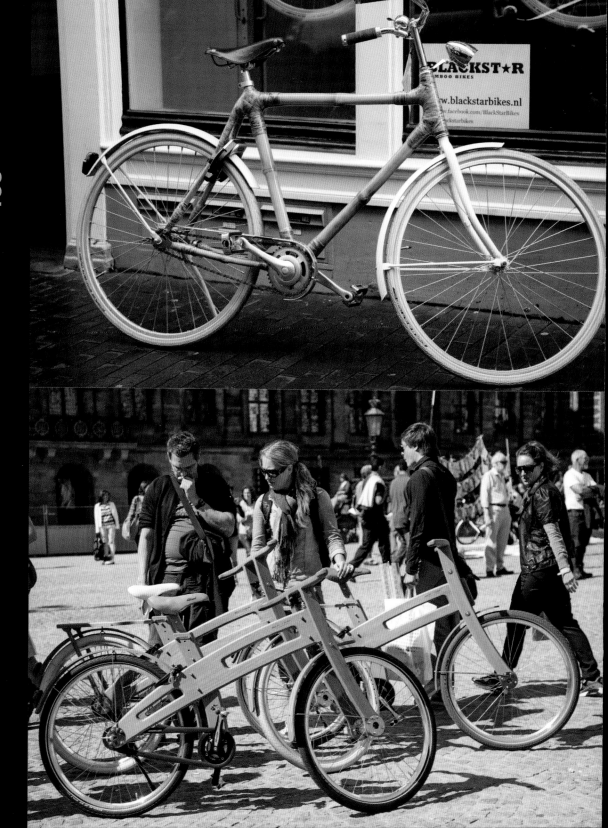

"Nowadays Dutch cycling is much more influenced by designers, creative entrepreneurs and artists. The bicycle has become a *lifestyle* product and is not only functional anymore."

Jos Sluijsmans, Fietsdiensten.nl

"The Netherlands leads the world in innovation related to bicycle design and materials. You might say the Netherlands has turned bicycle-making into a fine art."

HollandTrade.com

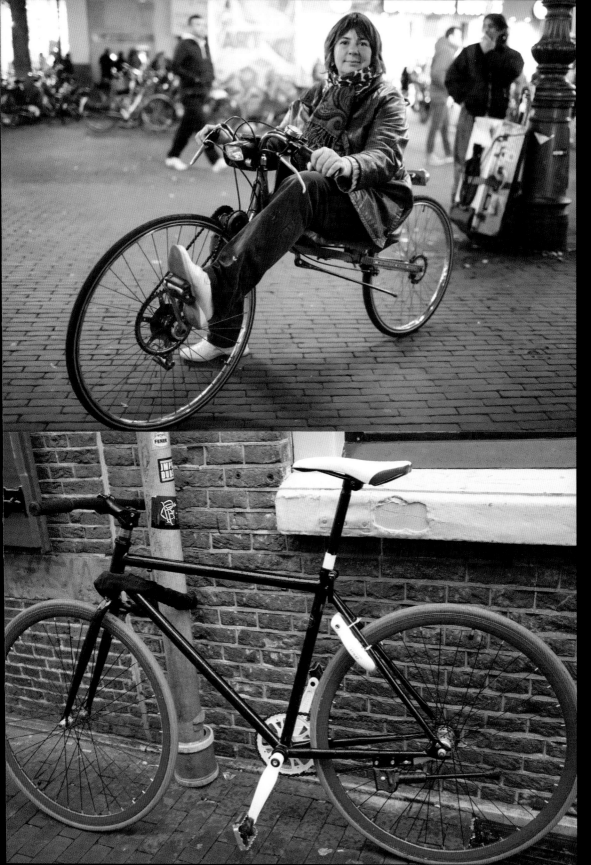

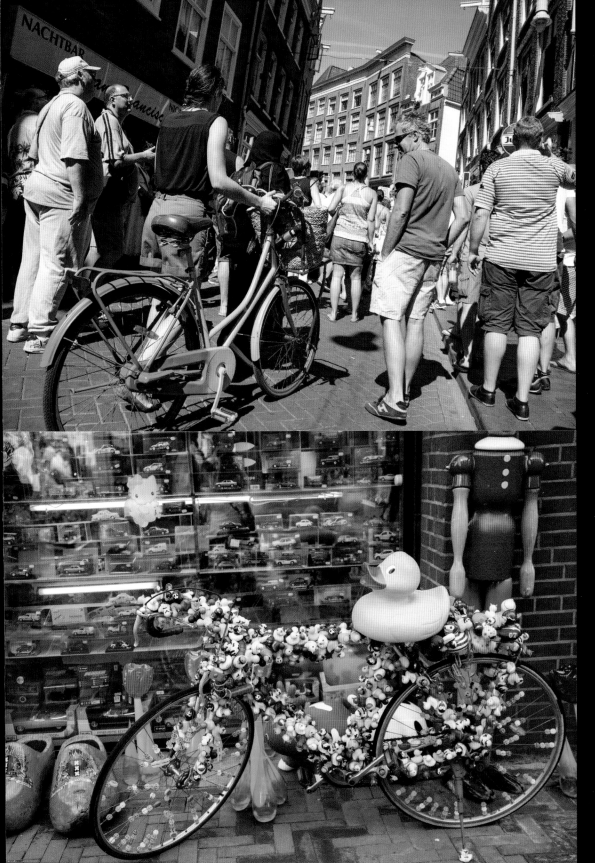

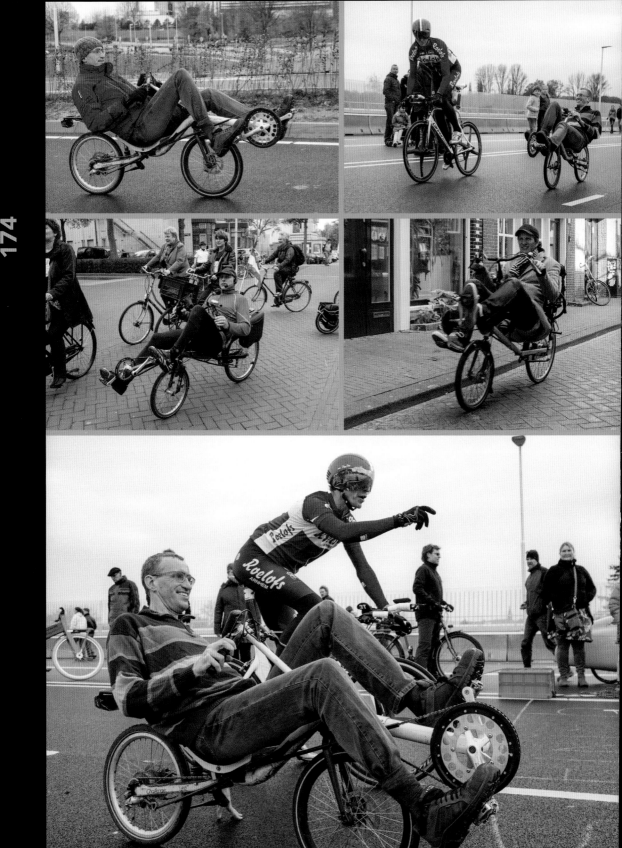

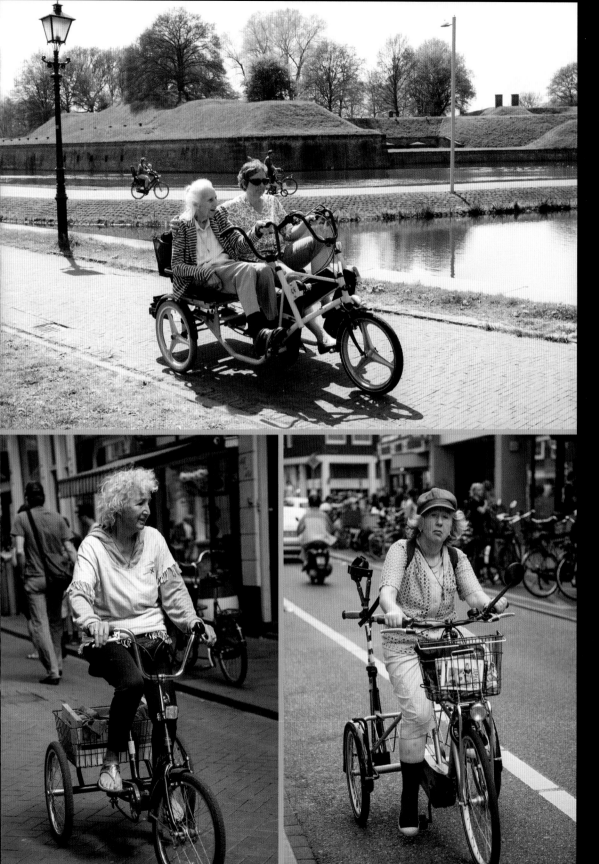

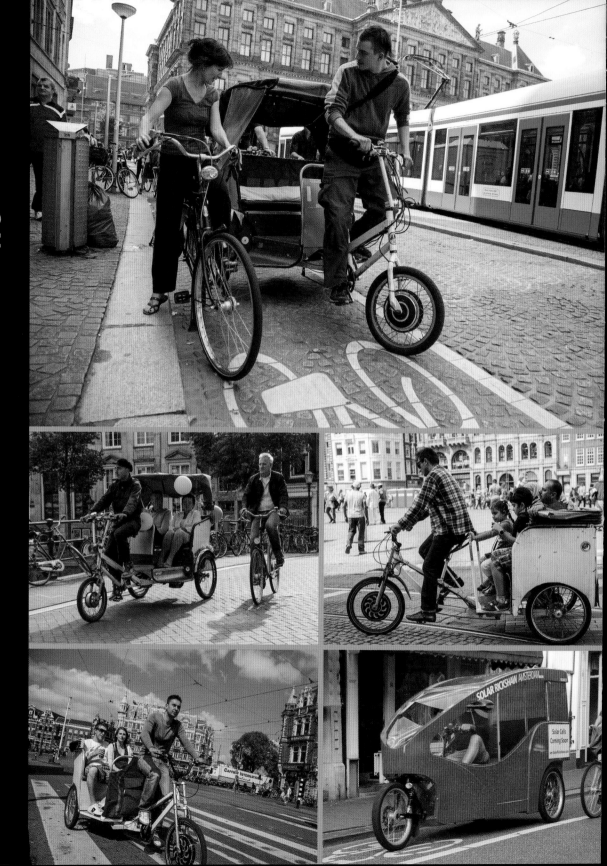

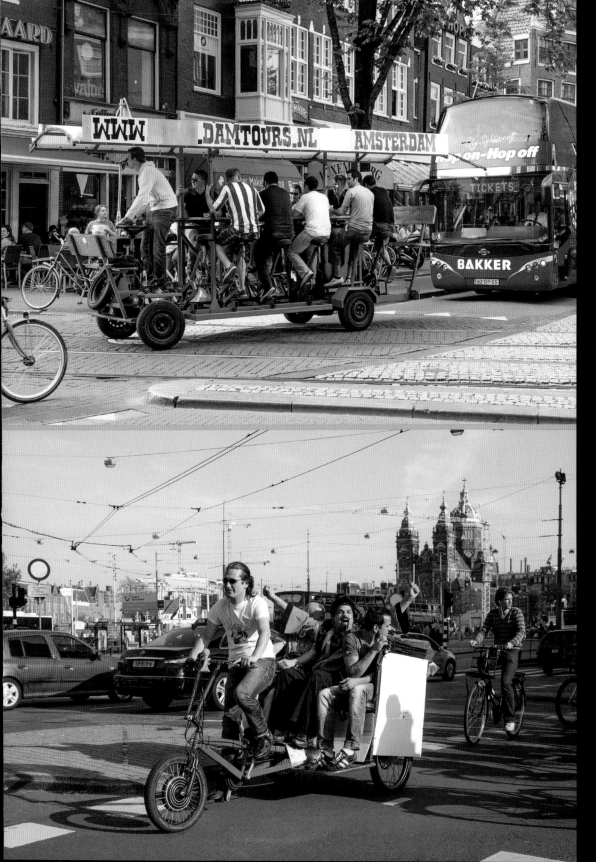

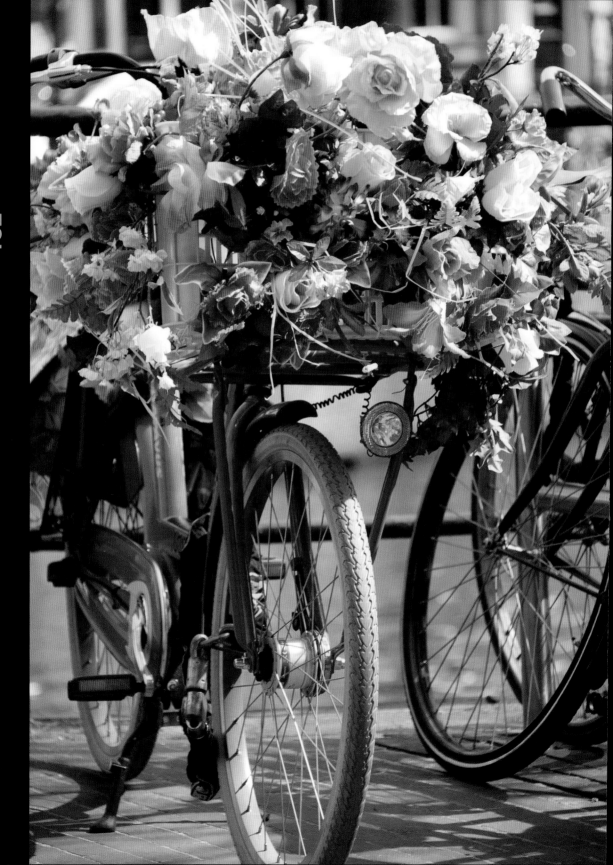

'WHY IS CYCLING POPULAR IN THE NETHERLANDS: INFRASTRUCTURE OR 100+ YEARS OF HISTORY?'

"It's not the same in the Netherlands. People of all classes ride bikes. It's not just because of the joined-up bike paths. The Netherlands isn't a country of cyclists; it's a country where people ride bikes a lot. It's Europe's top cycling nation. And it's been top of the pile since 1911."

Carlton Reid, Executive Editor of Bike Biz.com
and Bikehub.co.uk, and author
of *Roads Were Not Built for Cars*

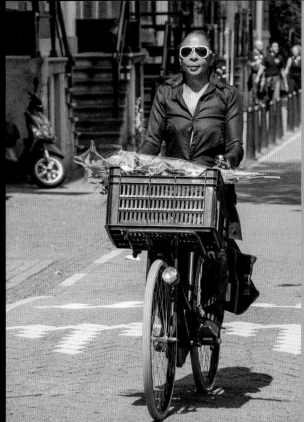

"In some countries, cycling has a bad image and represents low social status, i.e. the cyclist is apparently not able to buy a car. This is not the case in the Netherlands, where bicycle use is the same for almost every population group. Here, cycling reflects a sporty, environmentally-aware lifestyle. The population groups with both the highest and lowest educational levels are the ones that cycle most."

Hans Voerknecht, Senior Advisor, KpVV
(Dutch Knowledge Platform on Mobility)

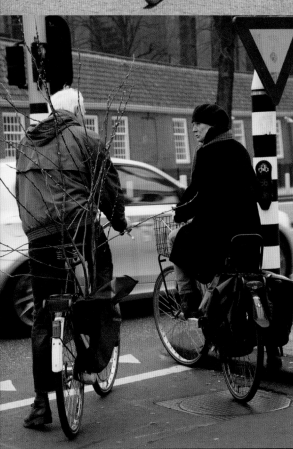

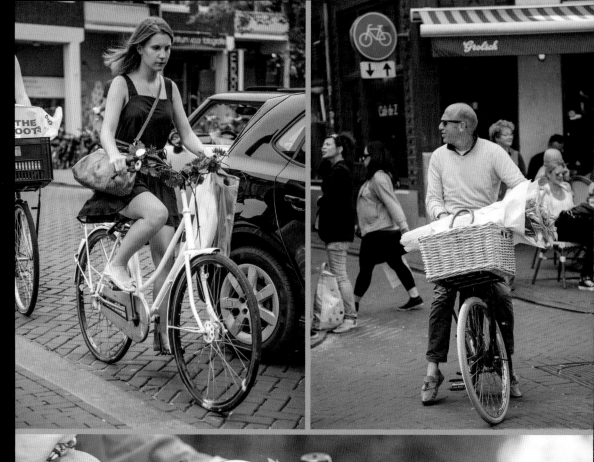

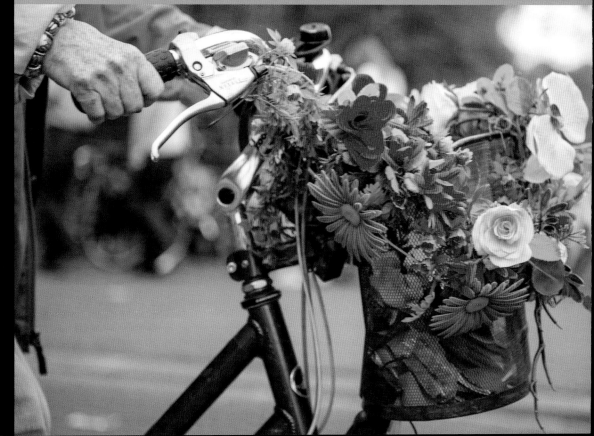

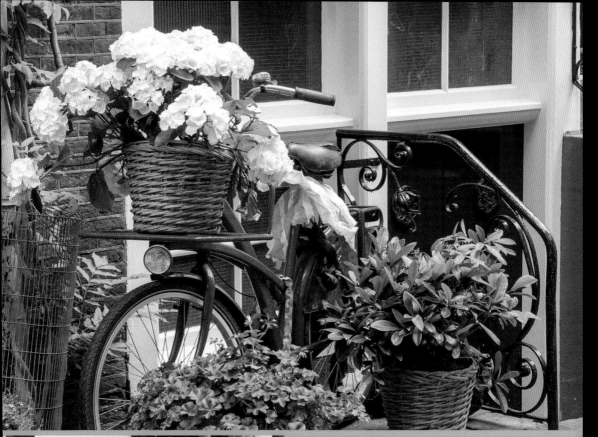

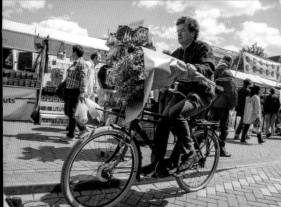

"Nothing compares to the simple pleasure of a bike ride."

John F. Kennedy

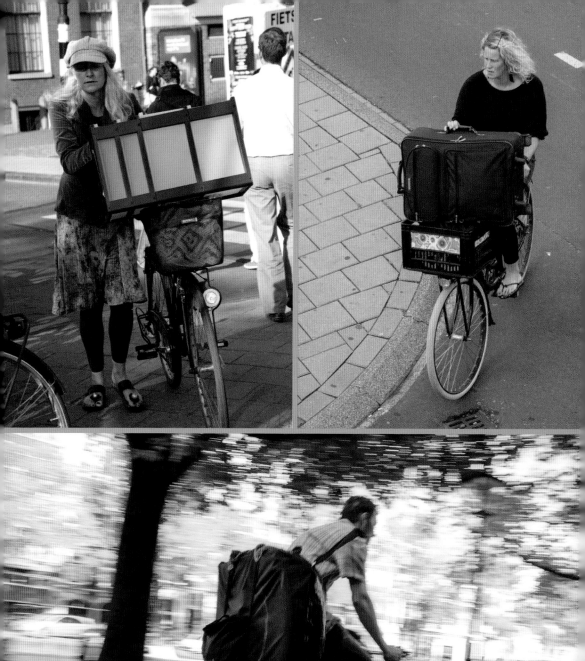
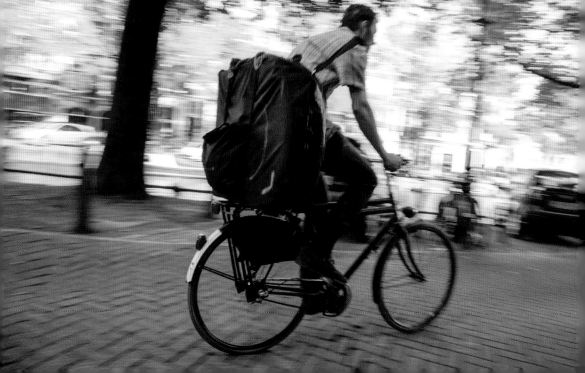

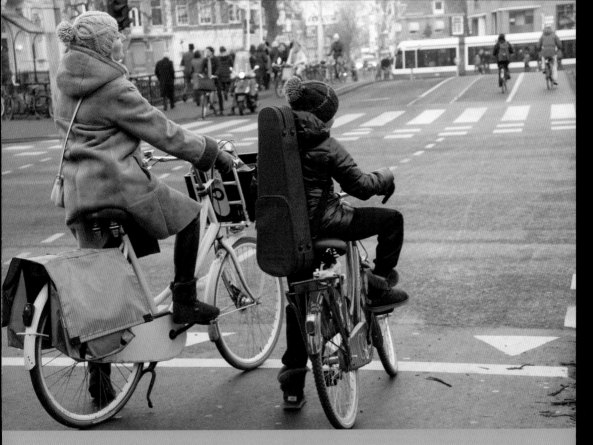

"The export from the Netherlands of bicycle-enabling policy instruments is booming. Recently, urban motoring congestion traumas have renewed international interest, in attempts to determine these Dutch 'magic ingredients' and copy them to Paris, London, New York or Barcelona."

Kaspar Hanenbergh, co-author of *Ons Stalen Ros* (*Our Iron Horse*), from his article 'Cycling Culture in the Netherlands from 1870 to 1920', in *The Boneshaker: The Journal of the Veteran-Cycle Club* (Winter 2012)

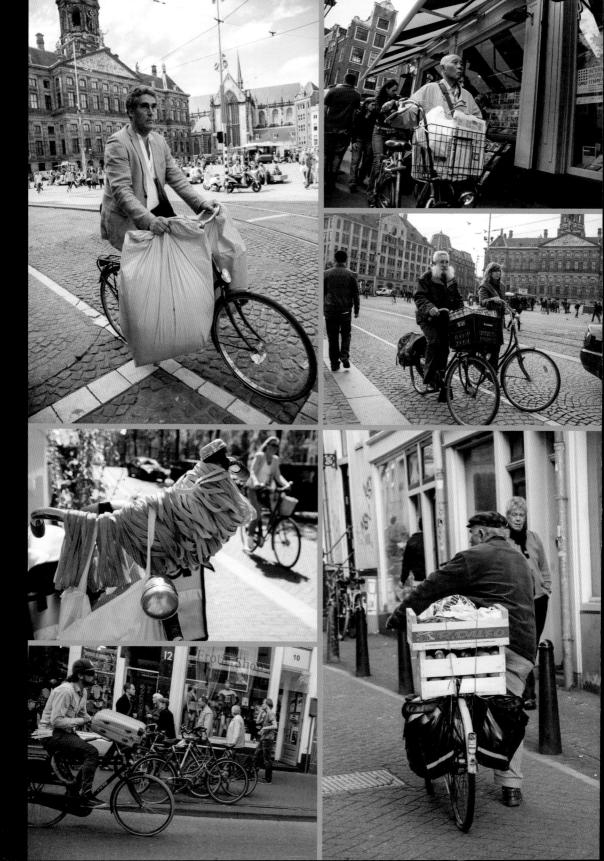

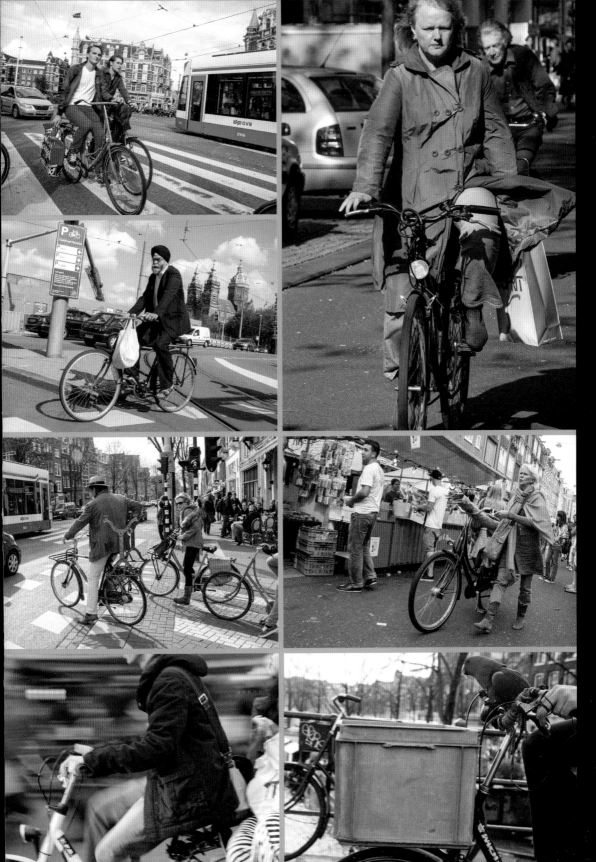

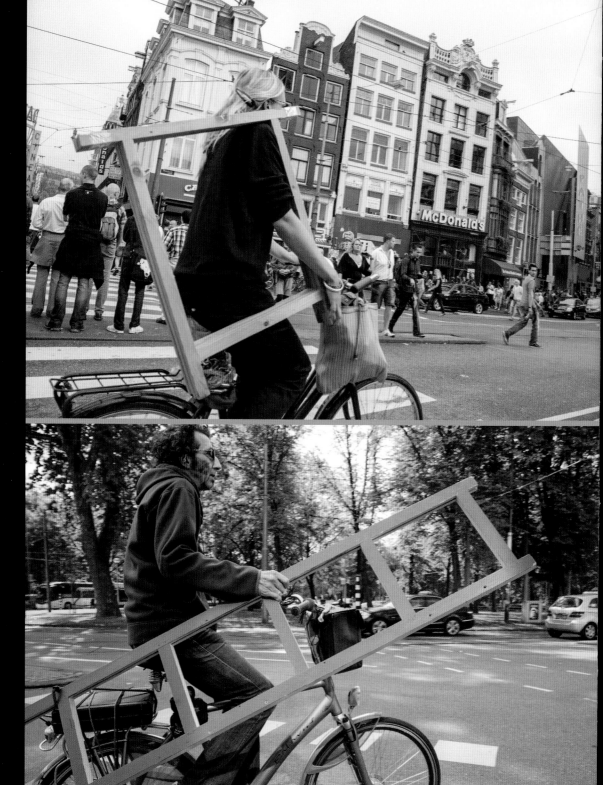

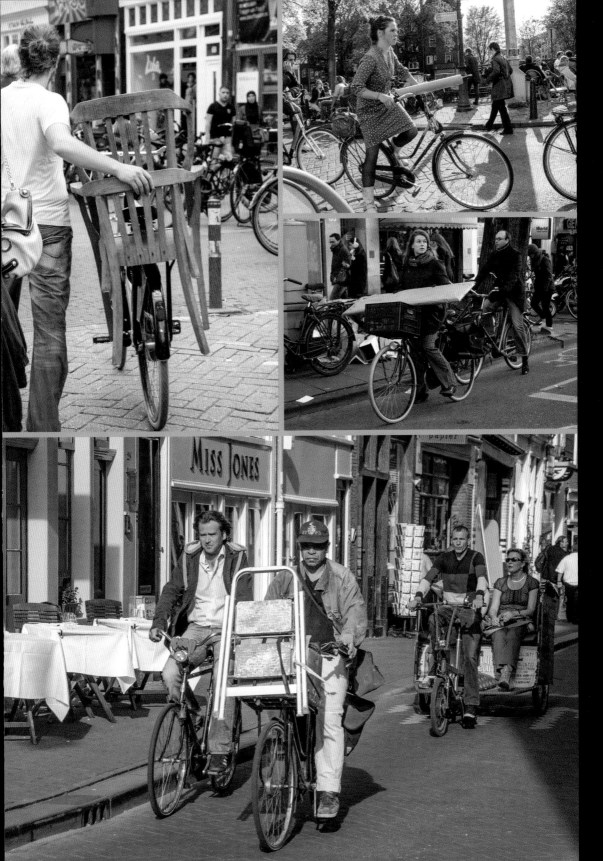

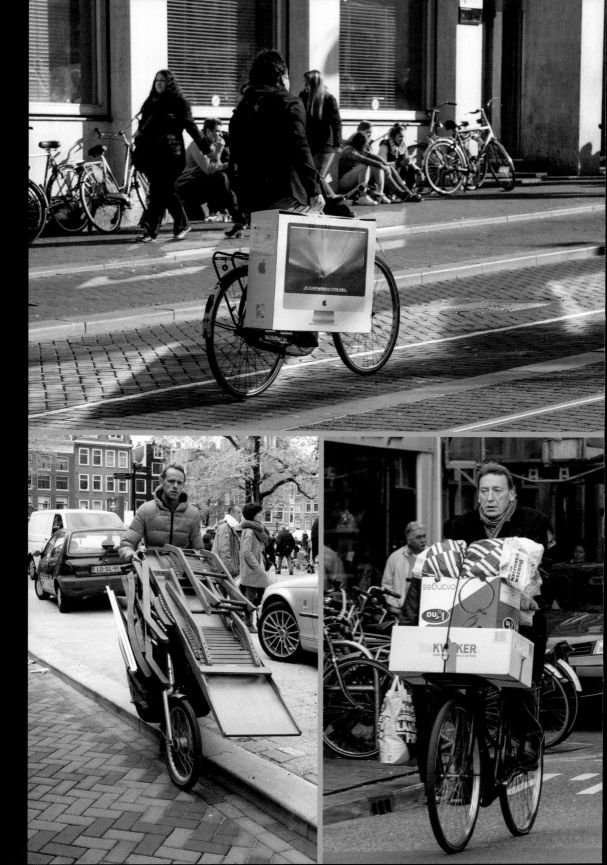

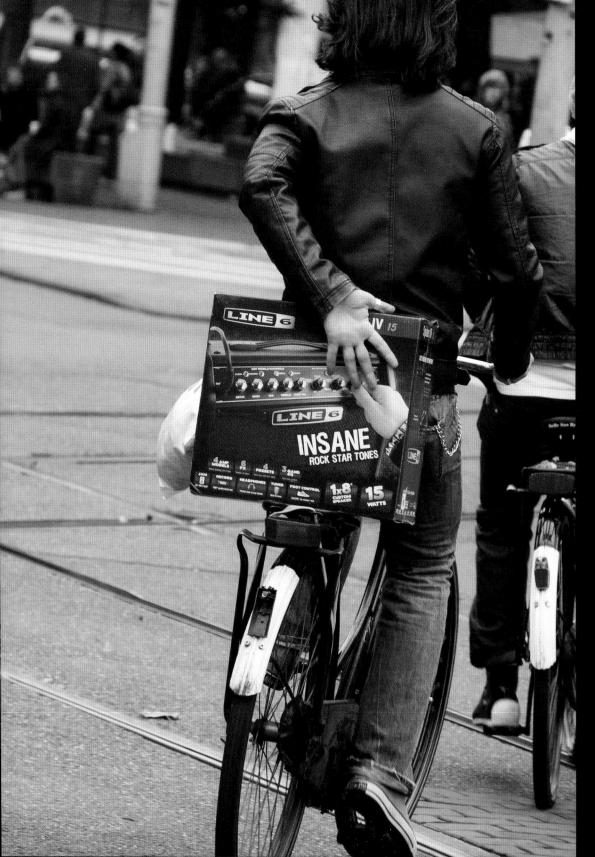

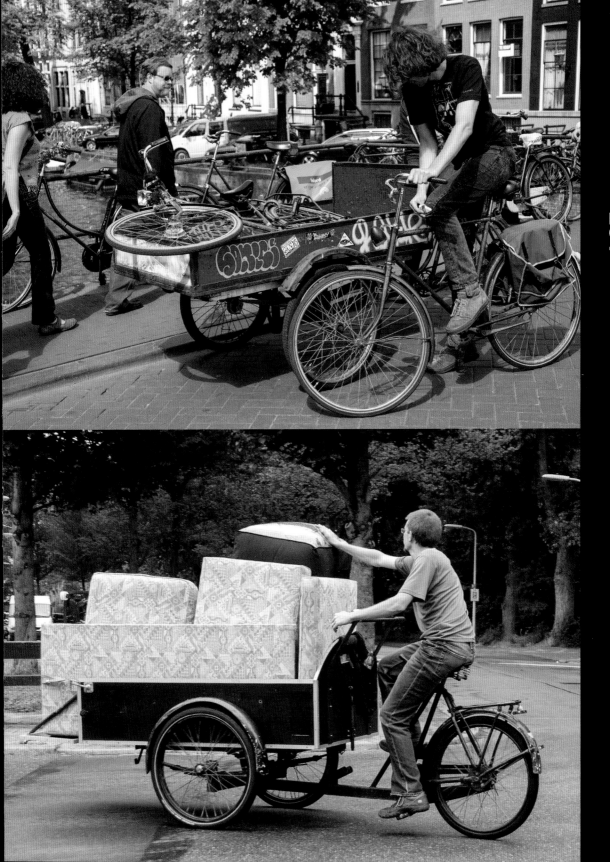

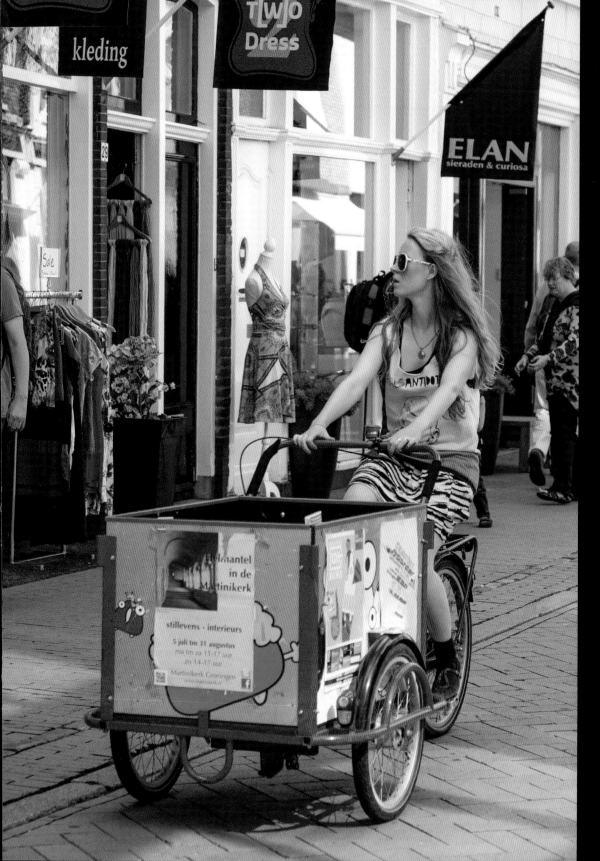

In the Netherlands, if you hit a cyclist with your vehicle you will almost without exception be considered at fault – no discussion. The stance is that cyclists don't cause as severe accidents as motorists do. So, even if a cyclist goes through a red light, crosses an intersection and a car hits him, the cyclist will not necessarily be deemed at fault. The law sides in almost all cases with the cyclist – or the pedestrian, as the case may be… If a child under 15 years of age is hit by a car, there is no discussion. The motorist is automatically at fault. If the victim is 15 or older, there may be some discussion, but the judge will most likely decide in favor of the cyclist – simply because a cyclist is more vulnerable. … Cars are dangerous, so drivers need to be aware of that, and behave responsibly. For that reason, they are, almost without exception, liable."

Ria Hilhorst, Cycling Policy Advisor, City of Amsterdam's
Department of Infrastructure, Traffic and Transport

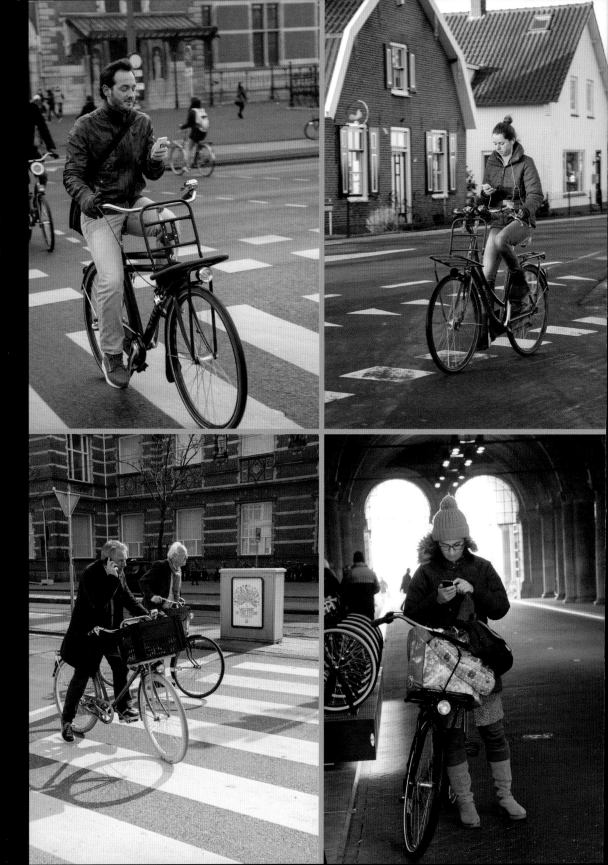

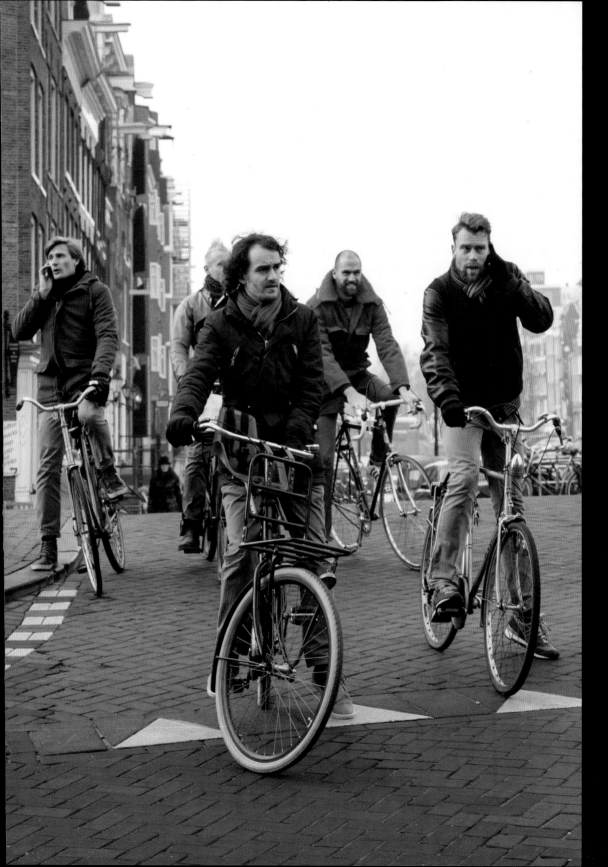

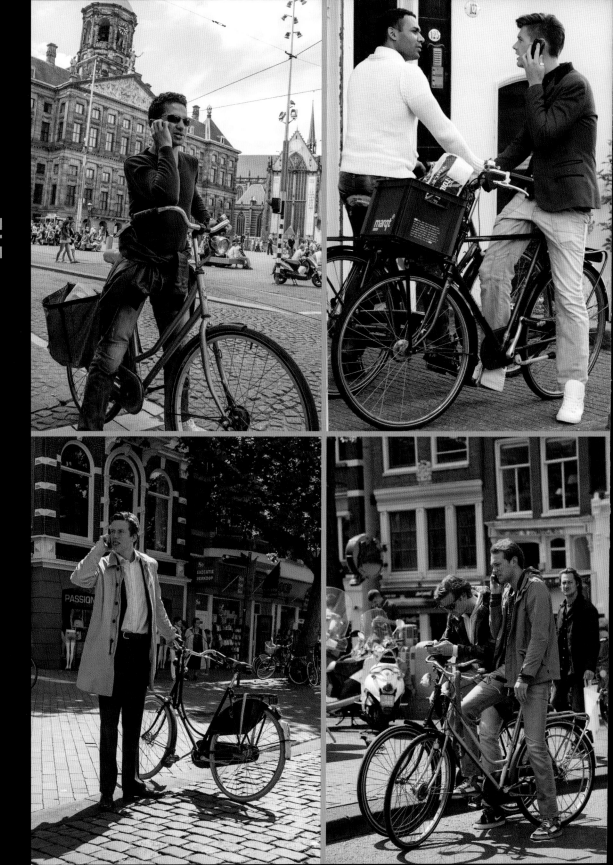

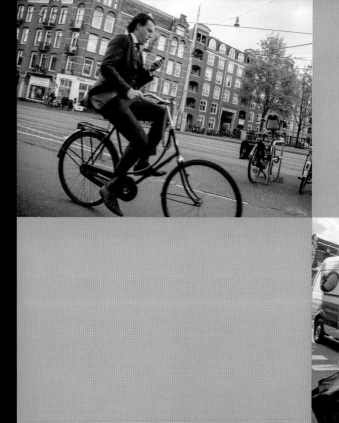

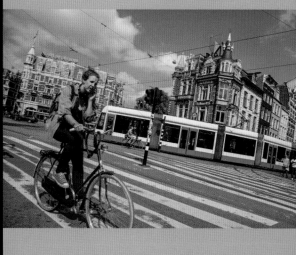

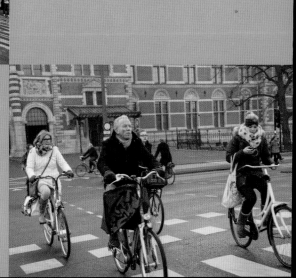

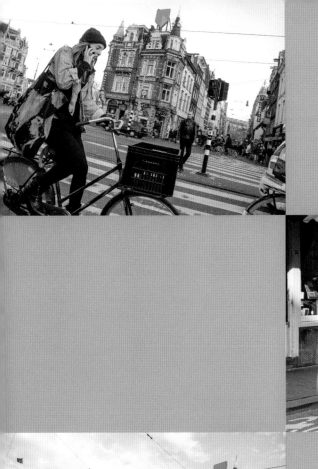
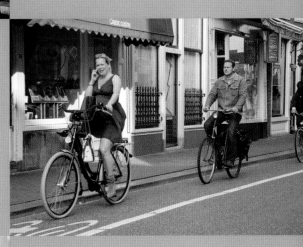
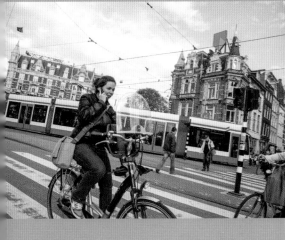
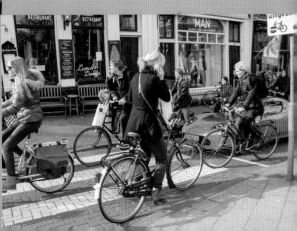

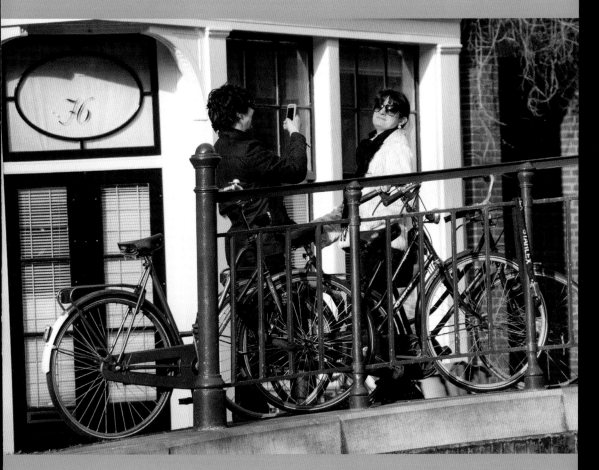

"... 50% of all trips in Groningen are done by bike, and reach as high as 60% within the city itself. The city has 190,000 inhabitants (50,000 of which are students), 75,000 cars and around 300,000 bicycles. That's pretty extraordinary, but not car-free by any means. ... How can bike mode shares possibly go that high? Well, wherever you go in the Netherlands, great care is taken to make your bicycle trip safe, swift, and convenient. You prefer to ride a bike no matter the distance because it will be faster, healthier, and cheaper!"

Clarence Eckerson, Jr., Director, Streetfilms.org

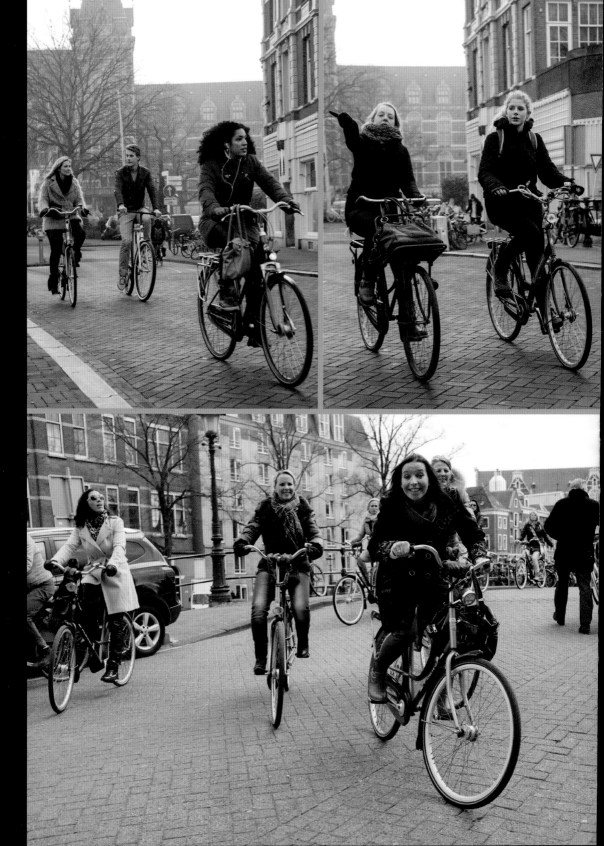

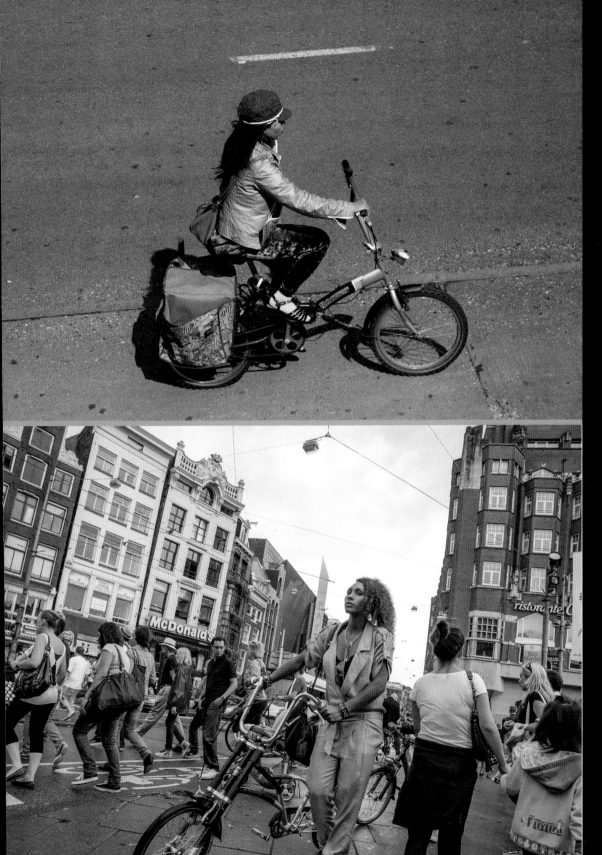

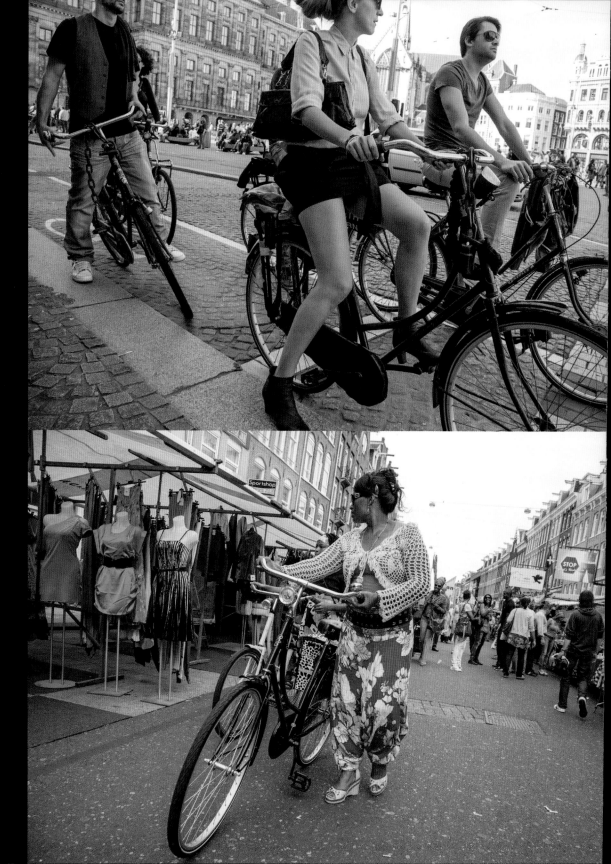

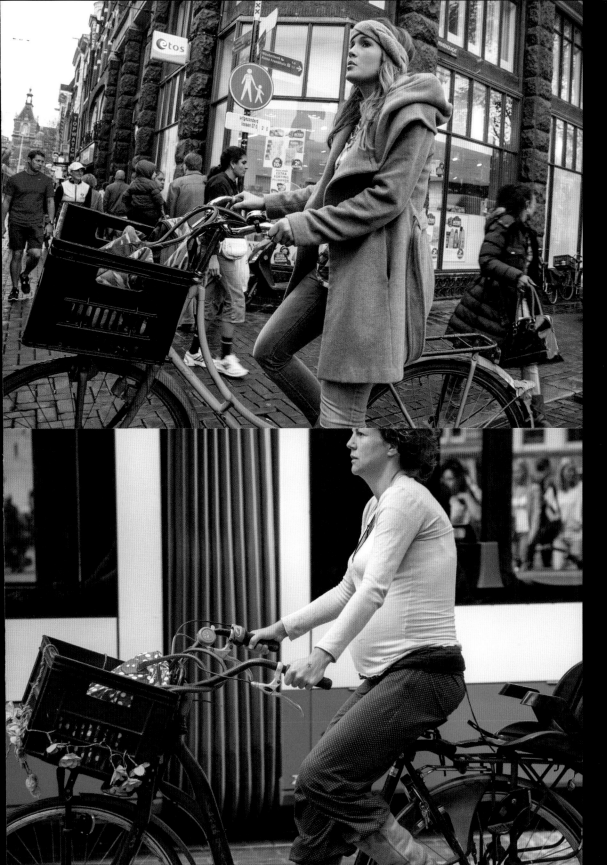

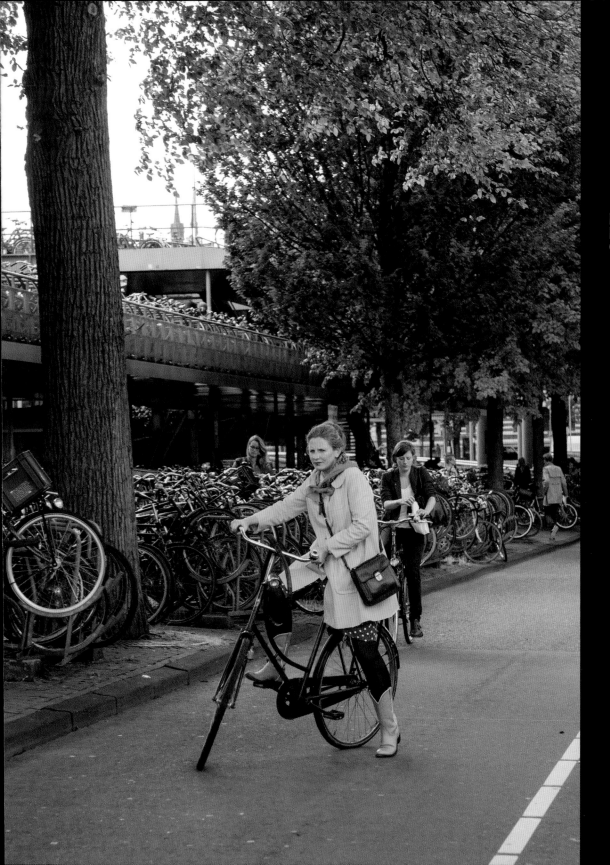

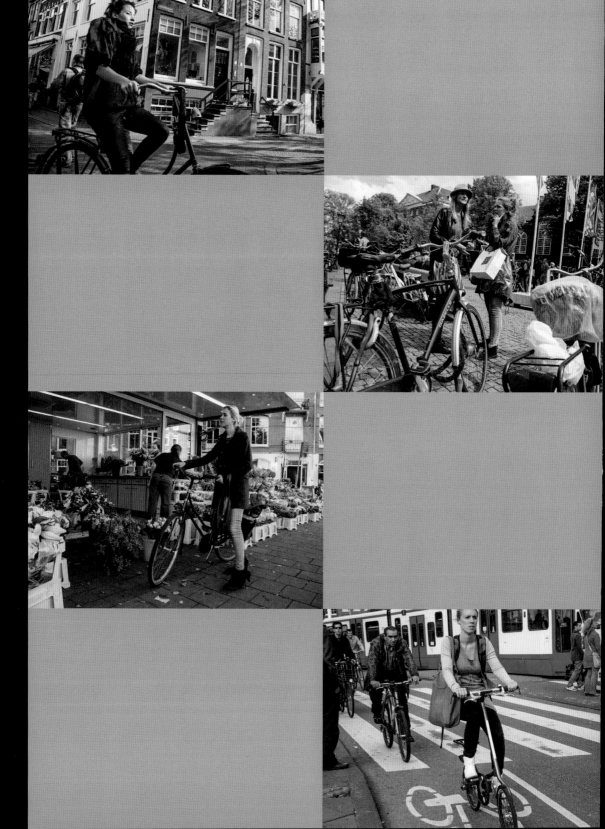

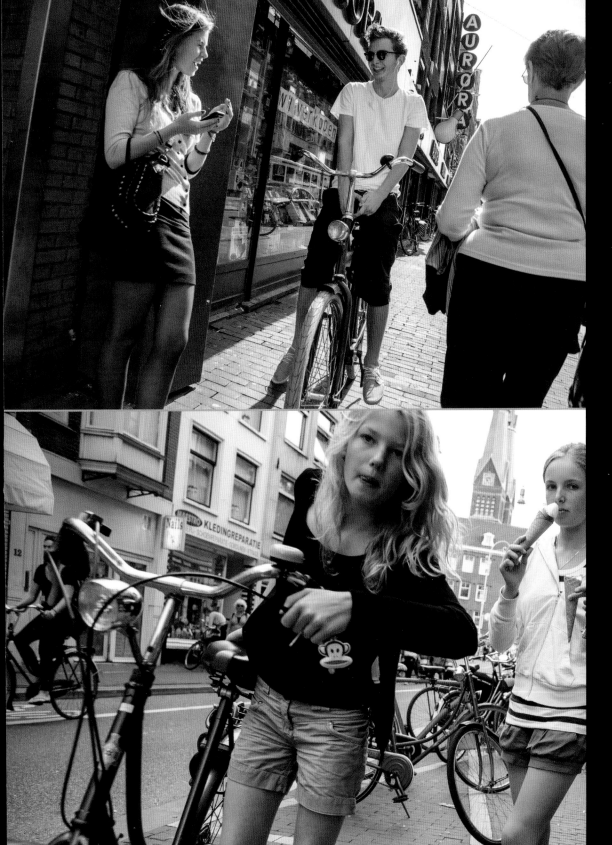

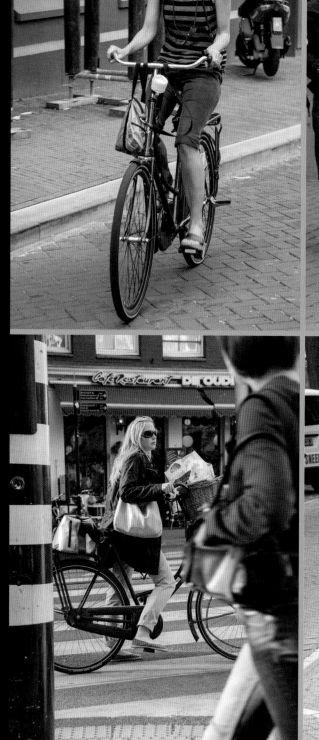
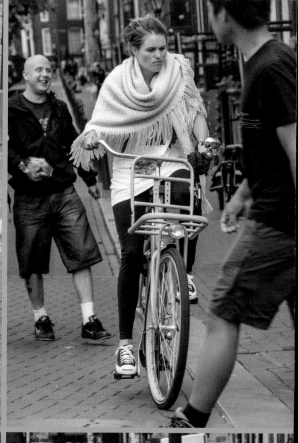
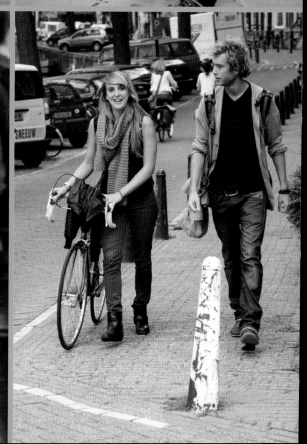

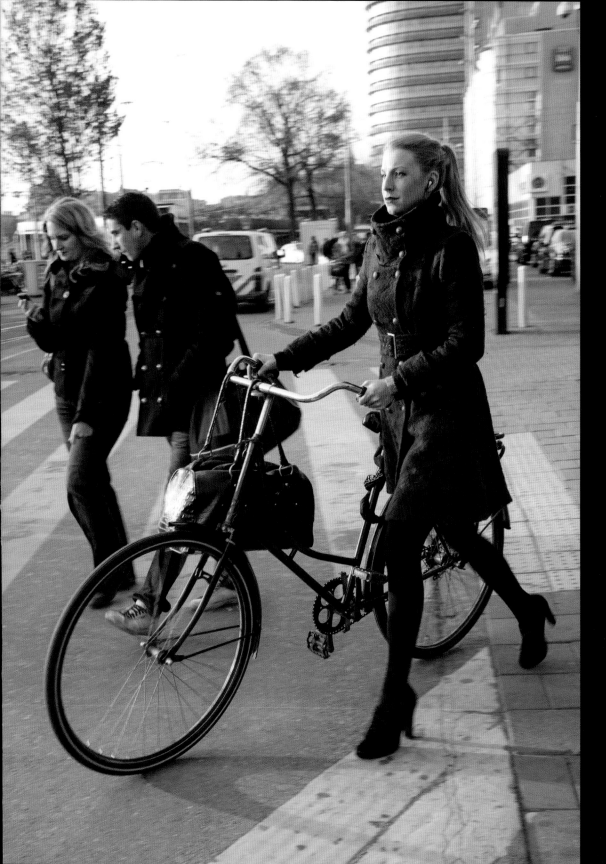

www.BAKFIETSWEB.NL

"Safety comes first for Dutch cyclists. There are special traffic laws for cycling and these are seriously enforced."

HollandTrade.com

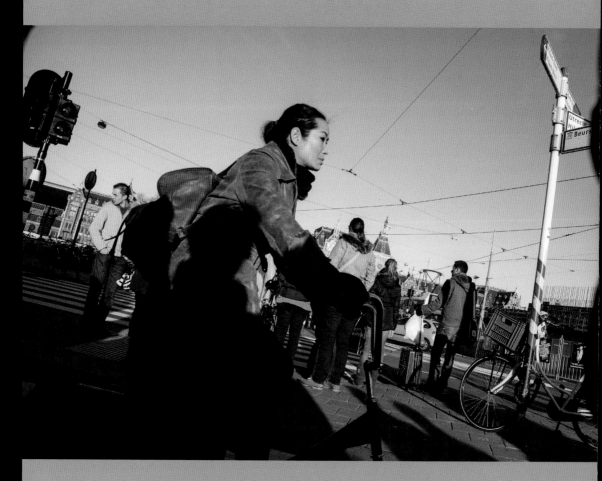

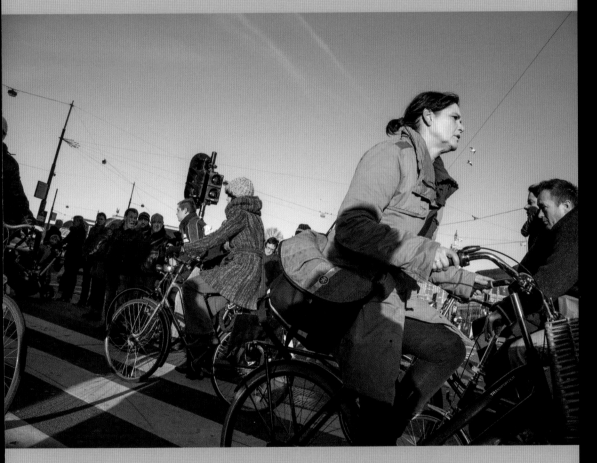

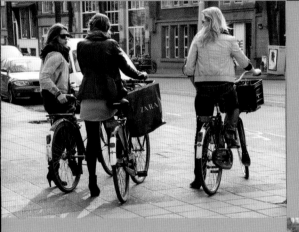

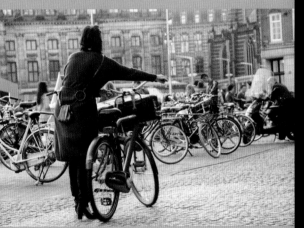

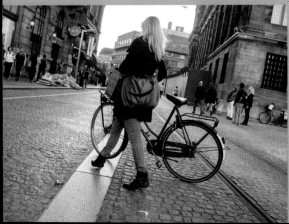

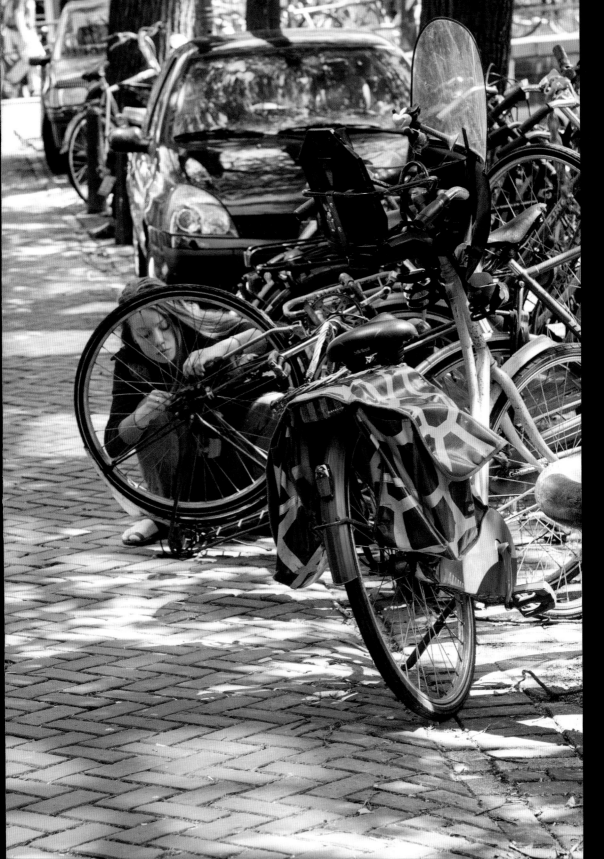

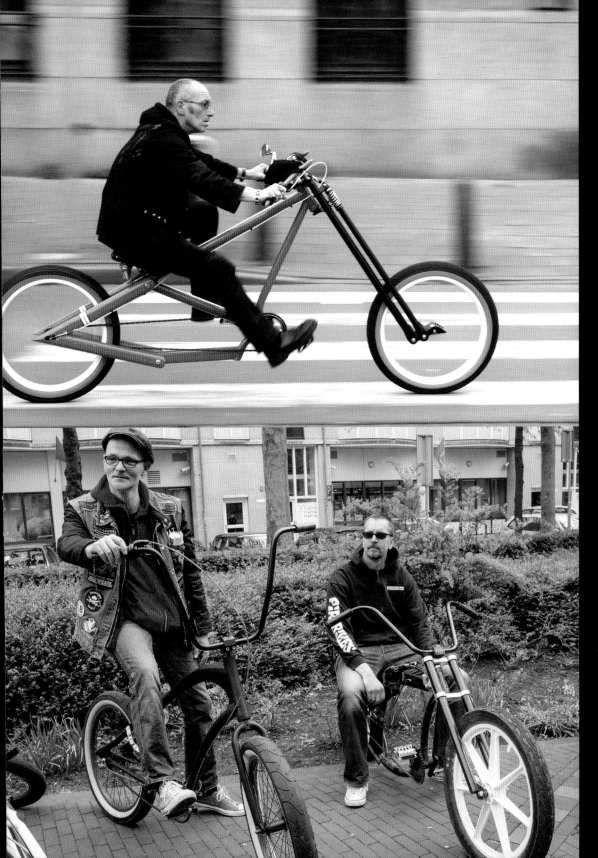

PLACE
DES
AMOUREUX

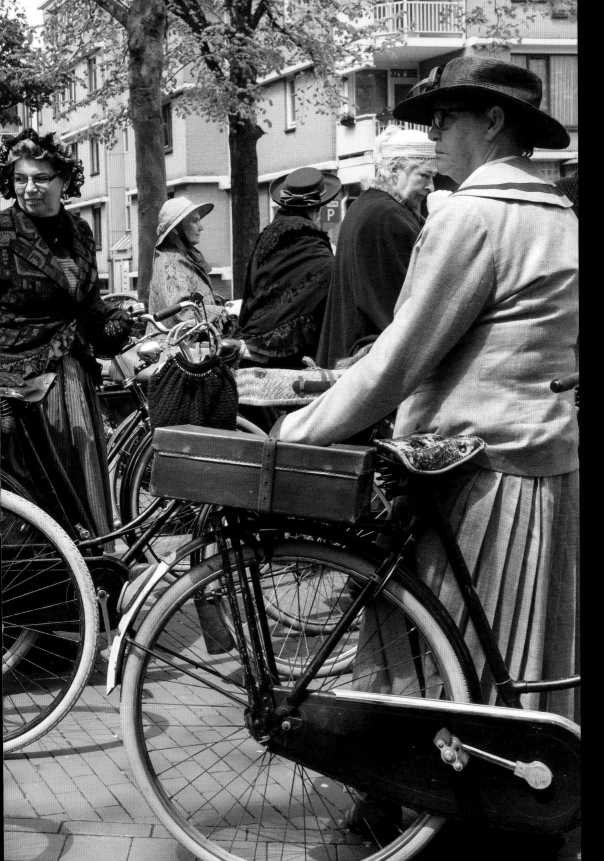

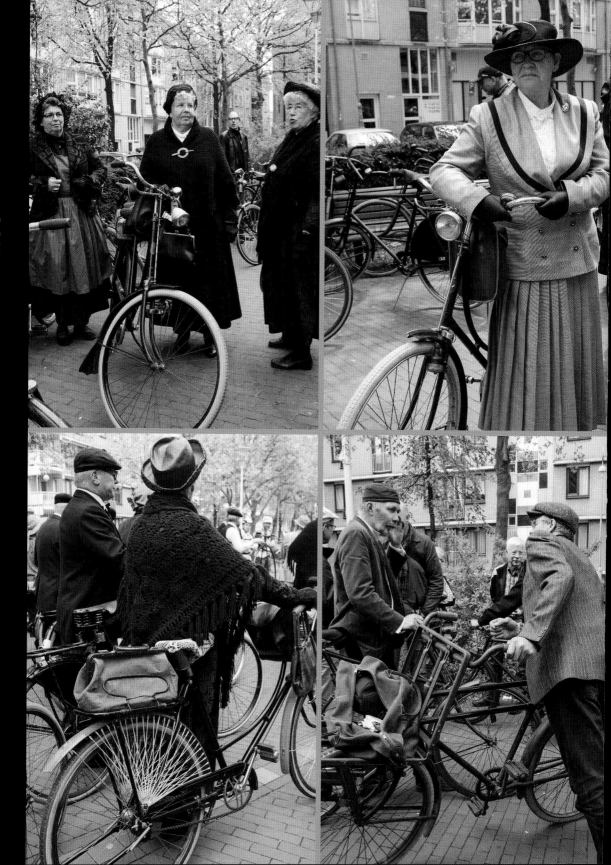

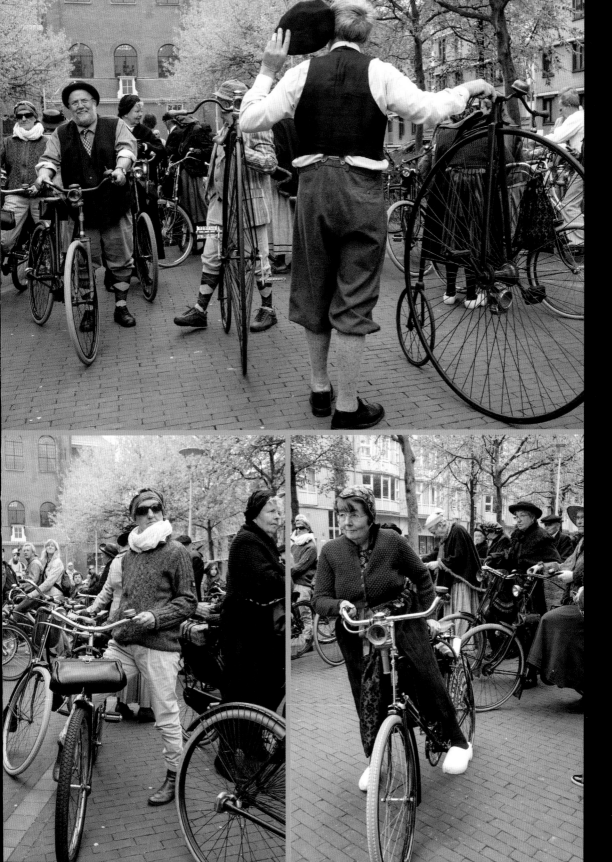

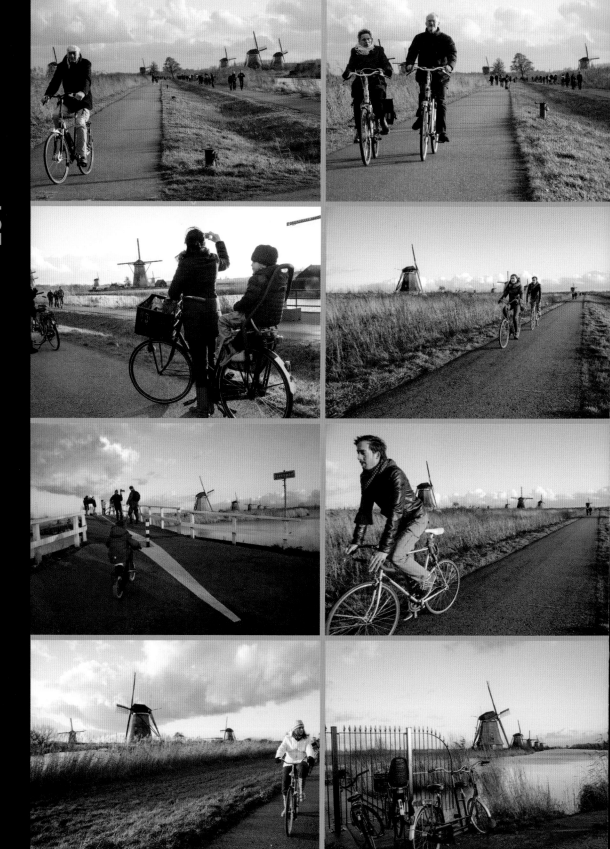

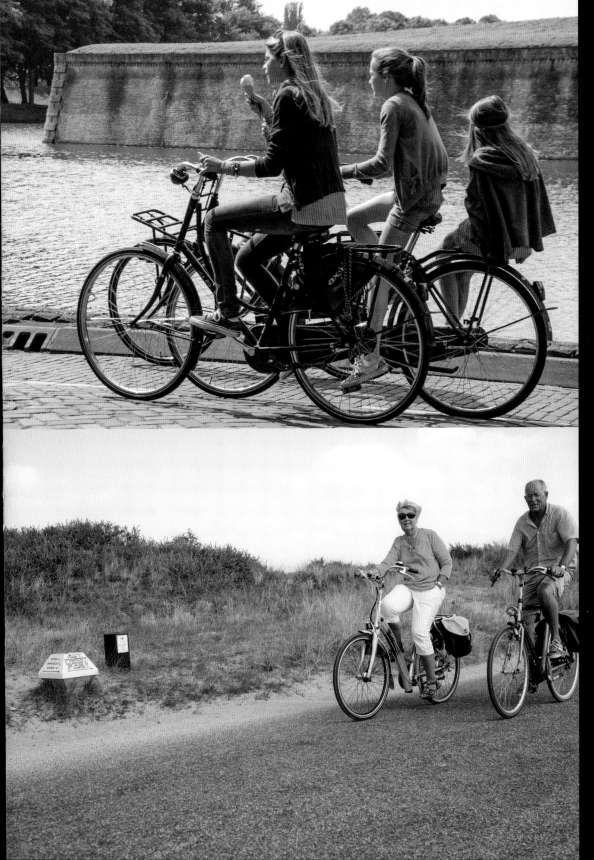

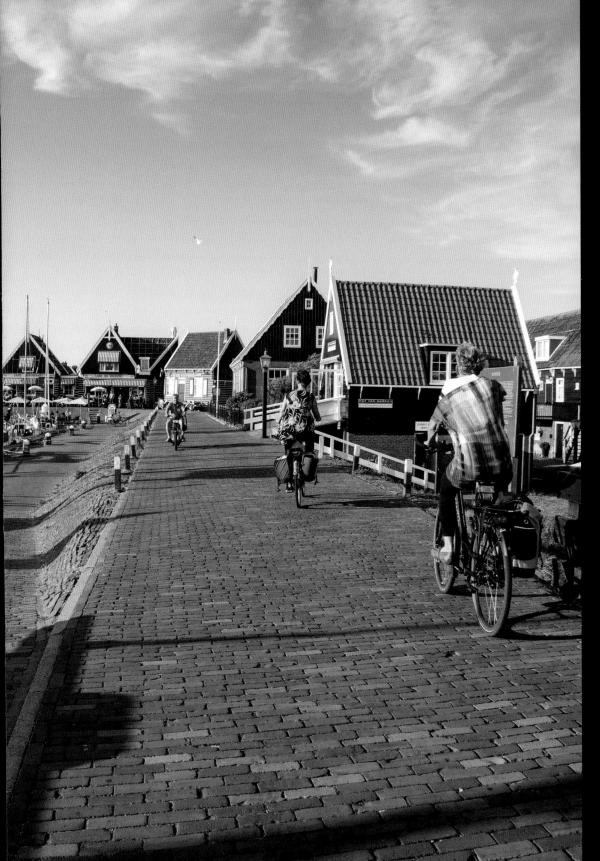

"Although cycling has been a common mode of transportation for decades in countries such as the Netherlands, Denmark and China, it is gaining in popularity elsewhere due to the growing concern about the environment and healthy living. Cycling has a small environmental footprint and big health advantages. However, in order to get more people biking, there needs to be good bike-friendly infrastructure."

HollandTrade.com

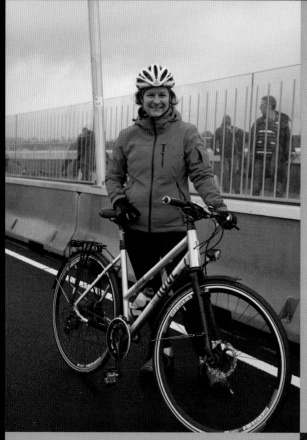

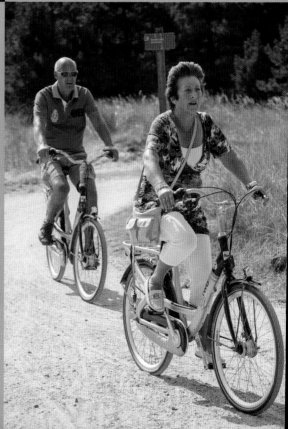

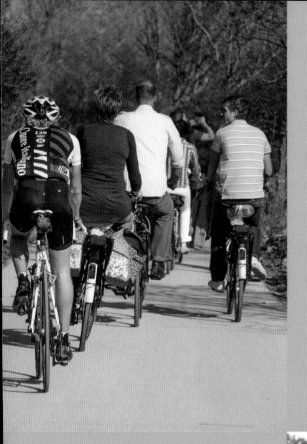

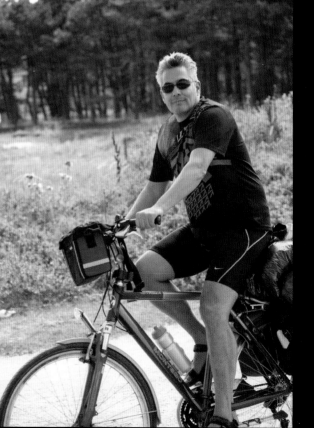

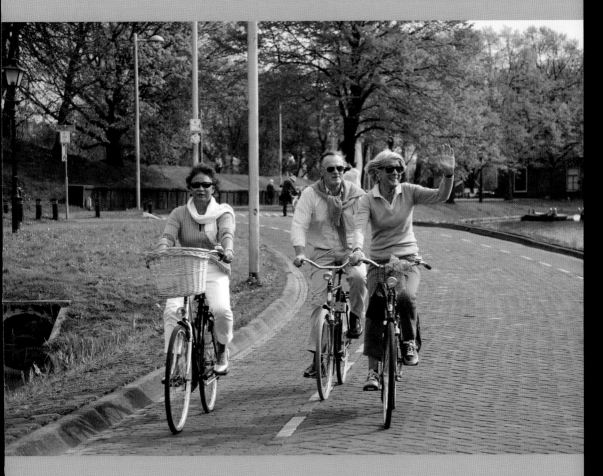

INTERVIEW WITH STEVEN ROOKS, DUTCH PROFESSIONAL ROAD RACING CYCLIST FROM 1982–1995

Shirley Agudo: *As someone who has represented the Netherlands in your professional cycling career, why do you think that your nation has become the most advanced and cycling-friendly country on earth?*

Steven Rooks: I think it's because we have a very good infrastructure for cycling. Another reason may be that, in cities like Amsterdam, you will get to your destination faster on a bike than by car. ...And don't forget it's both fun and healthy to ride a bike.

Agudo: *What infrastructure enhancement or other cycling-related innovation do you particularly support for cycling?*

Rooks: There are many bikes stolen in Holland, so there should be more possibilities to park your bike where it is safe, such as bicycle garages, etc. ... In terms of innovations, e-bikes (electric bikes) are very popular in the Netherlands now.

Agudo: *What is the most important piece of advice you would give to other nations trying to develop a similar bicycle culture, as many of them are trying to do today?*

Rooks: I would say: Start with a fine infrastructure and see to it that cycling and other means of transport, like cars, go together well. Safety for cyclists is a very important issue.

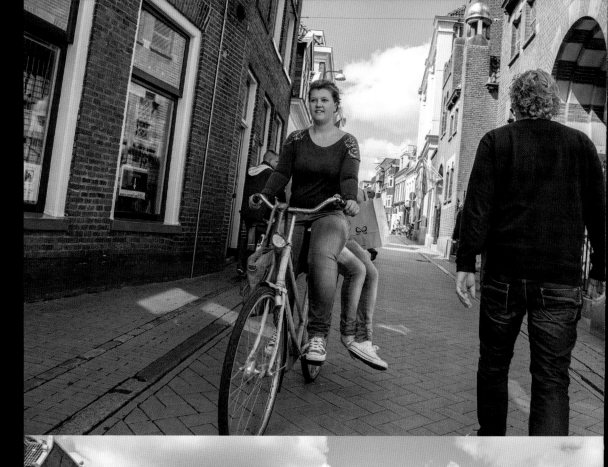

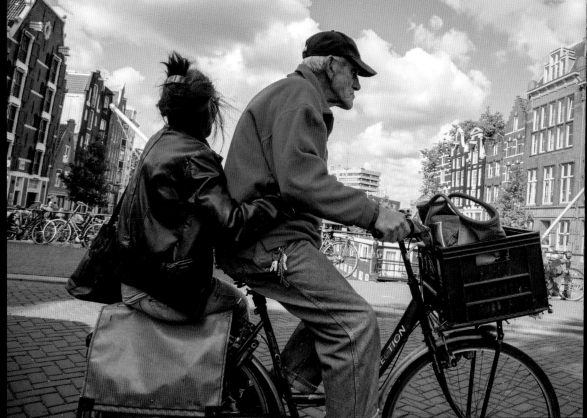

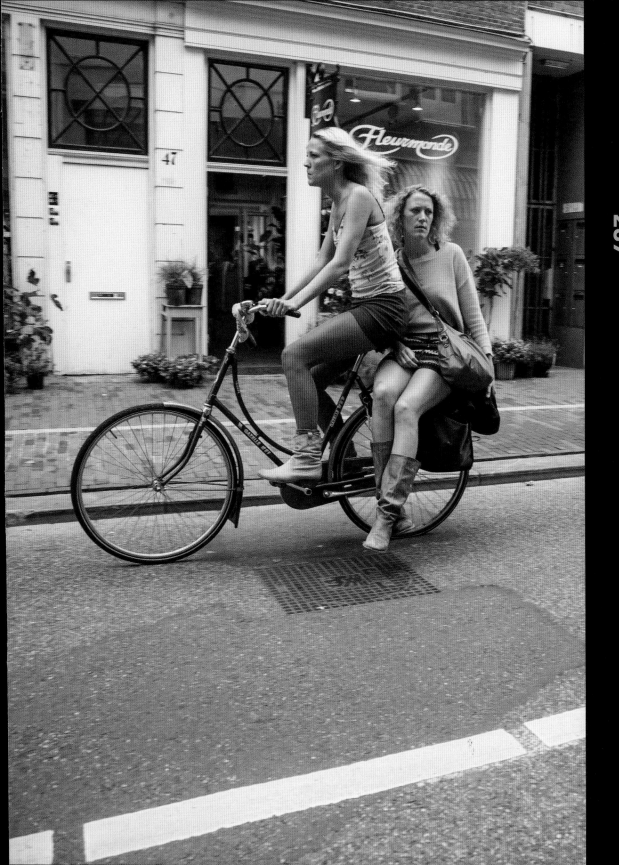

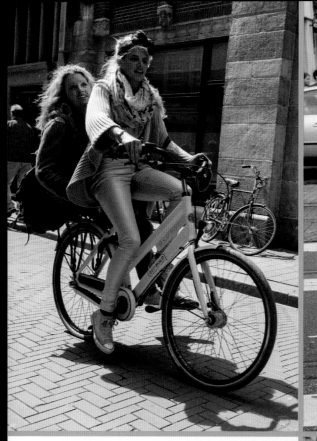
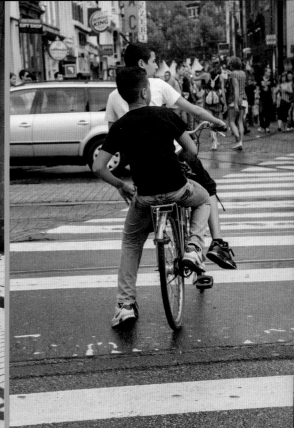
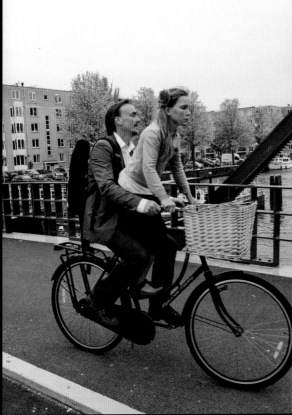
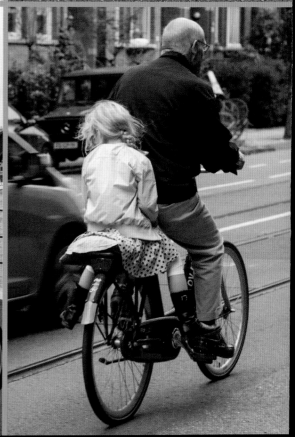

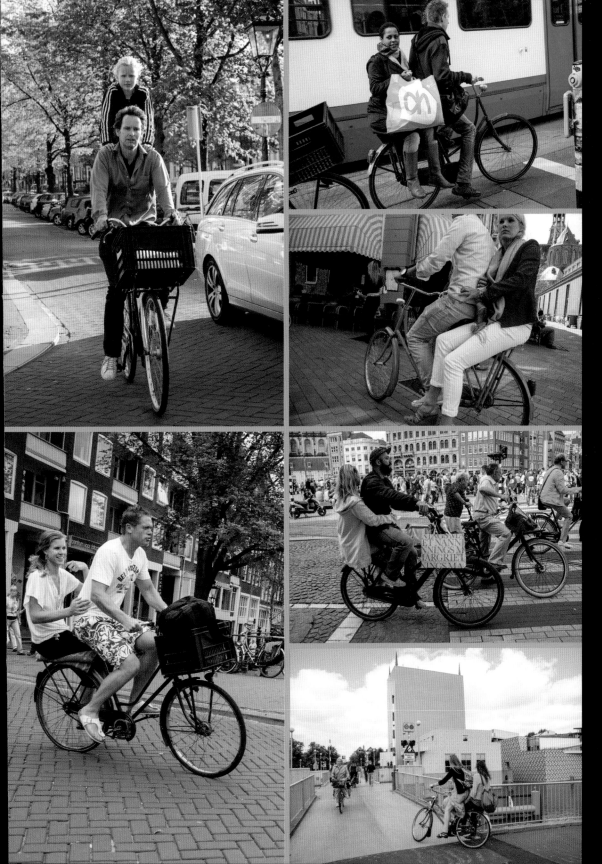

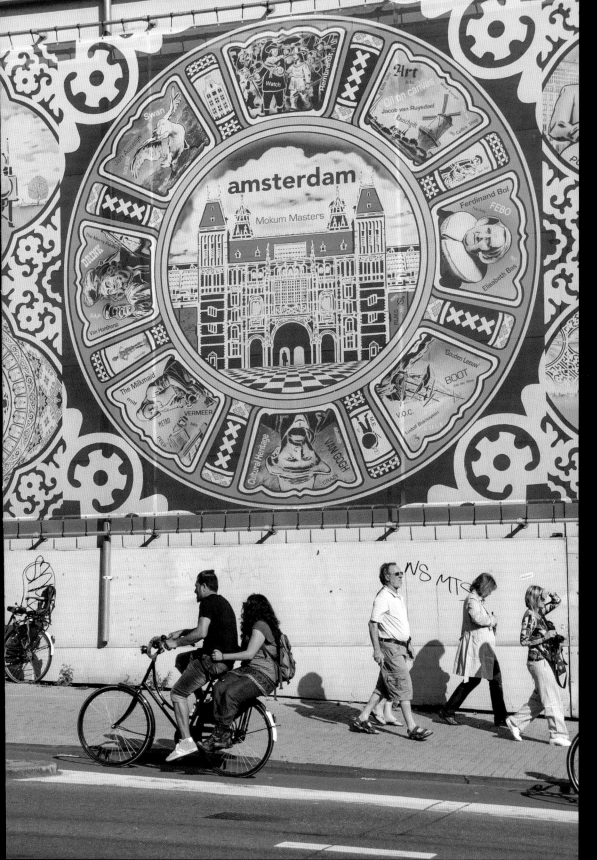

"Cycling should not be elitist, but for all."

Tom Godefrooij,
Sustainable Urban Transport Specialist,
and Senior Policy Advisor,
Dutch Cycling Embassy, The Netherlands

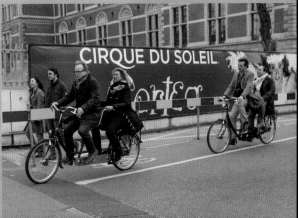

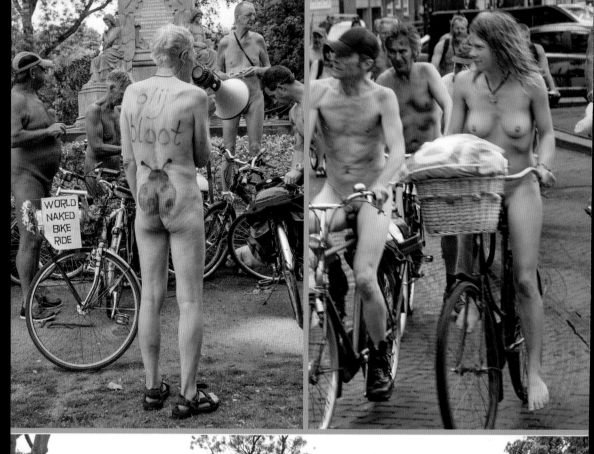

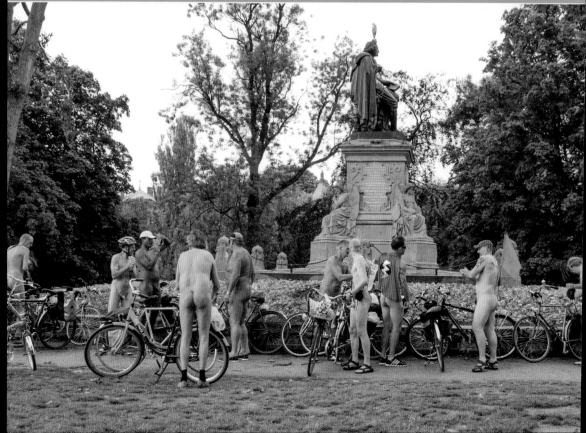

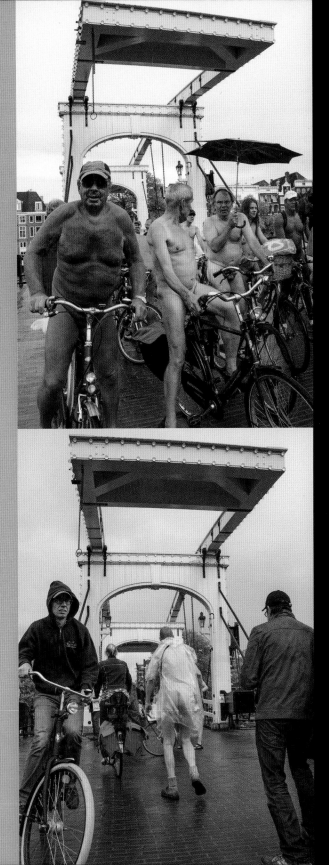

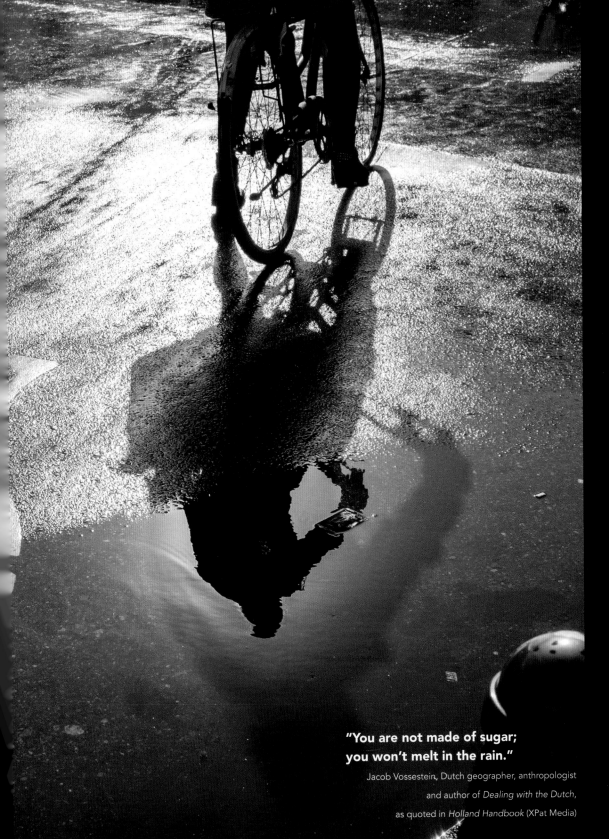

"You are not made of sugar;
you won't melt in the rain."

Jacob Vossestein, Dutch geographer, anthropologist

and author of *Dealing with the Dutch*,

as quoted in *Holland Handbook* (XPat Media)

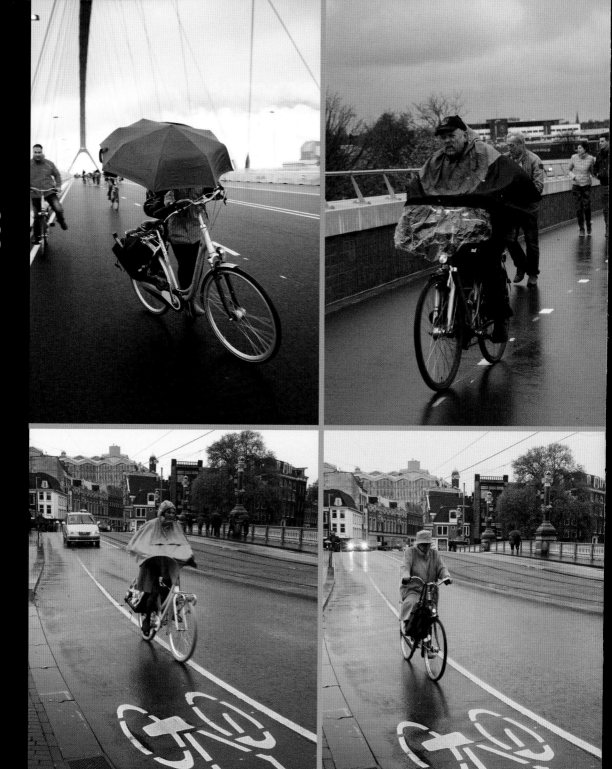

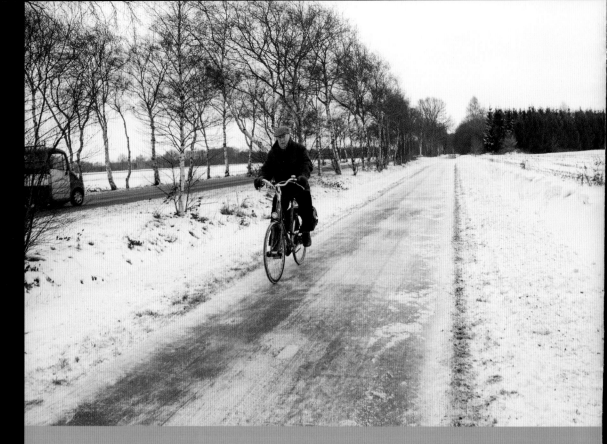

"Worldwide there is a need to better
serve accessibility and create equity
with respect to mobility. The rise
of road fatalities has to be stopped.
We cannot tolerate either air pollution
and a sedentary lifestyle – nor a
further increase in GHG emissions.
An integrated approach for all
modes, with priority for public
transport, cycling and walking is
asked for, worldwide. Within that,
optimal conditions for cycling are
most cost-efficient to serve the
goals for sustainable mobility.
The Dutch way has created the
highest level of smooth urban
transport, accessibility for all,
and road safety standards."

Dutch Cycling Embassy, The Netherlands

"In Groningen, the average person cycles 1.4 times a day ... that's how it goes. Ten times a week people ride a bike somewhere.

...You're not going to get a cycling revolution by having a few 30-km-per-hour streets; you're not going to get it by building just a few cycle paths, and you're not going to get it by traffic calming just a few streets either. You have to do *everything*, and you have to do it *everywhere*. You never have to ride more than a few hundred meters from your home in the Netherlands in order to find yourself on a facility of such quality that you will be happy to cycle on it and you will be happy for your children to cycle on it.

...The reason why it's pleasant to cycle here is because the infrastructure removes conflicts ... and so you don't have people cycling in close proximity to fast cars or large trucks."

David Hembrow, AViewfromtheCyclePath.com, for Streetfilms, 'Groningen: The World's Cycling City'

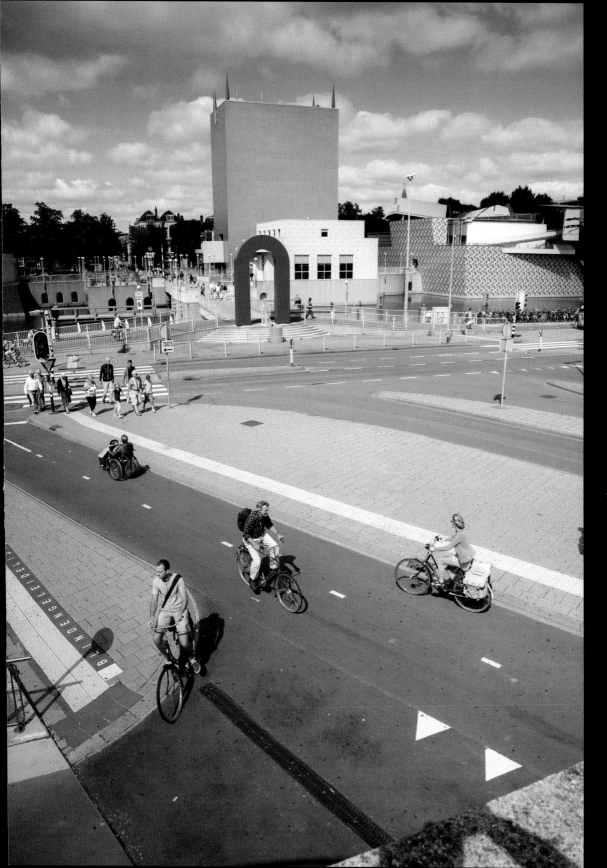

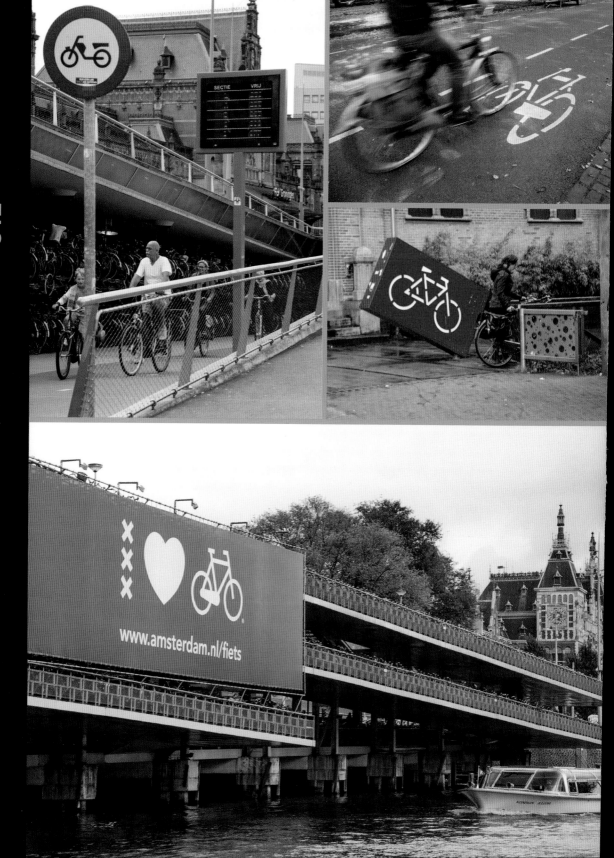

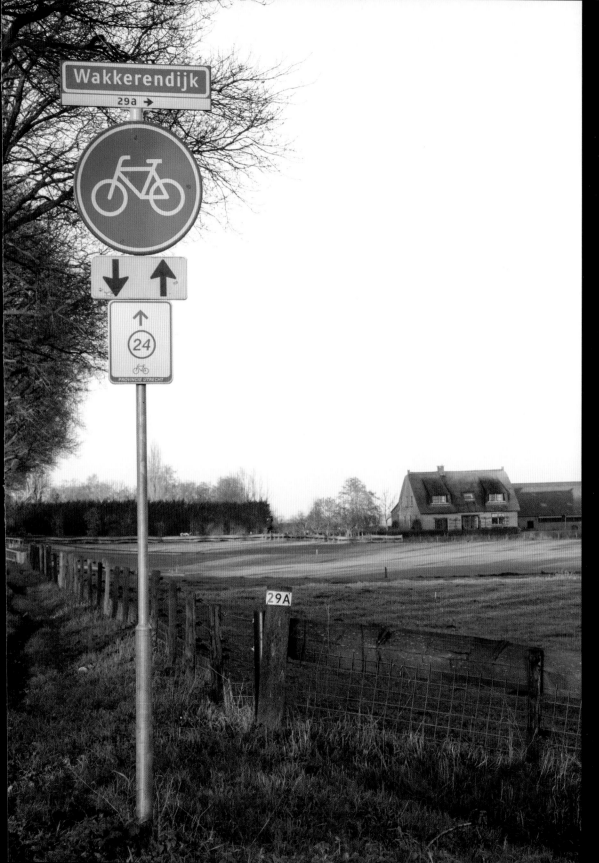

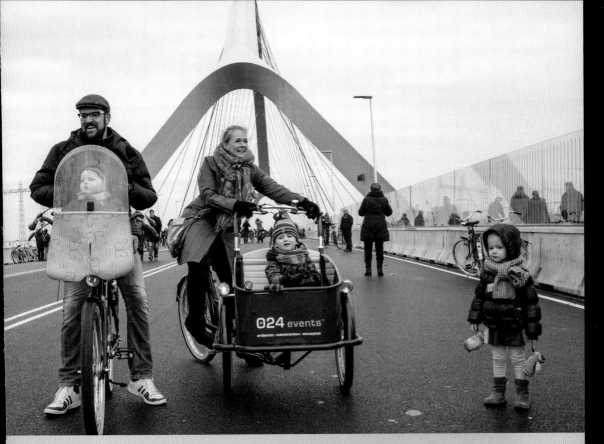

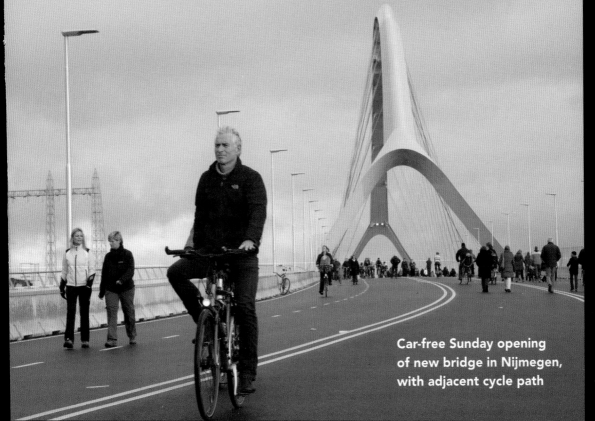

Car-free Sunday opening
of new bridge in Nijmegen,
with adjacent cycle path

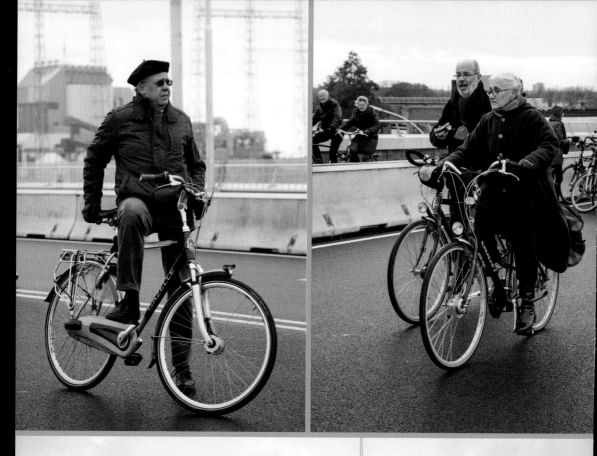

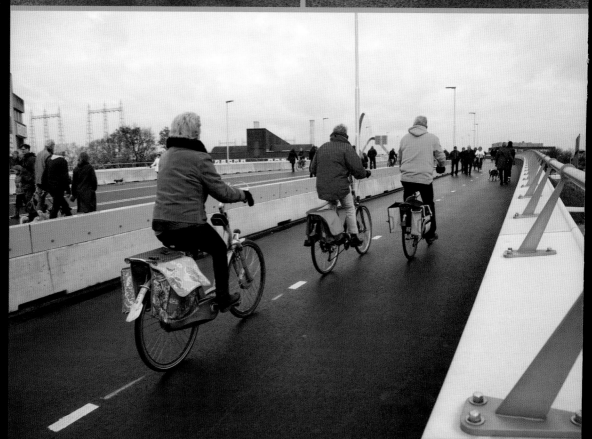

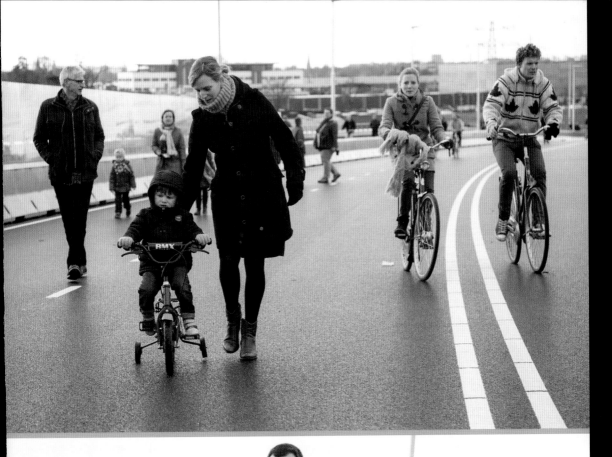

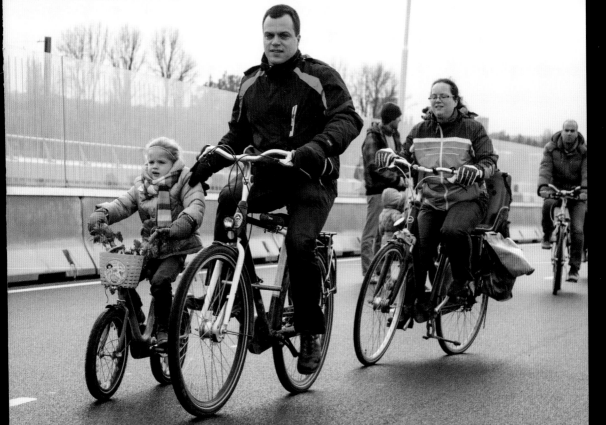

"The *Hovenring* (opened June 2012)
is a cyclists' roundabout that is
suspended above a busy junction
near Eindhoven. Thanks to a
combination of a challenging traffic
concept and a high-quality design,
the Hovenring is more than just
an alternative to a cyclists' tunnel
or bridge; it is also a distinctive
recognition point along a new
cycle route and marks the entrance
to the city. This effect is intensified
in the evening by lighting that
emphasizes the roundabout's
suspended character while at the
same time generating a feeling
of security for cyclists.
...The cyclists' roundabout (diameter:
72 m) (236 ft) is supported by a
single 70-meter-high (230-ft-high)
pylon. This in turn makes it possible
for the junction under the bridge
to be free of columns, yielding an
entirely unobstructed view in all
directions for motorists."

Cycle Infrastructure,
by Stefan Bendiks and Aglaée Degros

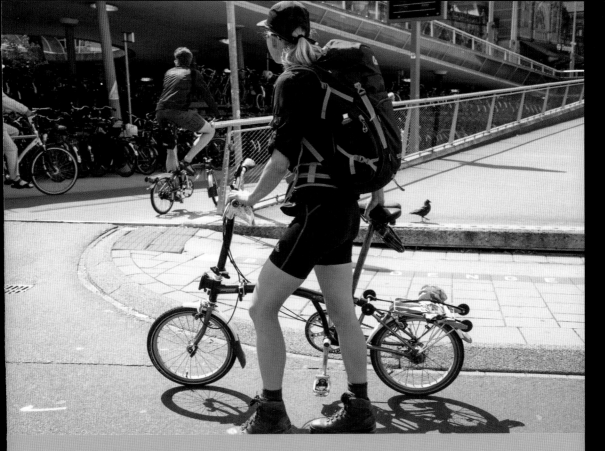

"As the Dutch are not 'into' status games, cycling becomes a very egalitarian means of transport."

Jacob Vossestein, Dutch geographer,

anthropologist and author of *Dealing with the Dutch*

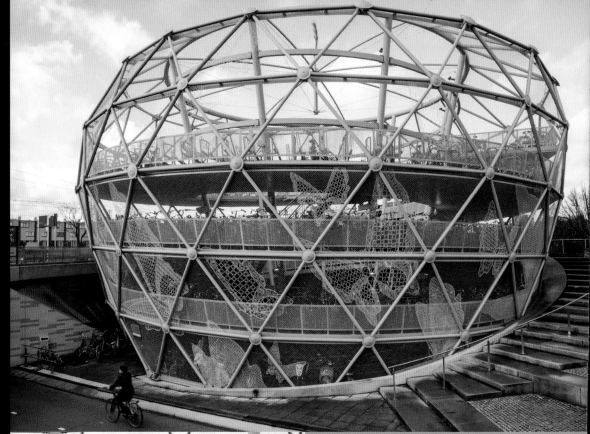

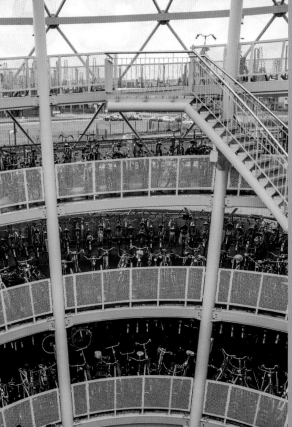

"Standing beside the train station of the town of Alphen aan den Rijn, the *Fietsappel* (Bike Apple) is a distinctively designed bicycle shed which, due to its design and position, appears very much like a large green apple to both train passengers and cyclists, and is therefore a new variation on the postmodernist theme of structures located along traffic infrastructure that are specifically designed to be perceived while in motion. The Bike Apple is 27.5 m (90 ft) in diameter and 15.5 m (51 ft) in height and can accommodate a maximum of 970 bicycles.."

Cycle Infrastructure,
by Stefan Bendiks and Aglaée Degros

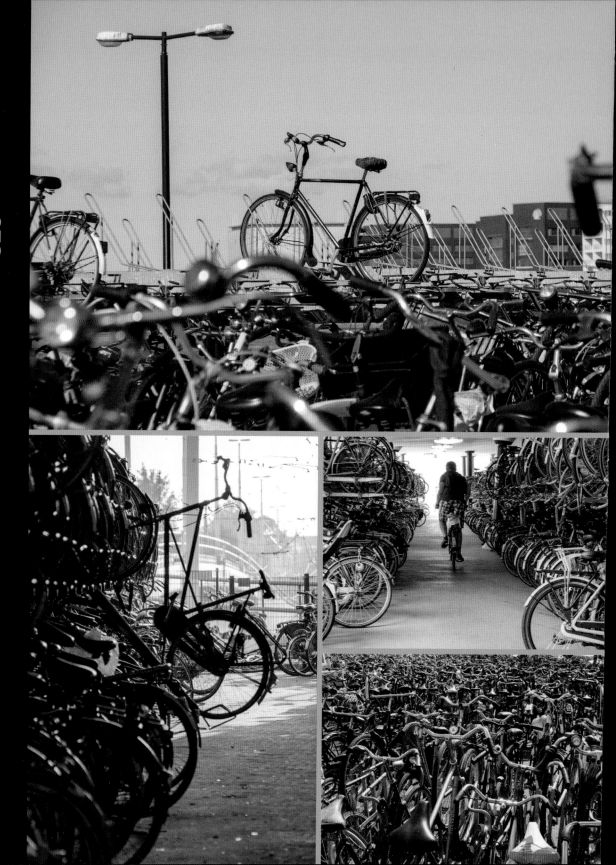

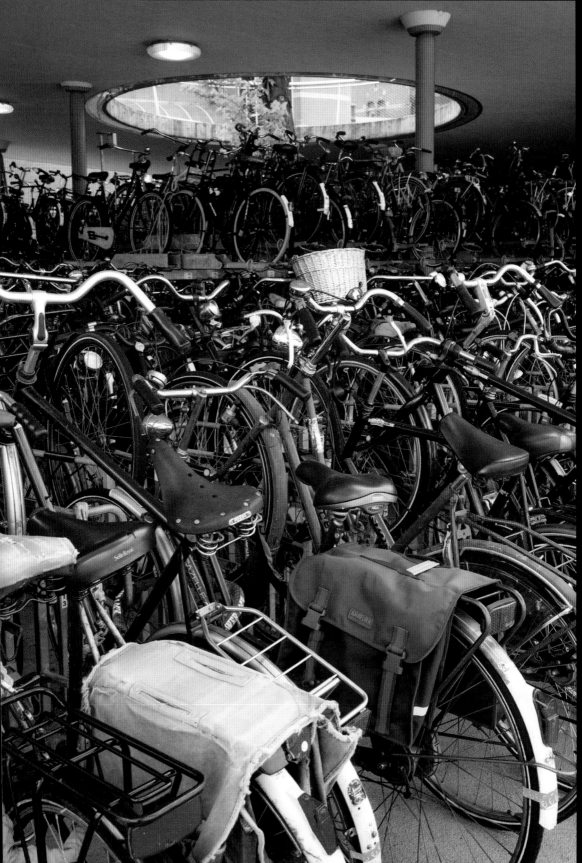

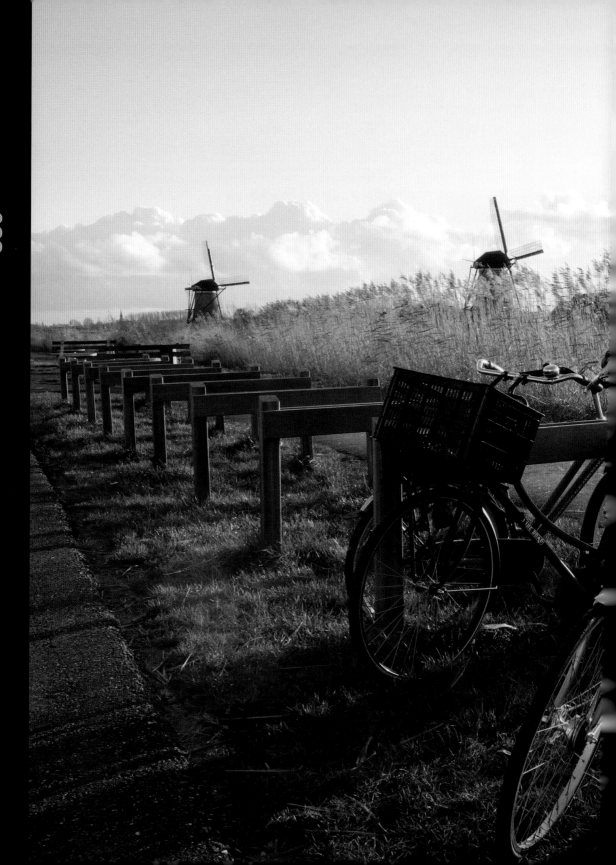

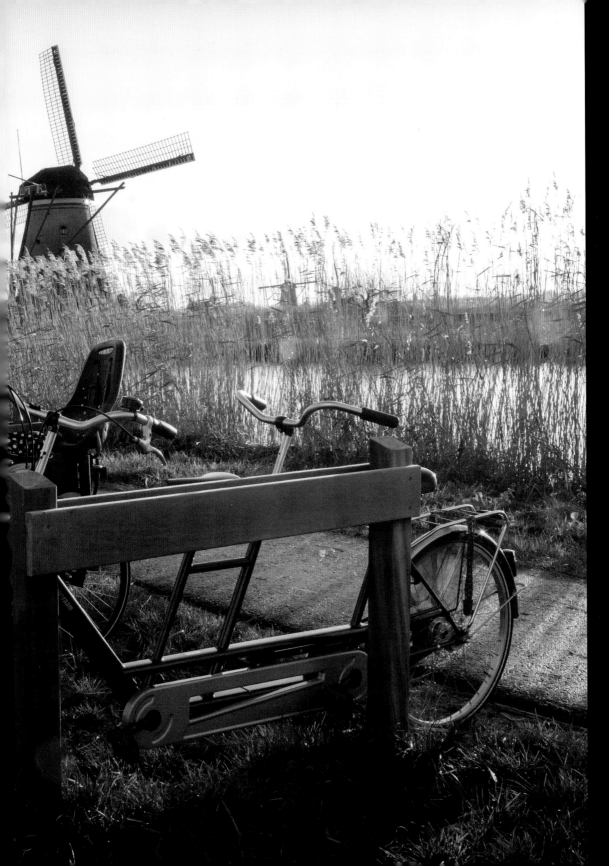

"The bike satisfies the Dutch inclination to not waste any resources – an aspect of ingrained practicality."

Jacob Vossestein,
Dutch geographer, anthropologist
and author of *Dealing with the Dutch*

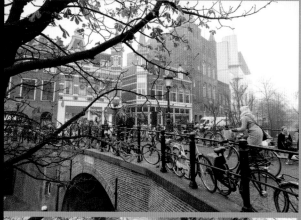

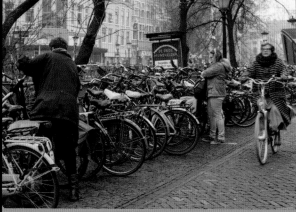

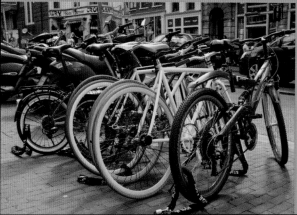

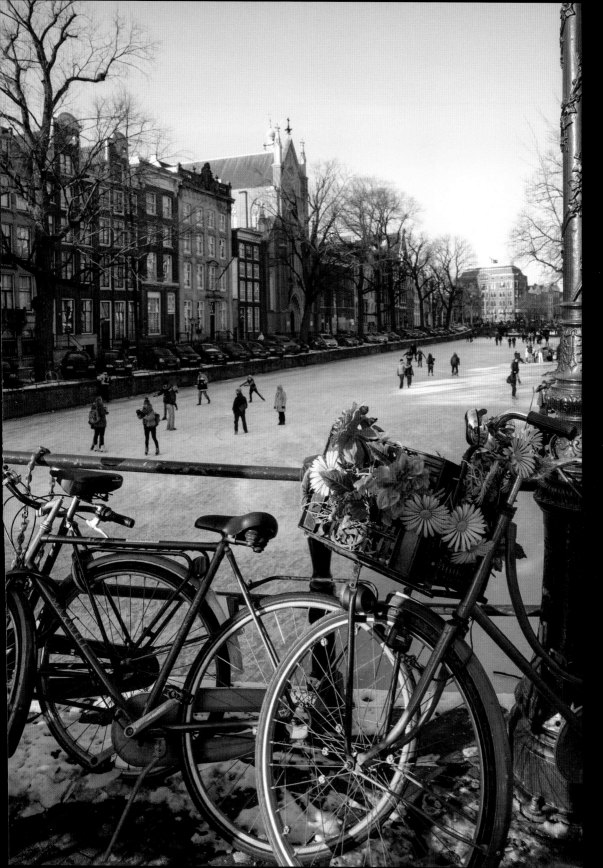

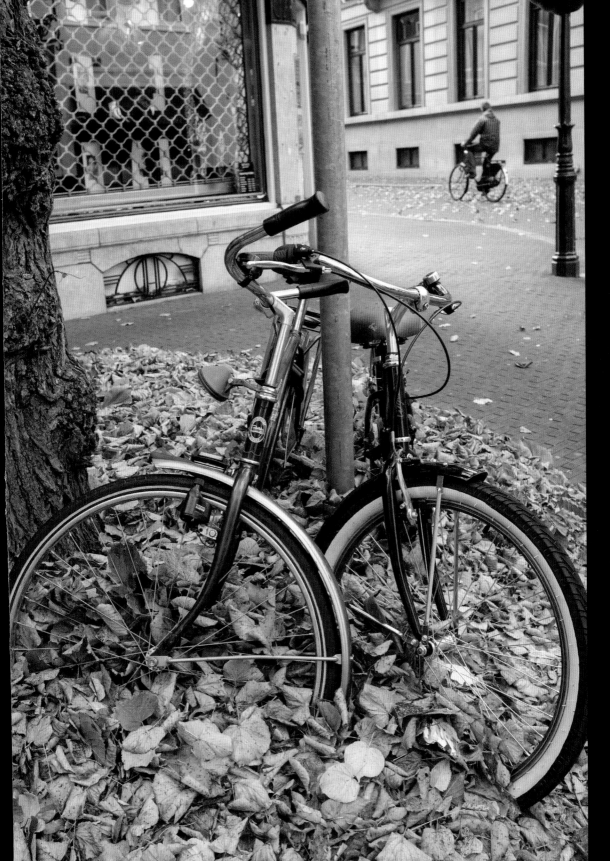

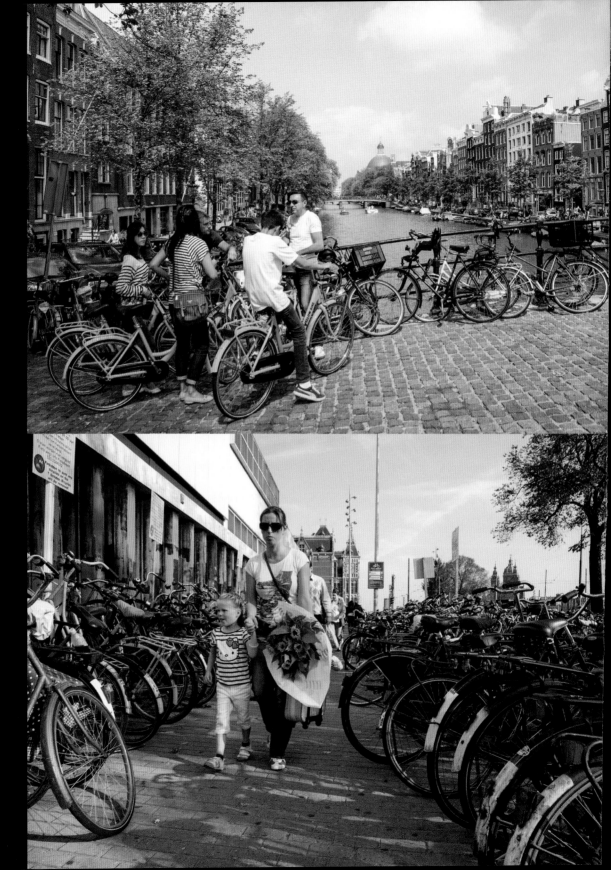

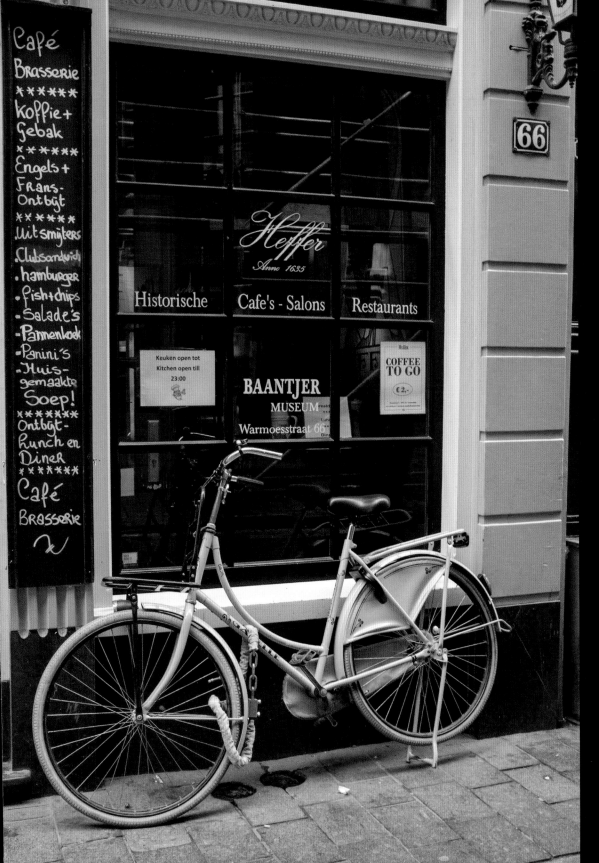

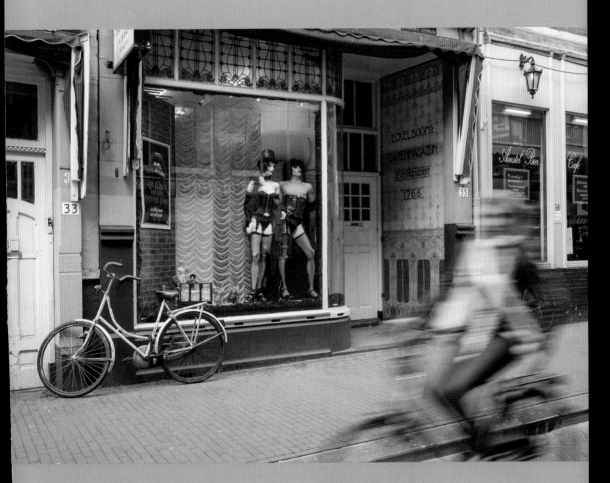

"For many countries, the Netherlands is a prime example of how cycling can be incorporated into everyday life. Several Dutch organizations are actively promoting Holland's expertise and technology abroad. For example, the Dutch Cycling Embassy is an advocacy group with representatives from non-profit organizations, private companies, bike manufacturers and local and national governments in the Netherlands. The embassy's goal is to help organizations and governments abroad to find partners for developing cycling infrastructure, policies and products."

HollandTrade.com

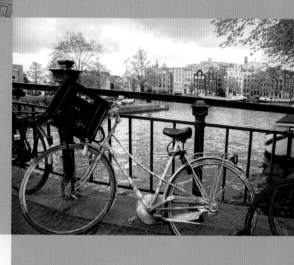

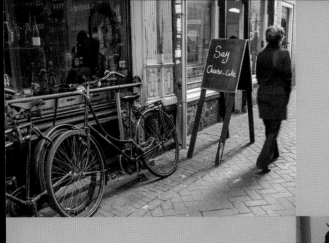
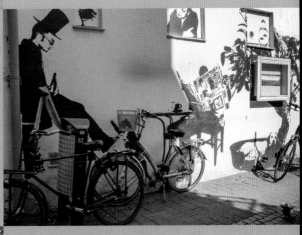

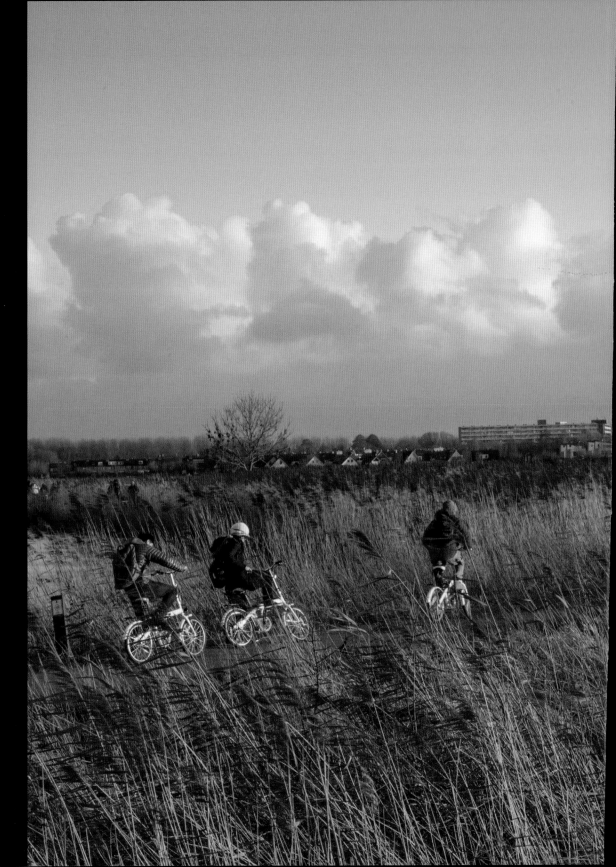

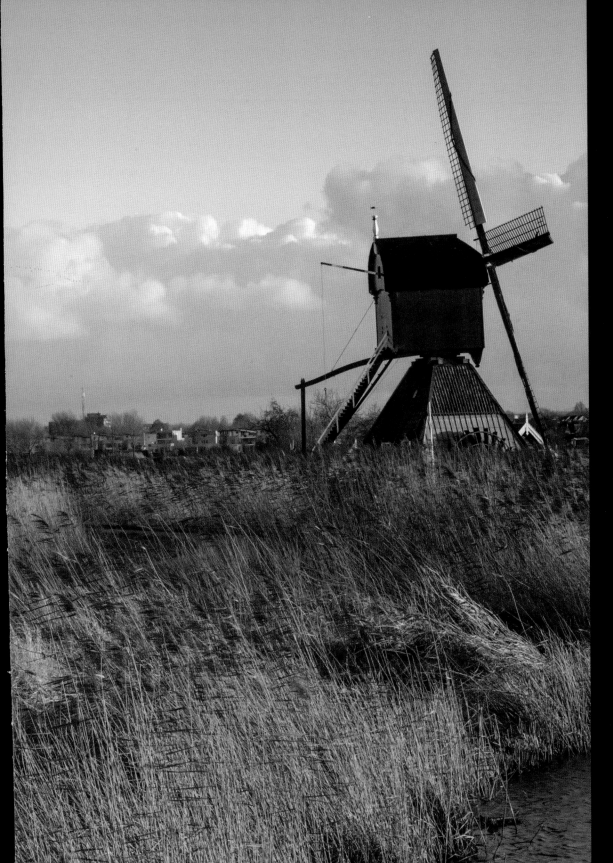

LINKS AND RESOURCES

- Dutch Cycling Embassy: www.dutchcycling.nl
- Fietsdiensten.nl (cycling advice and services, the 'Bike Experience')
- Fietsersbond (Dutch Cyclists' Union): www.fietsersbond.nl
- CROW, national knowledge platform for infrastructure, traffic, transportation and public spaces: www.crow.nl
- Fietsberaad (Center of Expertise on Bicycle Policy): www.fietsberaad.nl
- KpVV (Dutch Knowledge Platform on Mobility): www.kpvv.nl
- Nederland Fietsland (Netherlands Bikeland): www.nederlandfietsland.nl
- Landelijk Fietsplatform (Knowledge and Coordination Point for Recreational Cycling): www.fietsplatform.nl
- ANWB, national Dutch motoring/touring organization with a wealth of cycling (and walking) information: www.anwb.nl/fietsen
- ANWB biking app: www.anwb.nl/mobiel/fietsen
- Dutch biking routes: www.fietspad.nl
- Inexpensive B&Bs in the Netherlands, catering to cyclists: www.vriendenopdefiets.nl
- Nationaal Fietsmuseum Velorama (National Bicycle Museum), Nijmegen, The Netherlands: www.velorama.nl
- Amsterdam Fietsmuseum (Amsterdam Bike Museum, currently in development): www.amsterdamfietsmuseum.nl
- National tourist site for the Netherlands/Holland: www.holland.com
- NBTC Holland Marketing: www.nbtc.nl
- General train information for the Netherlands: www.ns.nl
- Information about taking bikes on Dutch trains: www.nsfiets.nl
- Public transport bikes for rent in the Netherlands: www.ov-fiets.nl
- National tourist information for the Netherlands, including cycling routes: www.vvv.nl
- Tourism and recreation in the Netherlands: www.lekkerweg.nl
- Bikes, bike routes and bike vacations in the Netherlands: www.fietsen.123.nl
- History of the Dutch bicycle and various models: www.oudefiets.nl
- Netherlands cycling blog: www.bakfiets-en-meer.nl (see also www.workcycles.nl and www.workcycles.com, Dutch bike manufacturer/American entrepreneur Henry Cutler)
- Dutch cycling blog and study tours: www.AViewfromtheCyclePath.com and www.hembrow.eu/studytour
- Dutch cycling blog: www.bicycledutch.wordpress.com
- Bicycle Culture, www.bicycle-culture.com
- Urban mobility with focus on Amsterdam: www.amsterdamize.com
- Gifts for cycling fans: www.cyclocadeau.nl
- Learning to cycle in the Netherlands: www.hetfietscollege.nl
- European Cyclists' Federation (ECF): www.ecf.com
- The European Network for Cycling Expertise, www.velo.info
- Velo Mondial, sustainable mobility, www.velomondial.blogspot.nl
- Mobycon, sustainable traffic, transport and mobility solutions, www.mobycon.com
- European Cycle Logistics Federation: www.federation.cyclelogistics.eu
- London Cycling Campaign: www.lcc.org.uk
- Bike Hub, supporting the future of cycling, www.BikeHub.co.uk
- The League of American Bicyclists: www.bikeleague.org
- Movement to improve bicycling in the U.S.: www.peopleforbikes.org
- Bicycle Museum of America: www.bicyclemuseum.com
- Bike touring inspiration: www.travellingtwo.com
- The 'soul of cycling': www.redkiteprayer.com
- Shirley Agudo, photographer/author, *The Dutch & Their Bikes: Scenes from a Nation of Cyclists*: www.shirleyagudo.com

BOOKS

- *Bicycle Mania Holland*, Shirley Agudo, www.bicycle-mania.nl (Available through Scriptum.nl and ShirleyAgudo.com)
- *In the City of Bikes: The Story of the Amsterdam Cyclist* (*De Fietsrepubliek*, in Dutch), Pete Jordan, www.cityofbikes.com
- *Cycle Infrastructure (Fietsinfrastructuur)*, Stefan Bendiks and Aglaée Degros
- *Ons Stalen Ros (Our Iron Horse)*, Dutch cycling history to 1920, with English summary, Kaspar Hanenbergh, Michiel Röben and Pepijn Janssen. (For release in 2014)
- *Roads Were Not Built for Cars*, Carlton Reid, www.roadswerenotbuiltforcars.com
- *Cycle Space: Architecture & Urban Design in the Age of the Bicycle*, Steven Fleming, PhD, Senior Lecturer, School of Architecture & Design, University of Tasmania, Australia, www.cycle-space.com

MAGAZINES

- *Kampioen* (in Dutch), ANWB, www.anwb.nl
- *Toeractief* (in Dutch), ANWB, www.anwb.nl
- *Vogelvrije Fietser* (in Dutch), Fietsersbond, www.vogelvrijefietser.nl
- *Verkeer in Beeld* (in Dutch), www.verkeerinbeeld.nl
- *Momentum Magazine*, www.momentummag.com
- *BikeBiz*, www.bikebiz.com

ARTICLES

- 'Cycling Culture in the Netherlands from 1870 to 1920', *The Boneshaker: The Journal of the Veteran-Cycle Club* (Winter 2012), Kaspar Hanenbergh, cycling historian
- 'Why is Cycling so Popular in the Netherlands', BBC News Magazine (August 7, 2013), Anna Holligan, www.bbc.co.uk
- 'A Cyclist's Mecca, with Lessons for Boston', The Boston Globe (Sept. 22, 2013), Martine Powers, www.bostonglobe.com

FILMS

- 'The Dutch & Their Bikes', Shirley Agudo, www.youtube.com
- 'Bicycle Mania Holland', Shirley Agudo, www.youtube.com
- 'Bicycle Anecdotes from Amsterdam', Clarence Eckerson, Jr., Streetfilms, www.streetfilms.org
- 'Groningen: The World's Cycling City', Clarence Eckerson, Jr., Streetfilms, www.streetfilms.org
- 'Even More from The Netherlands: Journey from Assen to Groningen', Clarence Eckerson, Jr., Streetfilms, www.streetfilms.org
- 'Amsterdam Loves Bicycles', www.youtube.com or www.amsterdam.nl/cyclingpolicy

For more photos and information, be sure to visit www.dutchandtheirbikes.com and www.shirleyagudo.com. You- can also connect with me on Twitter@TheDutch&TheirBikes.

This collection of Dutch cycling images is the second volume published by photographer Shirley Agudo. Her first collection, 'Bicycle Mania Holland', is available in limited quantities directly through her or Scriptum.nl.

ACKNOWLEDGMENTS

As every author knows, doing a book is a labor of love – one that includes the talent, kindness, generosity – and patience – of many people who help to make it a reality.

The Dutch & Their Bikes is no exception, and my heartfelt thanks go out to these very talented people for their extraordinary assistance and support:

- Co-publishers Bert van Essen (XPat Media) and Gerjan de Waard (Scriptum)
- Ad van der Kouwe, book designer, Manifesta, Rotterdam
- Guido van Woerkom, President and CEO, ANWB
- Theo de Groot, Stadsarchief Amsterdam
- Peter van der Knaap, PhD, Managing Director, SWOV (Institute for Road Safety Research)
- Ria Hilhorst, Cycling Policy Advisor, City of Amsterdam, Department of Infrastructure, Traffic and Transport
- Aletta Koster, Director, Dutch Cycling Embassy
- Tom Godefrooij, Sustainable Urban Transport Specialist, and Senior Policy Advisor, Dutch Cycling Embassy
- Angelique Vermeulen, Marketing Consultant, NBTC Holland Marketing
- Kaspar Hanenbergh, cycling historian and author (Ministry of Foreign Affairs, The Hague)
- Jos Sluijsmans, Fietsdiensten.nl
- Mark Wagenbuur, BicycleDutch.wordpress.com
- Charles Rubenacker, Bicycle-Culture.com
- Marco Hietberg, photo editor, Marco Hietberg Fotografie, www.marcohietbergfotografie.nl
- David Hembrow, cycling study tours – for the photo of me in his Mango velomobile, www.aviewfromthecyclepath.com
- Alison Cavatore, Founder & Editorial Director, Global Living Magazine, for her eagle eye and advice
- Trevor Waldron, photography consultant, www.trevorwaldron.com
- Michiel Fokkema, photography consultant, www.PhotographySchool.nl

I also want to thank *all* the people who have been quoted in my book. Your points of view are invaluable, and this book is much stronger with your voices.

"Respect cycling – invest in cycling –
build a cycling-friendly world!"

Manfred Neun, President, ECF (European Cyclists' Federation)

('Cycling Economy 2.0: The Human Rights Approach',

Sound of Cycling: Urban Cycling Cultures,

Velo-city Vienna 2013 Conference Magazine)

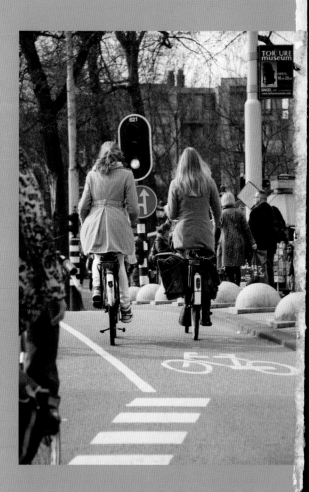

COLOPHON

ISBN 978 90 5594 899 4
NUR 370

©2014 XPat Scriptum Publishers / Shirley Agudo

**No part of this book may be reproduced or
transmitted in any form or by any means without
permission from:**

XPat Scriptum Publishers
Nieuwe Haven 151
3117 AA Schiedam
The Netherlands
Tel +31(0)10.427.10.22
E-mail: info@xpat.nl

Photography and text: Shirley Agudo,
www.shirleyagudo.com
E-mail: dutchandtheirbikes@shirleyagudo.com
Twitter: @TheDutch&TheirBikes.

Design and layout: Ad van der Kouwe,
Manifesta Rotterdam
www.manifestarotterdam.nl

Print: DZS Grafik

Visit us at:
www.dutchandtheirbikes.com
www.scriptum.nl